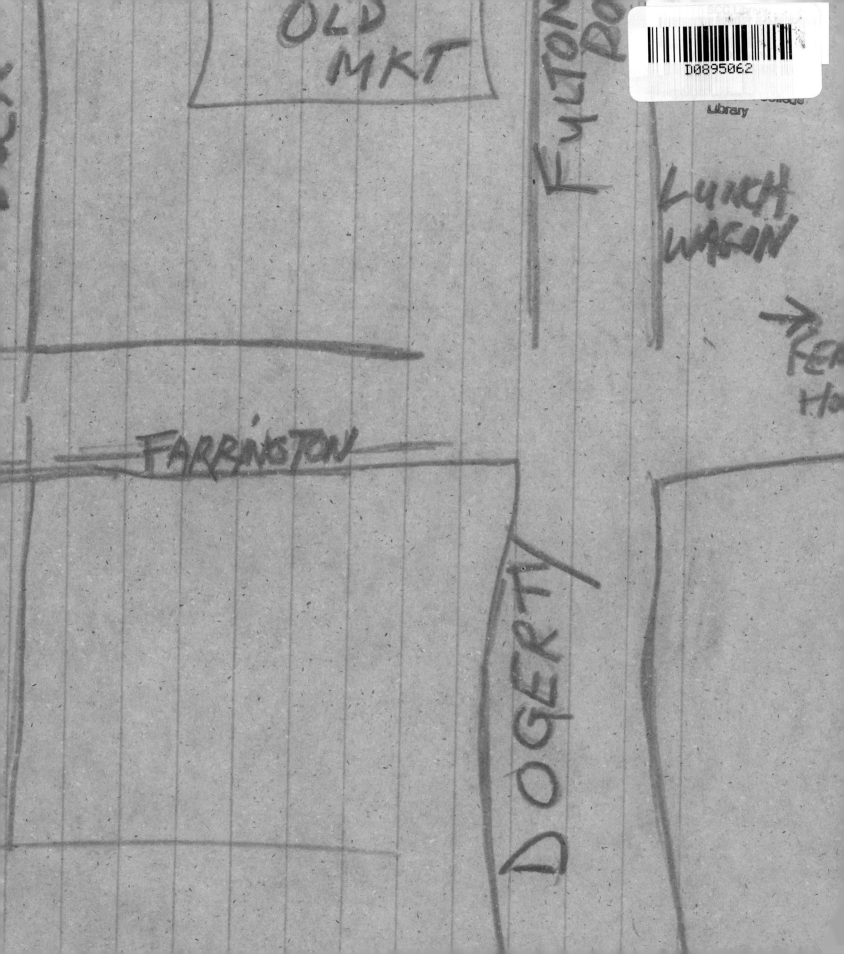

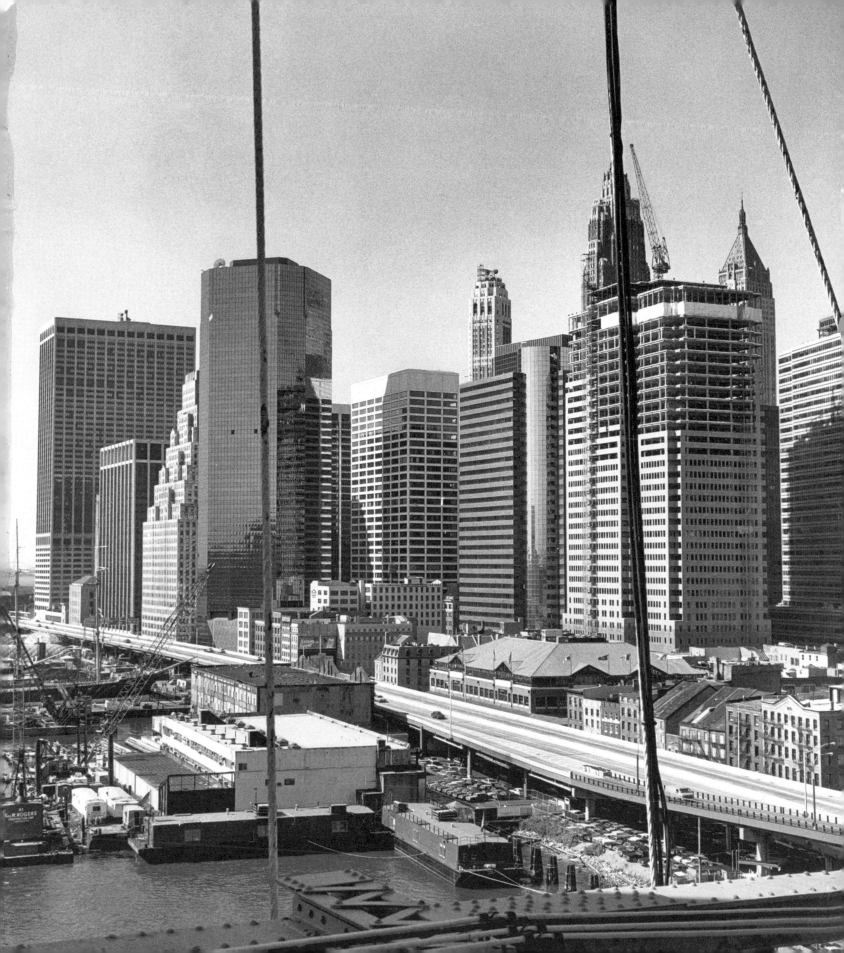

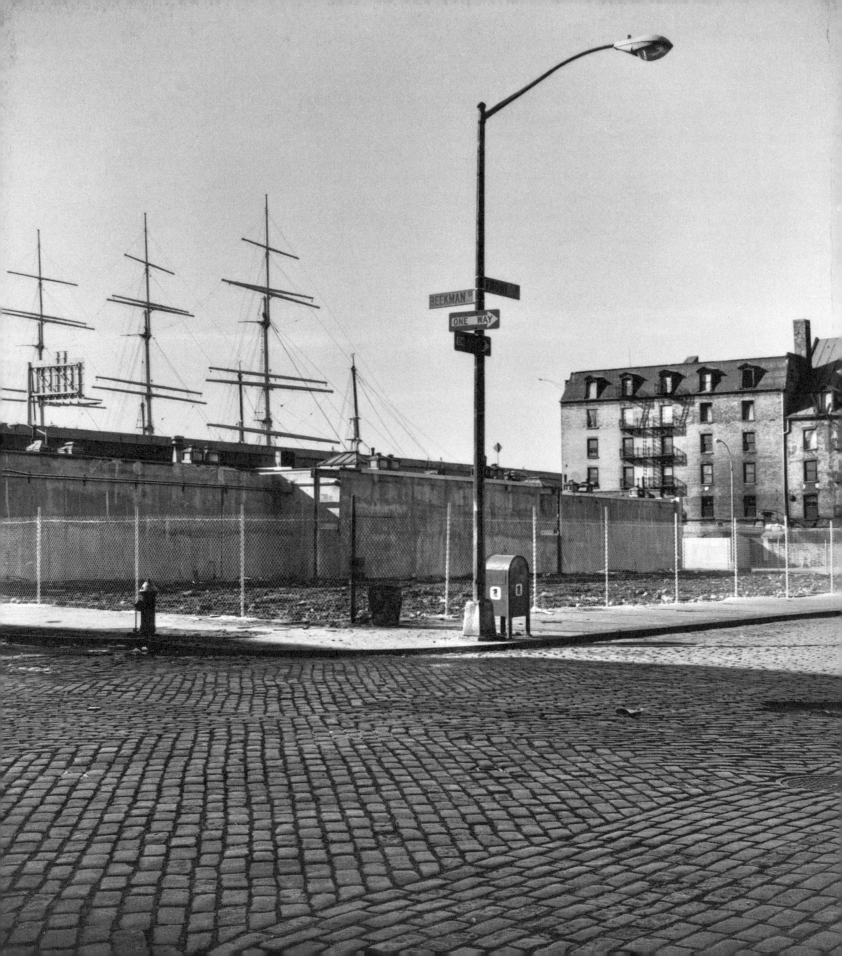

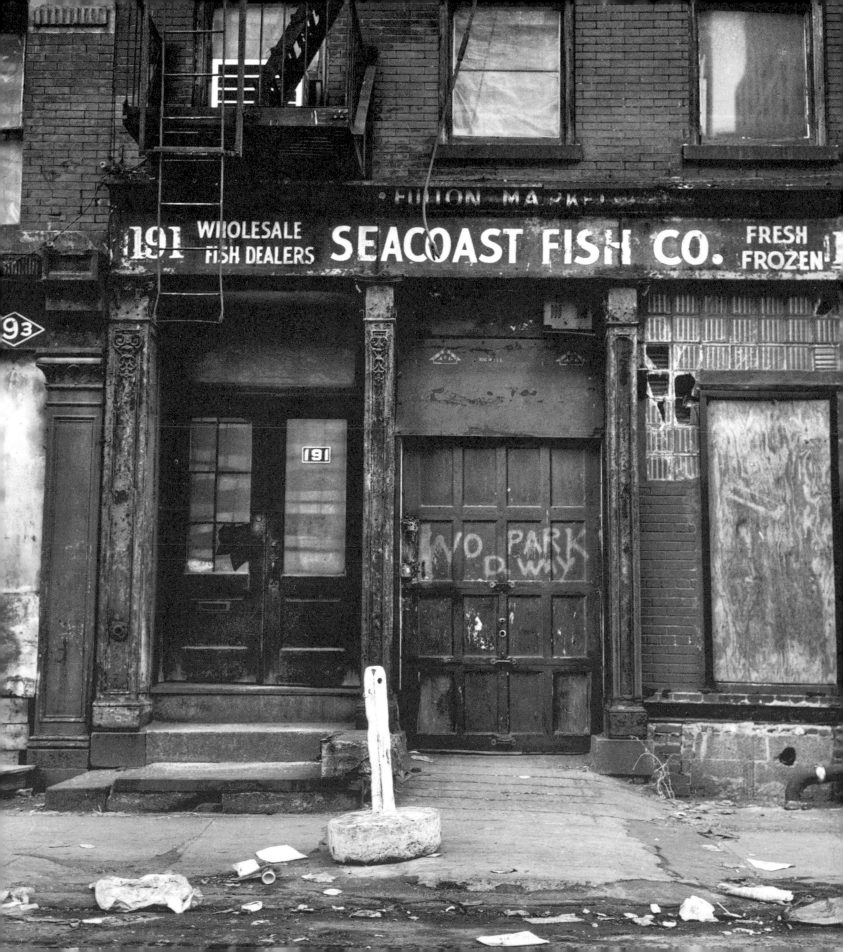

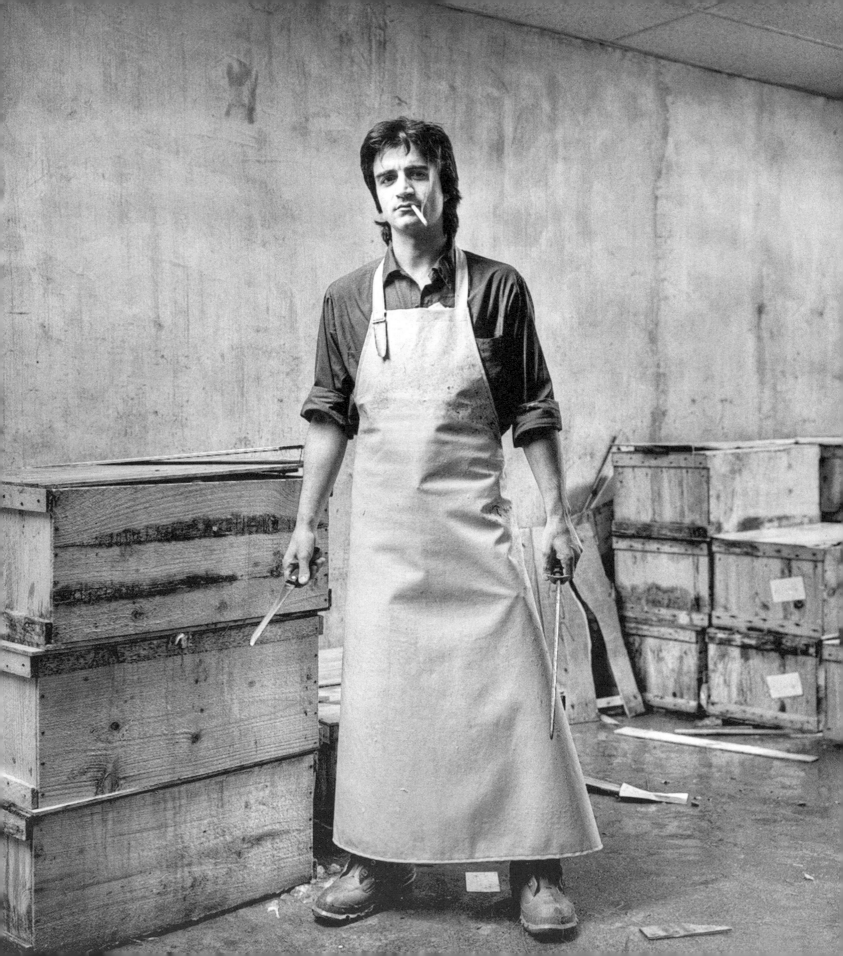

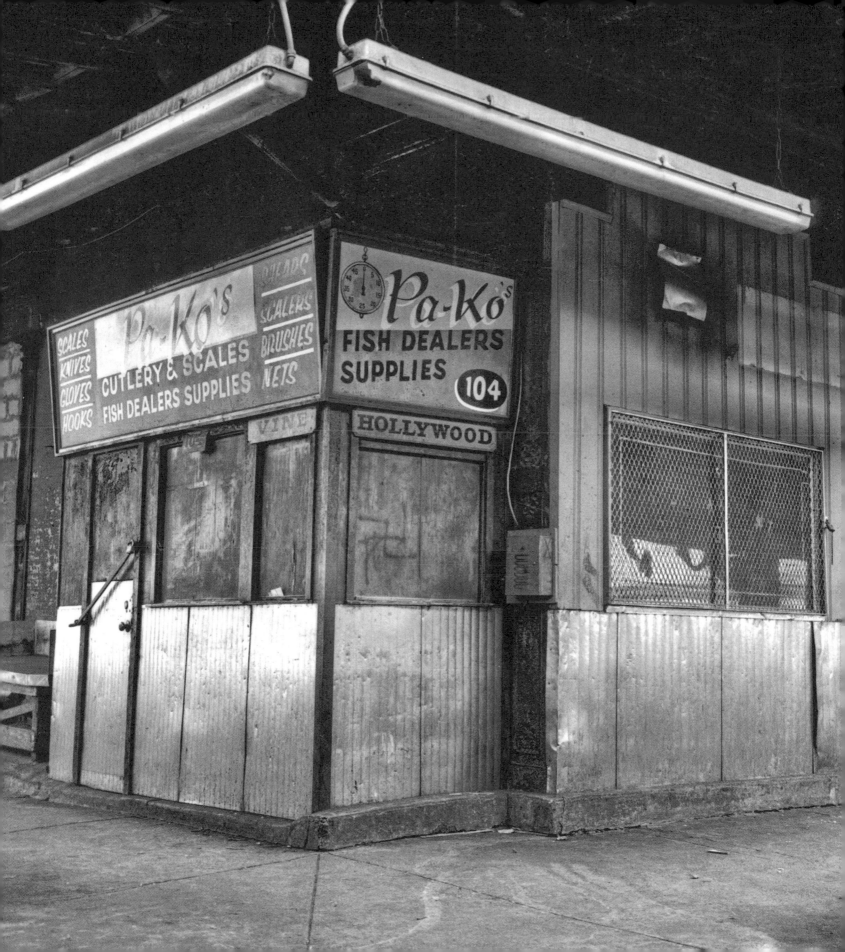

SOUTH

COLUMBIA UNIVERSITY PRESS NEW YORK

STREET

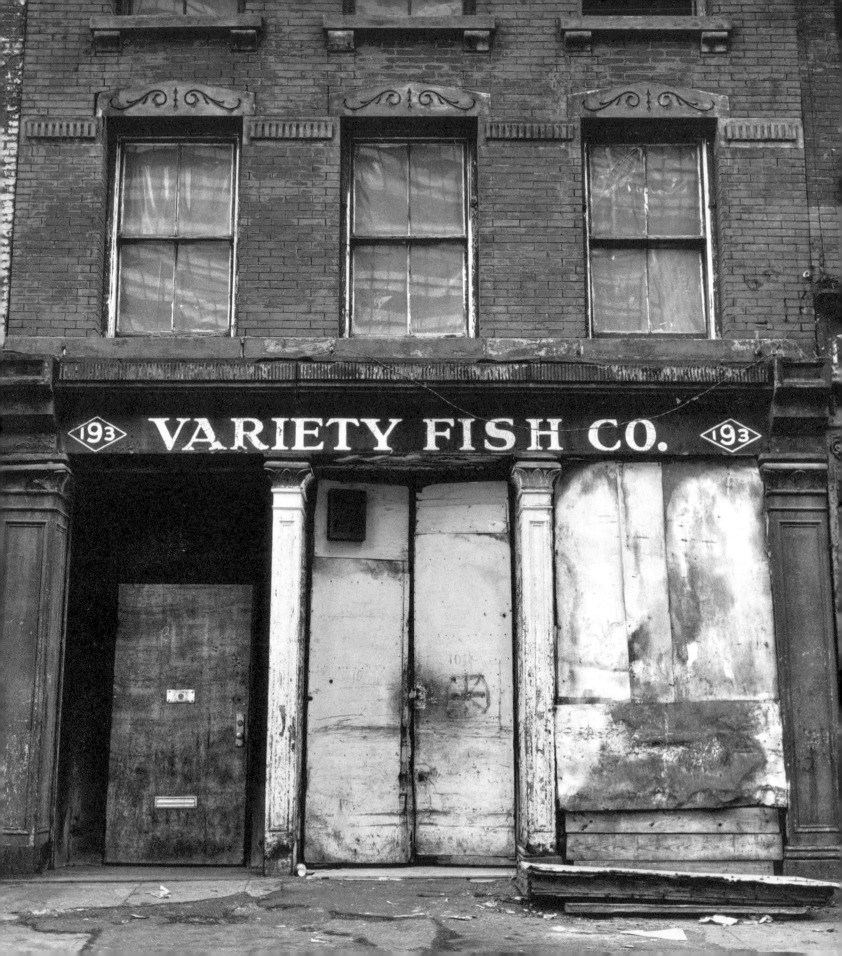

Contents

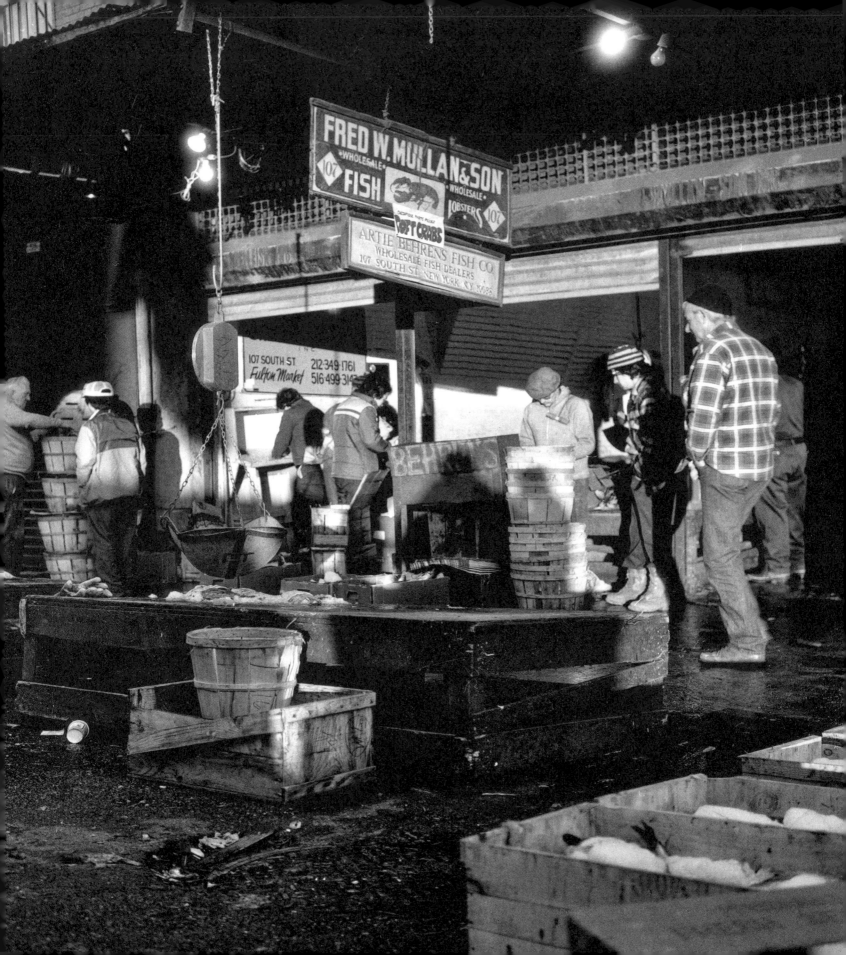

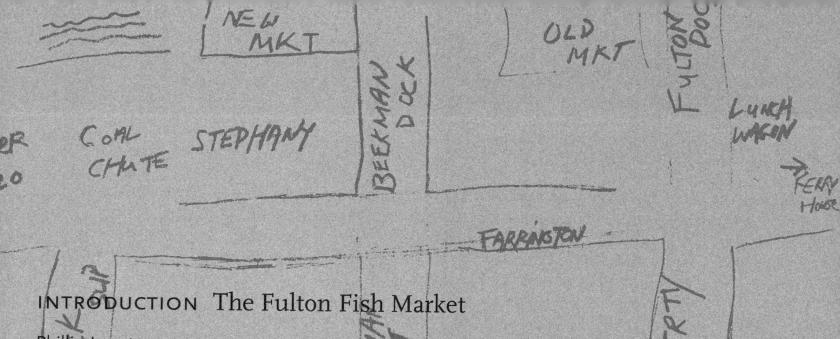

INTRODUCTION The Fulton Fish Market

Phillip Lopate

FOR MORE THAN 180 YEARS, from 1822 to 2005, fishmongers plied their wares in a crowded area on the Lower East Side of Manhattan island, hard by the East River. The Fulton Fish Market was variously described in its lifetime as one of the two, three, or four largest wholesale seafood markets on the planet (the others located in London, Paris, and Tokyo, depending on the year); the largest in the Western Hemisphere; modestly, the largest on the Atlantic Coast; or simply the oldest wholesale fish market operating continuously on one spot.

Though it grew into a closed, somewhat mysterious world, operating according to its own rules, it nevertheless became a beloved New York City landmark: the older it got, the more its funky, handmade ways of doing business seemed a precious last vestige of historic Gotham.

Its obstinate prolonged existence points to one of the main paradoxes embedded in the city's character: for all that the image of Manhattan has rightly become identified in the world's imagination with modernity, its local population has often resisted technological upgrading and clung to provisional, stopgap work practices that become fixed through tradition. Quick to innovate, New York will then conservatively attach itself to a physical status quo, however cumbersome and even ugly, so long as it is reassuringly familiar. Two reasons may be proffered: first, the large immigrant population

often prefers casual, under-regulated work environments; second, the town being a famously difficult if exciting place to live, the typical New Yorker does not expect comfort, proudly adjusting to crisis or hassle through a mixture of resilience and resignation.

From about 1830 to 1960, New York had the busiest port in the world, in terms of both available waterfront and numbers of dockings. The port dominated the Greater New York region and colored every aspect of its culture and daily life. Though not officially part of the port of New York, the Fulton Fish Market was very much its creature and danced to its tune: at the port's zenith, the fish market was riding high; when corrupt unions took over the docks, the rackets similarly fed on the fish market; just as the port resisted industrialization and cleaved to its old-fashioned, human-chain means of loading cargo, the fish market clung to ice barrels and grappling hooks; and when the port of New York died, or rather, was moved to New Jersey, it was only a matter of time (though it took forty years!) before the fish market relocated to the Bronx.

In retrospect, it was inevitable that the Fulton Fish Market would be moved one day to a more efficient setting. That occurred on November 13, 2005, when the fish market was transplanted to Hunts Point in the Bronx. Much sorrow and outrage, much mournful eloquent keening in advance had been expressed years previously, by writers, fishmongers, preservationists, and lovers of historic New York, at the prospect that such a colorful piece of the city's character might be allowed to disappear. But when the time came, the move was greeted by a characteristic shrug, even from the fish workers themselves. Now that the Fulton Fish Market is no more, we can consider it calmly, as a case study in urban ecology. Perhaps the key question is not, Why was it permitted to die? but, How did it manage to last as long as it did?

Beginnings

In the beginning, as in the Bible, there was water, nothing bur salty river water on the site; plenty of fish too, appropriately, though swimming free. The district that would hold the market did not exist until landfill created the blocks from John Street to Fulton Street and Fulton Street to Peck Slip, between 1737 and 1756. His-

torically, the large meat, fish, and fruit and vegetable markets had congregated around the lower tip of Manhattan, on both the eastern and western shores. One of them, the Fly Market (its unappetizing name a corruption of the Dutch word *vley* for valley or meadow) on Pearl Street, developed a large following; but by the early nineteenth century its rickety structures and unsanitary proximity to an open sewer raised alarm among public-spirited citizens, who clamored for the creation of a new market, one more suitable to the dignity of the growing metropolis. This self-conscious assertion that New York stood disgraced by a makeshift operation and deserved a more substantial, impressive facility was a theme sounded by editorialists and civic groups throughout the nineteenth century, and after. Often it was ignored; but this time the city governors set their sights on the area adjacent to Fulton Slip, which made sense because the Fulton Ferry landed there.[1] At the Fly Market, customers and farmers from Brooklyn had had to pay an additional four to six cents per basket of groceries or produce to have them carried to and from the ferry, which would not be necessary if a new market were located right near the landing. Also, this was the only spot where a fish market could logically be built, because the incoming tide through Buttermilk Channel (a branch of the East River) is deflected in the mouth of the slip. The Common Council passed legislation in 1817 to take possession of the land for purposes of erecting a market, but did nothing until their hand was forced, when a fire destroyed the wooden buildings on the site.

New York Evening Post, Wednesday, January 24, 1821:

FIRE. This morning about three o'clock, the city was alarmed with the cry of fire, which was found to have originated in a wooden building occupied by Sarah Smith as a tavern or boarding house on Front Street, between Fulton Slip and Crane Wharf, in a cluster of wooden buildings, close upon the East River, to which the citizens and engines repaired with all speed. The night was intensely cold, the engines could not be supplied readily with water, and became soon choked with ice; the narrow streets were rendered impassable by drifts of snow, and the flames soon became a conflagration threatening a sweeping destruction. It was, however, by great and persevering exertion, at length got under control about six

o'clock this morning, but not until it had consumed about thirty dwelling houses and stores [and] some vessels lying in at the wharves.

This disaster presented an opportunity, as *The Gazette* somewhat hard-heartedly observed a few days later: "The late conflagration has exposed to view this beautiful spot of ground, which has so universally been considered as the most eligible situation for a market, and which has already been actually vested in the Corporation for the purpose of a market. Its vicinity to the ferry, by which the marketing from Long Island will be saved the expense of cartage, a basin for smacks and fish-cars, unequaled in its purity, from its depth of water and the rapidity of its current, being decidedly in its favor for keeping and having good fresh fish, which the waters at the Fly Market could not furnish, in consequence of the large sewer entering the slip, and, in the summer season, so offensive as to be prejudicial to health." Though it began as an all-purpose market, with butcher shops and fruit and vegetable stalls, the site's suitability for fish vending was recognized right from the start, long before it became wholly devoted to that product.

By December the handsome Fulton Market had been built according to plans drawn up by architect James O'Donell, in a manner that combined "strength and elegance." Its stands were sold at auction. The butchers banded together to resist bidding on the sale, whose minimum was set at an exorbitant (to them) $100 a year. Thomas DeVoe, in his 1862 history of the city's public markets, *The Market Book*, wrote: "At the sale, the butchers stood their ground; but one individual, named Leonard, (a dealer in cigars,) who, not being a regular butcher, and in opposition to the announcement made by the butchers, bid and bought the first stand offered; but when his name was announced by the auctioneer, he was seized, and dragged or hustled towards the dock, when he was thrown in the river, and came near being drowned." An early instance of the market's community spirit and internal governance, for better or worse.

Eventually a compromise was reached, and the Fulton Market opened on January 22, 1822, roughly a year after the fire. It was considered the most spacious, costly market in the country, which

even Europe might envy. By mid-year, many of the stalls had been abandoned, their butchers being unable to pay their rent. They were soon replaced, but considerable turnover became the norm those first years; a yellow fever epidemic cut into business, forcing still other butchers to close up shop. The fishmongers, meanwhile, flourished, and took over the east wing on Beekman Street.

Tensions continued between the fishmongers and the other marketmen, who complained about not only the offensively rank, fishy smells but also water damage from seepage through the walls and ceilings, the result of necessary, frequent hosing down. The butchers and other vendors petitioned to have all the fish stalls evicted from the east wing and moved across the street, to the riverside. In 1831 a shed located on the East River, between the present-day Piers 17 and 18, was erected for the selling of fish, and for the first time reference was made to the Fulton Fish Market as an entity separate from the Fulton Market.

When fishmongers first began operating at the Fulton Market, their business was almost entirely retail, it being too difficult to maneuver large numbers of fish in that cramped space. But when they moved to the river side of the street, they increased the whole-sale part of their business. Many of the fishermen, who came from nearby Sandy Hook and Long Island, simply drew up to the docks and sold over the boats' sides, without unloading their wares in the market. In time, they squeezed so close together that people could hop from one deck to another without risking immersion.

Stiff competition for docking berths led to the fishmongers petitioning the city in 1842 to keep steamboats to a minimum during heavy business seasons:

That it is absolutely necessary that the portion of your petitioners occupying the fish market, now yielding a revenue to the city, in order to supply the market with fresh and healthy fish, that they should enjoy the uninterrupted use of a part of the slip adjoining the market for fish-cars, thus keeping their fish in the water until required for use.

That, as your petitioners are informed and believe, a lease was granted of the west side of said slip, restricting the occupancy thereof to two steamboats; instead whereof, the lessees have

three, and often four steamboats there at a time; and in addition to that, introduce other large vessels, to the great detriment and endangering of the smaller craft of your petitioners. That as steamboats lie blocking up nearly the whole entrance to said slip in a strong ebb-tide, they are inevitably borne by the current under the steamboat guard, breaking their stanchion, and carrying away their chain-plates, and otherwise injuring them; and in many instances the slip has been so much occupied with steamboats and other large vessels, that the smacks are unable to obtain entrance, and are compelled to go elsewhere and discharge. (DeVoe, *The Market Book*, 511)

The fishmongers' petition was granted.

Meanwhile, the butchers, who had insisted that the fish stalls vacate the east wing, began to notice that their own business had declined, and now reversed themselves and begged the fishmongers in 1843 to come back: "The business of said market has been declining since the fishermen have been removed to their present location, owing to the great inconvenience experienced in crossing the street from the meat to the fish market, on account of vehicles of every description being continually congregated at that place; and the result has been, that many persons (especially females) who formerly purchased at this market, in order to obviate this difficulty, have gone to Washington and other markets."

The fishmongers sarcastically replied: "They wish your Honorable Body to take into consideration why they were first removed from that east wing—which was on account of the nuisance they were said to create, by their being compelled to use a great quantity of water, etc. They cannot now see any advantage they can have more than they had then, to obviate such complaints." The fishmongers refused to return. But the butchers made an end run around this resistance by pressuring the Board of Aldermen to appoint a Committee on Markets, which conveniently found that the fish market shed was "in a very dilapidated state" and ordered the fishmongers to return to the east wing for the good of all concerned.

Eventually, the fishmongers would spread to both sides of South Street, continuing to occupy the east wing and functioning on the river side as well. In 1847, a new wooden shed was constructed "on

the bulkhead where the old fish market stood, fronting the main market, extending nearly the whole length of the same" (DeVoe, *The Market Book*).

New York's nineteenth-century markets were spectacles of crowded, noisy, boisterous activity—perhaps the Darwinian origin of that ability by the natives to cram aggressively into tight places. "What a squeeze, what a crowd!" wrote George G. Foster in his 1850 guidebook, *New York by Gaslight*:

It is not here mere elbows and knees, and brawny chests and broad stout backs that you are to encounter. Now you stumble against a firkin, and now you are overset by a bag. And there is a woman who has somehow—it is impossible to tell how— squeezed through between you and your next neighbor: but her basket, to which she clings with death-like tenacity, appears to be made of less elastic material than herself. It has assumed the position of a balloon, and forms a target for a score of noses pushed on from the rear. There is no chance of its coming through, that is certain; and the woman will not let go of it—that seems equally clear. There is nothing, therefore, for you to do but to crawl under it.

On September 27, 1851, the Fulton Market consisted "of 64 butchers' stalls, 40 fish stands, 14 oyster stands, and 165 vegetable and fruit stands," according to *The Illustrated American News*. Merchants there also sold shoes, stockings, hats, knives, pistols, flashy jewelry, books, pamphlets, papers, pictures, cigars, ice cream, candy, and hardware. The mixed nature of the Fulton Market, mid-century, and the important role fish played can be gleaned from this entry by the lawyer George Templeton Strong, who kept the fullest diary we have of daily life in nineteenth-century New York: "October, 28, 1855, Sunday. Went through Fulton market yesterday with Charles E. Strong and George Anthon and got some very special roast oysters for lunch at a stand there, famous for the quality of its bivalves rather than the refinement of its habitués. Inspected various tempting prodigies, ichthyological, crustacean, and so forth, and bought Johnny [his son] a pair of very lively and vicious grey squirrels with superb canopies of bushy tail."[2]

An anonymous correspondent, writing in *Harper's Magazine* a decade later, in 1867, makes a similar point about the paramount nature of fish in the still-varied Fulton Market:

> If you should only have walked around the market once and then passed judgement on the place you would be of the opinion that it was devoted entirely to the buying and selling of the piscine tribes; should you cross through it by one of its parallel sections you would imagine it to be a vast butchers' store; and should you form an opinion of it by its corners only you would be positive that it was merely a gigantic oyster-room or a tea and coffee stand of Herculean proportions. Fulton Market is nearly omnigenous. It is a butchers' store, a fruiterers' stall, an oyster-stand, a poultry-yard, and a fish-mongers' establishment. It is one vast repository for the sale of every article of diet you could fancy, from lamb chop to "steak for two," from a shrimp up to a lobster, from a cup of coffee to the largest table d'hote fare you could pick out. Fish, however, is its staple article. Fish is as natural in Fulton Market as they are in their own briny element. On fish does Fulton Market especially pride itself with very just reason, and it should be judged by fish alone.

In the Gilded Age, the Fulton Market continued on its dual-track destiny, with the fishmongers' incomes rising and the other stall-keepers' fortunes declining. Small butcher shops had begun proliferating around the city, drawing business away from the large open markets, and, with better ice deliveries, householders no longer saw the need to shop every day. But it still made intuitive sense to buy fish close to the waterfront delivery point, where it was freshest. Mondays and Thursdays were the busiest days.

Advertisements were placed by Fulton Fish Market dealers in the *Fishing Gazette* to attract fishermen. The Fulton Market's eating cellars operated full blast at high noon.

"In the 1870s a gong signaled the beginning of sales, and with it, buyers rushed in to make deals with the rubber-booted men wearing white aprons tied around their waists," wrote Priscilla Jennings Slanetz in her finely researched article, "A History of the Fulton Fish Market" (*The Log of Mystic Seaport* [Spring 1986]:14–25). "Cus-

tomers would weave their way between stalls, dodging eels slithering along the floor, men stabbing fish with sharp hooks and flipping them into scales or pitching them into baskets, and men and boys with hooks dragging large crates of live fish over the slimy floor. An undistinguishable vernacular rang throughout the building: 'One hundred and fifty live cod, at four, Smeeley; ninety-six haddock, Podgers; ninety-eight smelt, Quiggles; eighty-serving cod, Slurket; sixty-six white fish, Pennyroyal; eighteen mackril, Noses; hundred and thirty-nine Jennie-cod, Fabblers; two hundred and eleving halibut, Blackford.'" This last name referred to the fishmonger E. G. Blackford, who had done much to promote the Fulton Market, including overseeing the construction of a new Victorian-style building. In 1877, as State Fish Commissioner, Blackford had declared the first of April trout opening day, establishing a seasonal attraction that lasted two or three days and attracted great crowds annually. The crowds could also visit Blackford's Barnumesque museum in the northeast tower, with its displays of fish and animal "curiosities" and its ichthyological laboratory. Throughout the year, the legendary New York oysters were sold in oyster bars such as Dorlan's, which stayed open well into the night, thus preparing the way for the Fulton Fish Market to be perceived as a nocturnal experience.

Another reason the nonfish businesses at Fulton Market were languishing had to do with changes in the surrounding neighborhood. The area, once the fashionable heart of New York, had been deserted by the moneyed classes for districts farther uptown, and their places had been taken by the tenement-dwelling, largely immigrant poor. As early as April 4, 1857, a *Tribune* editorial had argued, in what would later become a recurrent refrain, that it made more fiscal sense to close the downtown markets and sell the property to realtors:

> The ground occupied by Washington Market is estimated to be worth $385,000; Fulton Market, $210,000. A more accurate estimate, at present values, would make the aggregate near a million of dollars—certainly as much as that including the wharf and dock rights. These markets are now far away from their customers; dwellings and boarding houses have been generally abandoned in their vicinity, and for many blocks

northward, especially on the North River side, the population is sparse and of a floating kind. In 1830 the six lower wards embraced forty per cent of the population of the city; in 1855 the same district counted but 15%. The people who still resort to these markets would be more generally accommodated if they were removed a considerable distance up town; the city would profit largely by selling the sites, and the rush and crowd of Broadway below the park would be sensibly relieved by withdrawing the thousands of carts and wagons which necessarily throng around the present markets.

The opening of the Brooklyn Bridge in 1883, more than anything else, sounded the death knell of the Fulton Market as an all-purpose emporium. No longer would housekeepers from Brooklyn arrive daily on the Fulton Ferry; instead, pedestrians and passengers would be deposited many blocks west, on Centre Street. With the closing of the ferry itself, the area around the market became less habituated by ordinary citizens; under the shadows of the Brooklyn Bridge and (soon to join it in 1909) the Manhattan Bridge, its hotels and boardinghouses began catering to a more down-at-the-heels, transient clientele.

As the turn of the century approached, the fish market dominated the neighboring Lower East Side slum and its inhabitants. An 1892 photograph shows a group of young boys, naked, preparing to dive off the floating docks behind the Fulton Fish Market into the river, while laborers drag barrels of fish nearby. Al Smith, future Governor of New York, wrote in his autobiography, *Up to Now*, "Beginners learned to swim in the fish cars. These were directly back of the fish market. The water in them was about three feet deep and the cars were six feet wide and about twelve feet long. They were used for preserving fish caught alive, and particularly for green turtles. When empty, the covers were lifted from them and they provided a kind of swimming pool for the amateur who was not quite ready to trust himself in the East River."[3]

Smith, born at 174 South Street, was nineteen in 1892; he had already quit school and gone to work at the market to help support his widowed mother and his siblings. From four in the morning to four in the afternoon he rolled heavy barrels of fish up and down the ramps, helped keep the accounts, and did everything else asked

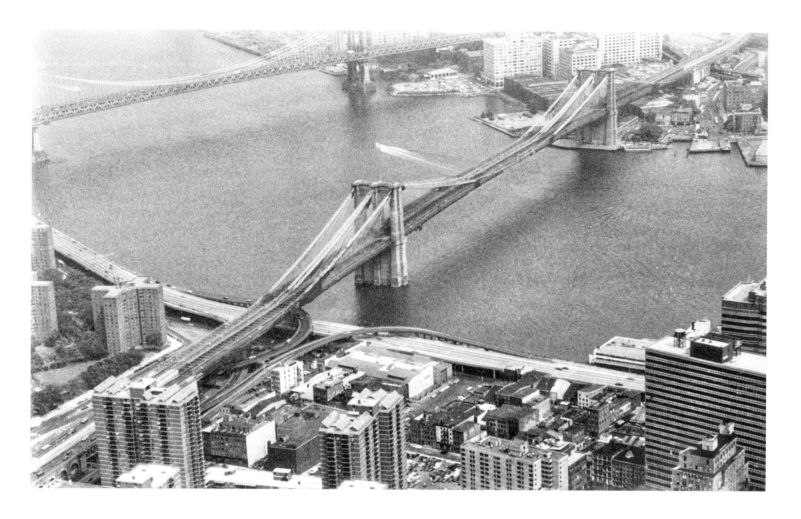

by his employer, the wholesale commission house of John Feeney & Co. That included scooping the other firms with information about whether the day's catch held a scarcity or a glut, so that prices could be set accordingly.

Part of my job was the use of a pair of strong marine glasses from the roof of the fish market in order to pick out the fishing smacks of the fleet operated by my employers as they turned out of Buttermilk Channel into the lower East River. A low draft was a big catch. Riding high on the crest of the wave meant a failure, and as it was known to the owners of the business where each particular smack was operating, so also was the cargo known. In September, the smack that was operating off Seabright, New Jersey, was in quest of bluefish.

The well-laden smack, turning out of the Channel, indicated a plentiful supply of blue, and that regulated the price. Cold-storage warehouses had not been invented to circumvent the economic law of supply and demand.

Smith, along with the other employees, was allowed to take home as many fish as desired for the family larder. "I think I may well say that for a long time we had such a complete fish diet that the entire family developed a fear of them. A live one might at some time wreak his vengeance for the devoured members of his finny family."

The sell-everything Fulton Market struggled on, but around 1910 ceded all venues to the fishmongers. Thus the Fulton Fish Market began its most celebrated chapter, transforming itself into a purely wholesale venture, operating in the early morning hours, selling a minimum of ten pounds per order to retail fish stores, restaurants, hotels, caterers, and passenger line stewards. The market's whole-sale identity turned out to be "the factor most responsible for its unique longevity and its relative immunity to the ups and downs of the neighborhood," wrote Bruce Beck in *The Official Fulton Fish Market Cookbook*. By going wholesale, the market's nature changed profoundly, from an accessible daytime spectacle to a more private nocturnal society, whose rites would be reported to the outside world by night owl intruders who, from now on, would be only re-luctantly tolerated within its purlieu.

Riding High

In its heyday the Fulton Fish Market grew to cover an area of six city blocks bounded by Fulton, Water, Dover, and South streets, and included two large markets on the South Street docks near Fulton. These buildings faced a series of stores carved, cavelike, out of the first-floor entrances of old rose-brick buildings on the west side of the street. The more "solid" firms tended to be housed in the two large markets, while the more fly-by-night outfits, which sometimes sold cheaper grades of fish, would occupy the storefronts. Dealers in freshwater fish congregated around the corner on Peck Slip.

The southernmost of the two large markets dated from 1869, when the Fulton Market Fish Mongers Association was formed.

Flush with success, the association raised $123,000 to erect a solid, enclosed wooden structure of two stories and a loft, with a tin roof. The first floor consisted of a great hall, bustling with stalls and punctuated by iron columns, while the second floor held dealers' offices and storage. This was the first embodiment of the Tin Building, which still stands on South Street. It is truly a building with nine lives: after it burned to the ground in 1878, it was rebuilt in almost exactly the same form. Its next incarnation occurred in 1907; this time it was equipped with concrete floors that had holes for easier drainage. (It burned again in 1995, and was again rebuilt.)

Those dealers who could not get into the Tin Building formed their own association and built a new market, situated just north. It opened in 1909 and continued in operation until 1936, when a section of it collapsed and fell into the river. Fortunately, no one was hurt; but Mayor Fiorello La Guardia decided to replace it with a new, modernized Fulton Fish Market building, which still carries on its façade the art deco lettering of that New Deal era. After its ribbon-cutting ceremony in 1939, it was nicknamed "the country club." Ace newspaper reporter Clementine Paddleford opined that "it was too, too clean! Gone forever are the fish-soaked planking of floors, the rickety dark stairs, the hungry army of slum cats, the open fish barrels lined along the street. . . . Every possible sanitary improvement has been included. Dressing rooms, yes dressing rooms are provided for the market salesmen. As one shiny faced worker remarked: 'Look at 'em. They'll have us dousing on perfume next!'" (*New York Herald Tribune*, 1939). Not to worry; the fish market stayed grungy and unperfumed. But Paddleford's lament sounds the anxiously protective note of an army of scribes who would follow, all frightened that the place might lose its gritty soul to Progress.

The procedures in the market stayed fairly constant. The fishmongers would begin unloading around midnight and start selling around 3 a.m. on Monday and 4 a.m. Tuesday through Friday. During its boom times the fish market was open six days a week, including Saturdays. Before the 1930s, fishmongers would gather at the docks to await the boats. Later, all the fish began arriving by truck. The early morning hours had a circus atmosphere: under bright lights mounted on roofs and lampposts, hand trucks would bear down from all directions, to cries of "Watch your back!" Loaders,

journeymen, salesmen, wholesalers, watchmen, inspectors, bosses, filleters, all mingled with a purpose. The customers, mostly male restaurant owners, with the occasional middle-aged Asian woman buying for Chinese or Thai places, would wander with studied skepticism among the stalls, sniffing and eyeing the fish, conferring with their favorite vendors about this or that species' availability and quality. When a deal was arrived at, the package would be marked with a code and brought to the cashier, and eventually all the customer's purchases would be sent over to the same panel truck. In this way, he or she did not have to carry mountains of fish all through the market.

Meanwhile, federal, state, and local inspectors would be testing the temperature of coolers and freezers or looking for insects and rodent droppings, and rabbis would be making sure that lobsters and other shellfish were kept away from the pike.

When changes in the fish market's operation occurred, they were often subtle. For instance, fish initially arrived in wooden boxes, which then gave way to cardboard cartons and ultimately to Styrofoam, less picturesque but better at retaining freshness. Some fishmongers clung to the old scooped scales, while others switched with alacrity to digital scales. Green-shaded lamps, suspended from the ceilings of the large market buildings, yielded to fluorescents. In the 1980s the columns in the Tin Building were painted red. Hand trucks gave way more and more to high-lows (forklift trucks), which did not do so well on the rutted pavement. At the peak of the market's popularity, between the world wars, there were many more stands on the side streets. The legendary restaurants and drinking holes that grew up around the Fulton Fish Market, such as Sweet's, Sloppy Louie's, Carmine's, and the Paris Bar, catered to their loyal clientele, many staying open late at night to serve the market workers who hung out before and after their shifts.

The construction of the Franklin Delano Roosevelt Drive in the 1940s sealed off Fulton Fish Market even further into its own world. Bracketed between the limbs of two mastodon bridges and lidded by an elevated section of highway, that stretch of South Street fell into an eternal night, sunless and boarded up during the day, springing into manic activity in the early morning hours, like the toys in Andersen's fairy tale "The Steadfast Tin Soldier." The FDR Drive,

though unsightly, provided excellent cover in all weather for the deliverymen pushing hand trucks, the coffee wagons, and the open stalls spilling out onto the sidewalks. It was the final piece, the roof for the nightly jewel-box theater production under the stars. It also protected the fish market in another way, discouraging or at least delaying developers by its very ugliness: who would pay millions for condos overlooking such an eyesore?

One of the biggest changes to affect the market's operation, and its ambience, was the dominant role that refrigerated trucks came to play. A simple comparison of methods of transportation used to bring saltwater finfish to Fulton Fish Market found that in 1924 trucks were responsible for 5 percent of the deliveries, while the rest were brought by a combination of vessel landings and rail freight; by 1957, truck deliveries had risen to 85.9 percent.

Air travel, too, greatly affected the market, making it possible for Cuban swordfish, king crabs from Alaska, lobster tails from South Africa, and mahi-mahi caught off Hawaii to be sold the next day on South Street. The technology of Styrofoam and freezer pouches, which sealed in freshness, also contributed to Fulton Fish Market's operation as a distributor of the world's catch, with an ever-expanding, sophisticated variety of piscine wares. But these advances also helped sever the age-old connection between local fisherfolk and the port, and made the market's reason for being where it was more abstract. If the adjoining docks no longer served any function and the fish market was nothing more than a staging area for trucks, it could be located anywhere—preferably near a major highway, with plenty of parking.

The Product

"If it swims, we handle it," boasted the Fulton Market Fish Mongers Association. Many more types of fish would turn up at the Fulton Market than anywhere else, if only to serve the city's immigrant groups: *scungili* (conch), squid, and whitebait for those of Italian ancestry; fresh carp, whitefish, and pike for Jews to make gefilte fish; dried codfish, or *bacalau*, for those of Mediterranean or Scandinavian descent. Studies show that the average New Yorker eats

more seafood than other Americans—at least ten more pounds per capita than the national average. Sited on the coast, the city has historically deviated from the meat-and-potatoes diet of the heartland.

Changes in the weather (storms) and the seasons, culinary fashions (such as Cajun-blackened this and that), international factors (overfishing, endangered species, economic blockades), the earth's climate (El Niño, global warming), and immigration patterns might all affect what would turn up at the fish market's stalls on any given day. "Had anyone told me 25 years ago that we would be selling sea cucumbers in the market, I would have laughed and laughed," said Jack Putnam, an old market hand who now works for the South Street Seaport Museum. While immigrants certainly broadened the palate, the average fish-eater stuck very conservatively with half a dozen types. In 1880–81, the top 10 species delivered to the Fulton Fish Market were cod (5,269,607 pounds), bluefish (4,284,613 pounds), mackerel (3,236,197 pounds), halibut (2,211,712 pounds), haddock (1,643,554 pounds), porgies (1,565,886 pounds), lobsters (1,311,981 pounds), weakfish (1,213,141 pounds), flounder (1,186,469 pounds), and eels (999,248 pounds). A hundred years later, Bruce Beck reported in *The Official Fulton Fish Market Cookbook*: "The best-known and largest sellers read very like the nineteenth century catch: cod, flounder, fluke, halibut, salmon, mackerel, swordfish, lake whitefish, rainbow trout, red snapper, bluefish, whiting, porgy, smelt, pompano, shad, lobster, shrimp, scallops, oysters, clams, and crab, to name the most familiar."

Fishmongers have long made claims for the superior salubrious properties of their wares. Fish are said to be "brain food" that makes you smarter, or to increase longevity. Mr. Flood, the retired contractor immortalized by Joseph Mitchell, was "convinced that the eating of meat and vegetables shortens life and he maintains that the only sensible food for man, particularly for a man who wants to hit a hundred and fifteen, is fish. To Mr. Flood, the flesh of finfish and shellfish is not only good to eat, it is an elixir . . . 'a drink from the fountain of youth.'" Mr. Flood also considered fish superior because the scientists hadn't yet "enriched," "improved," and thereby spoiled it as they had other food. "'I'll tell you a valuable secret,' he once said. 'The Fulton Fish Market smell will cure a cold within twenty minutes. Nobody that works in the market ever has a cold. They don't know what a cold is. The fishmongers are afraid the gen-

eral public will find this out. It's too crowded around here as it is, and if the public took to coming down here to cure their colds there wouldn't be room enough to turn around in.'"[4]

Such fanciful partiality requires all health claims for fish to be taken with a grain of salt. Still, they are certainly lower in cholesterol than meat, and probably better for your heart. During both world wars, when meat was scarcer, the federal government undertook propaganda campaigns to urge people to increase their fish intake. Suddenly it became patriotic to eat fish, and the Fulton Fish Market profited accordingly. So did it profit during those years when the Catholic Church prescribed fish for the Friday night meal. In recent years the health advantages must be countered with concern about the danger of PCBs, coal ash, and other undesirable substances that contribute to water pollution. Official warnings are issued periodically not to eat more than, say, one bluefish a month. Shellfish can be problematic in other ways. But government recommendations for a healthy, balanced diet continue to push fish as a staple.

The economy of fish relative to meat has always been an argument in its favor. A journalist writing in 1894 said that fish remained "the only rich food product within the purchasing power of even the man in humblest conditions." Some 50 years later, on December 24, 1948, a *New York Times* reporter listed the wholesale prices at the Fulton Fish Market, relative to store prices: "Whiting, 6c to 8c a pound (store price about 20c); flounder, 10c to 15c a pound (store prices about 30c to 40c); porgies, 15c a pound (store price about 35c); mackerel, 15c a pound (store price about 30c)." Still a bargain. "Perhaps no other commodity is as sensitive to the law of supply and demand," wrote the same reporter. "The price of a particular species of fish can double overnight—or drop to half the original cost if there is a radio report of a heavy catch." In the last 10 years, some fish have become pricier due to scarcities caused by overfishing, and are even more expensive than most meat. Other species, such as salmon, have become cheaper and more plentiful as a result of fish farming. Some consumers claim that farm fish raised in tanks have less flavor and fewer nutrients than those caught wild in the sea, but so far, blind taste-tests have failed to detect much difference.

One of the oddities of this commodity is that it encompasses both ends of the class spectrum: fish is a poor man's staple and a

rich man's delicacy, so that the chef for Le Bernardin, New York's fanciest restaurant, might be rubbing elbows with the proprietor of a greasy spoon as both inspected the latest catch at the Fulton Fish Market.

The University of the Streets

In Al Smith's prime, he would proudly say, when other politicians were boasting of their Ivy League alma maters, that he had graduated from F.F.M. Smith was quick to use similes picked up from his days at the fish market, referring to someone he disliked as having "an eye as glassy as a dead cod's," or saying of another, "He shakes hands like a frozen mackerel." The fish market's most famous alumnus, who had gone out into the great world and triumphed as a Democratic politician, falling just short of the U.S. presidency, was also an anomaly. Most of those who started in the market stayed there, owners as well as workingmen. Some family-owned firms went back a hundred years, while many workers continued to live on Cherry Street or elsewhere in the original neighborhood. Jobs were handed down from father to son. It was overwhelmingly a masculine world, a conservative, tradition-bound one.

And sometimes the traditions went back further than New York, to the Old Country. In Joseph Mitchell's classic essay, "Up in the Old Hotel," the subject of the piece, Louie, explains why he decided to set up his restaurant in the vicinity of the market:

> "The reason I did, Fulton Fish Market reminds me of Recco [the Italian fishing village he came from]. There's a world of difference between them. At the same time, they're very much alike—the fish smell, the general gone-to-pot look, the trading that goes on in the streets, the roofs over the sidewalks, the cats in corners gnawing on fish heads, the gulls in the gutters, the way everybody's on to everybody else, the quarreling and the arguing. There's a boss fishmonger down there, a spry old hardhearted Italian man who's got a million dollars in the bank and dresses like he's on relief and walks up and down the fish pier snatching fish out of barrels by their heads or their tails and weighing them in his hands and figuring out in his

mind to a fraction of a fraction how much they're worth and shouting and singing and enjoying life, and the face on him, the way he conducts himself, he reminds me so much of my father that sometimes, when I see him, it puts me in a good humor, and sometimes it breaks my heart."

At the Fulton Fish Market, the workers and owners were never far from the world of their fathers. It was a milieu seemingly designed for patriarchal ancestor worship.

Because the work required no formal schooling, was categorized as "unskilled" (which is not to say that certain jobs, such as filleting, did not require enormous craft), and, more importantly, was performed away from the government's prying scrutiny, it was perfectly suited for those with criminal records or new immigrants, including undocumented ones. Cousins or nephews without papers who had stowed aboard ships could find chances for employment in the insular, forgiving world of the fish market.

The relationship between immigration and work force, always a tight one in New York City, was even more symbiotic at the Fulton Fish Market. The original fishmongers had been English and Scottish. They were joined by the Italians and Jews, who became dominant players and whose percentages remained fairly constant, and some Norwegians, Spanish, and Portuguese. After the passage of the 1964 immigration act, which rescinded the quota system, Koreans, Chinese, and other Asians came in. A fishmonger named Bruce Lee became the powerful head of the Asian seafood dealers. There were many more Hispanics in recent years and, as always, very few African Americans.

The harsh working conditions, involving strenuous physical labor outdoors in all weather, in messy and malodorous conditions, promoted a rough parity between workers and bosses. On the surface, at least, all took on the trappings of a wise guy proletariat. Of course, the owners might go home to suburban villas and the workers to crowded tenements, but one of the Fulton Fish Market's peculiarities was that employers and employees shared a working-class manner: they dressed alike, for practical purposes, in an outfit of high rubber boots (obeying the old market proverb, "Keep your feet dry and you'll never die"), several layers of flannel shirts and sweaters, woolen caps or bandanas, white aprons, and blue

jeans; they talked alike, in a rough, earthy manner; and they often were afflicted by the same ailments, such as rheumatism, arthritis, heart trouble, lumbago. Perhaps the rarity of their wildcat strikes, compared to their brethren, the longshoremen, might be attributed in part to bosses and workers sharing the same punishing common conditions, or else to the small family nature of fish market companies, compared to the large, impersonal port employers. (Still, there had always been tacit social class divisions at the Fulton Fish Market: the more prosperous, established firms tended to crowd out the smaller ones, and anything that menaced the market's fragile order, be it fire, police investigation, or relocation threat, would increase opportunities for the larger firms to consolidate their power.)

Part of the market's lore was that if a fishmonger looked like a bum, grizzled, tattered, without a dollar, you could trust that his credit was good, whereas "if he's all dolled up, stay away from him," as Joseph Mitchell's informant, Mrs. Treppel, warned. This curious inversion of appearances fit with the general topsy-turvy ethos of the fish market, where trickery and guile were encouraged, yet everything operated on a system of trust. Since regular customers were crucial and both seller and buyer relied on a shared rapport that might last for years, there was really little point in risking the relationship by cheating a client by selling him bad fish, or conversely, stiffing a dealer. On the other hand, a certain teasing promise of moral fluidity was wafted, to keep both parties slightly off balance, as part of the game. Mrs. Treppel, speaking of a fishmonger she disliked, explained that "you couldn't trust him. You couldn't trust his weights or his invoices or the condition of his fish, not that that was so highly unusual down here and not that people necessarily looked down on him for that. After all, this isn't the New York Stock Exchange, where everybody is upright and honest and trustworthy, or so I have been told—this is the Fulton Fish Market" ("Mr. Flood's Party" [1945]).

So which was it—that a man's word was his bond at the fish market, or that you had to watch out constantly for con artistry, or that there was honor among thieves? It was said that you had to be very smart to thrive in the Fulton Fish Market, because the product would not "keep"; you had to dispense with the entire stock in a few hours at most, while surrounded by wily competitors. Aside from

a salesman's psychological shrewdness, other kinds of intelligence were required: a good head for figures; a strong memory, which included knowledge of the various species of fish, their life cycles and spawning patterns, and where and when they might be congregating at any given time; something of fish anatomy; the best ways to prepare and cook each species; and an understanding of the angler's art. (Marketers would sometimes give up their stalls and try fishing for a while, or vice versa.) In the conversations that took place between fishmongers and their suppliers or customers during a lull in the market action, abstruse points would be exchanged about the varieties and habits of piscine species that might pique a scientist's interest, in and among the crudities. This too was part of the contradictory ethos of the market: you were a mug, and proud of it, but a mug with the equivalent of a doctorate.

The Mob and the Market

"The Fulton Market has escaped the racketeering from which other food centers have suffered," wrote a Pollyanna reporter, Charles Foltz Jr., for the *New York Times* in the early 1930s. "The bond between fishermen, wholesaler and retailer is too closely knit by cooperative organizations to permit the entrance of racketeers." Close bonds there may have been, but the insular, gutty conditions that made the fish market friendly to immigrants also attracted the mob. Just how strong a presence organized crime came to have in the Fulton Fish Market has always been a matter of contention. Many fishmongers

and market mavens say that that influence has been exaggerated, that the public is enamored with the underworld, that what stealing occurred was minor pilferage, or that government efforts to investigate shakedowns and other illegal activities were all part of the white-collar Establishment's hostility against workingmen: "We're just tryin' to make a livin' here and they keep hasslin' us."

Crime and extortion go way back in the market's history. "By the early 1900s, oystermen and fishermen from the South Shore of Long Island refused to enter past Sandy Hook without police guard to deliver their catches to the market. One oysterman was almost 'gased to death' while sleeping in the cabin of his vessel tied to the Fulton pier as men tried to rob him of the money he had received for his catch," wrote Priscilla Jennings Slanetz. But *organized* crime is usually traced to Joseph "Socks" Lanza, a burly, 230-pound racketeer who started working in the Fulton Fish Market as a young man and organized the United Seafood Workers Union in 1919. Lanza is a legendary figure whom some regard as a labor hero, more Robin Hood than Godfather. There is no question that he kept the fish market running on an even keel, adjudicating conflicts, keeping labor peace, helping the unemployed find jobs by distributing patronage, and looking after widows and orphans. "Whether the man was right or wrong, people down there were with him. The guy was honorable," one of Barbara Mensch's subjects summed it up. At the same time, let's not romanticize: some of Lanza's rackets included a $10-a-load tax on fishing vessels; a $50 to $2,000 surcharge on each truck and trucking company bringing fish into the city from outside the state; a license fee charged to pushcart peddlers; a $300 "initiation fee" for new fish dealers; a $2 charge for parking in public city streets; a $50-a-year fee paid by fish dealers to avoid labor troubles. He also brazenly started a dummy organization called the Fulton Market Watchman and Patrol Association, which had no office, no patrols, and no watchmen, and collected a total of $40,000 a year for protection against thievery. Mob enforcement was effectuated by beating up those who refused to go along, by throwing stink bombs ("pineapples") into fish stands, and by slashing tires.

Lanza's main source of revenue was leaning on truckers. This twentieth-century way of transporting the market's goods also presented a novel opportunity for larceny. Just as the loading racket came to dominate the West Side docks,[5] so did trucking extortion

infect the Fulton Fish Market. In 1938 Lanza pleaded guilty to operating a million-dollar-a-year racket in the fish trucking industry (leaving aside his other rackets) and was sentenced to two and a half years in prison. From jail he continued to run his fish market enterprises. When he got out, he was reelected as union president by the rank and file. But the American Federation of Labor distanced itself aggressively from him, and in the end he was pressured to step down. There was a new trial in 1941, and again he was found guilty and sent away.

That these mob activities had never been merely a one-man operation but rather an entrenched way of doing business at the fish market is evident in their persistence. For a while, the authorities turned a blind eye. Then, in the 1980s, a new set of investigations commenced. A lawsuit, initiated by U.S. Attorney Rudolph Giuliani with the full support of Mayor Edward Koch, charged that the Mafia, through the Genovese crime family, had controlled Fulton Fish Market and Local 359 from the 1930s onward. The Romano brothers, Carmine, Peter, and Vincent, were named. Carmine and Peter Romano, both union officials at the time, were convicted of labor extortion: Carmine got twelve years and Peter, eighteen months. Five fish handlers were also charged in 1982 with the systematic theft of seafood unloaded at the market (a practice known as "tapping," by which several fish would disappear from each box as a matter of course). All five worked for the same unloading company. Other rackets included "leasing" the United Seafood Workers' cardboard signs for $25 a month to the market wholesalers to show membership, extorting Christmas contributions, and continuing to run a protection service called the Fulton Patrol.

Investigators complained that it had been difficult to get anyone at the market to talk about the racketeering: a code of silence, based on fear or *omerta*, remained in effect. For their part, the fish workers bitterly resented these investigative incursions, including the chilling presence of a patrol car at each end of the market every night. Typical was the response of a worker quoted in *The New York Times* (October 17, 1987): "I've been here for fifteen years, and I don't know of anyone paying off anyone. That man Giuliani has political ambitions, and ever since that Rouse Company decided to open up this mall or whatever they call it, they've done nothing but bust our chops."

It was said that Giuliani, because of his surname, was overly sensitive about malfeasances perpetrated by the Italian Mafia; also, that he did not want the public to forget he had cut his prosecutorial teeth on the fish market investigations. After being elected mayor, Giuliani waged another cleanup campaign at the Fulton Fish Market in 1995; it led to the ouster of a dozen companies for purported Genovese crime family ties but secured no indictments. His deputy mayor, Randy M. Mastro, claimed that the city's goal was "to eliminate the mob tax, which will ultimately lead to lower prices. . . . The cost of unloading the fish from the delivery trucks had been reduced twenty per cent, the cost of loading the fish onto customers' vans seventy per cent, and the cost of carting away the market's trash eighty per cent" (*New York Times,* August 17, 1997). Mastro's predictions about a fall in fish prices proved unduly optimistic, but a squeaky-clean Long Island carting firm with no prior ties to the fish market was brought in to do the unloading, and some fishmongers said afterward that the atmosphere had indeed improved; it was easier to do business.

On March 29, 1995, in the midst of the investigation, a suspicious blaze at the Tin Building gutted the second story; it was later determined to have been deliberately set. But by whom, and for what reason? The government insisted that no incriminating records were destroyed, as these had already been inspected or impounded. Was the fire, rather, a form of petulance, demonstrating that the men were fed up with these attacks on their venerable market, and therefore inclined to destroy it themselves? We may never know. The upshot was that Giuliani, no fan of the Fulton Fish Market and avid to relocate it to the Bronx, had to allocate funds from the city budget to restore the Tin Building. As long as a fish market still operated at the end of Fulton Street, it would have to be kept in working order. Nor would it do to leave an embarrassingly torched, wounded, historically landmarked shed in the middle of a prime tourist area.

Fulton Fish Market as Literary Muse

In the twentieth century, the seedy allure of the Fulton Fish Market dovetailed with the urban nocturne, a subgenre that enjoyed its own vogue. Workaholic New York had embraced the extra hours

provided through first gaslight, then electricity, famously claiming the title of "the city that never sleeps." The night was associated with sin, noirish danger, and leisurely indulgence in nightclubs and speakeasies. All the more piquant, by contrast, became those nocturnal areas devoted purely to work, such as could be found at the market.

Activities that look mundane in the daytime become charged with poetry at night. The sleep-deprived insomniac cherishes the compensatory impression of getting something extra, entry to a private world that the ordinary population, asleep in their beds, will never know. The waterfront has its own liminal aura, being an uneasy border between two states; and indeed, when major storms hit, the market would be flooded, annexed or returned to the sea. Another element that added to the sense of the uncanny was the combination of the artificial illumination and the natural fish, antediluvian creatures that predated mammals. Moreover, these silvery flashing creatures were, poignantly enough, displayed out of their element, "fish out of water," as the saying goes. So, too, the market and its denizens had a specially anomalous charm in postmodern New York City. "The lure of Fulton Fish Market," Jack Putnam phrased it, "was that it was comforting to see, in the midst of all this fiber-optic cable, something that would actually rust."

From its inception, the Fulton Fish Market was celebrated by writers. It became a literary trope, a synecdoche for New York City as a whole. Newspapers would periodically run features on it. Such assignments were plums awarded to the more literary journalists. One imagines a hard-bitten city desk editor telling his cub reporter, "Go and wander through the place and come back with plenty of local color. Don't take too long, though." Dozens of such stories came to be written, and now molder in the files of libraries and newspaper morgues. It is curious how much they resemble one another—how much, in a sense, they are exactly the same article. Usually there is some lyrical prose about dawn, and then the noise, the clamor, the rubber boots, the cats and the seagulls feasting on fish scraps, perhaps a little history going back to 1821, a mention of Al Smith, some statistics about fish consumption or yearly sales, a list of varieties sold, descriptions of unloading, several quotes from grizzled veterans, a regretful sigh about recent changes, and a wish that nothing else will change.

Most of these accounts have the superficiality of first impressions gleaned from a few hours spent in a novel place. But one periodical writer, Joseph Mitchell, took the time to learn it inside out, and in his long, leisurely portraits for *The New Yorker*, he became the bard, the patron saint of the Fulton Fish Market. He brought immense sympathy and knowledge of the market's ways, as well as his formidable literary skill, to the task:

> Every now and then, seeking to rid my mind of thoughts of death and doom, I get up early and go down to Fulton Fish Market. I usually arrive around five-thirty, and take a walk through the two huge open-fronted market sheds, the Old Market and the New Market, whose fronts rest on South Street and whose backs rest on the piles in the East River. At that time, a little while before the trading begins, the stands in the sheds are heaped high and spilling over with forty to sixty kinds of finfish and shellfish from the East Coast, the West Coast, the Gulf Coast, and half a dozen foreign countries. The smoky riverbank dawn, the racket the fishmongers make, the seaweedy smell, and the sight of this plentifulness always give me a feeling of well-being, and sometimes they elate me. I wander around the stalls for an hour or so. Then I go into a cheerful market restaurant named Sloppy Louie's and eat a big, inexpensive, invigorating breakfast—a kippered herring and scrambled eggs, or a shad-roe omelet, or slit sea scallops and bacon, or some other breakfast specialty of the place.

So begins Mitchell's great 1952 essay, "Up in the Old Hotel." We see in this quintessential passage how the melancholic, dyspeptic mood of the solitary writer is transformed by the healing hubbub of the early morning market, with all its abundant life and sensory treats. Here, in "Mr. Flood's Party," Mitchell tries to pin down the essence of Eau de FFM:

> The Fulton Market smell is a commingling of smells. I tried to take it apart. I could distinguish the reek of the ancient fish and oyster houses, and the exhalations of the harbor. And I could distinguish the smell of tar, a smell that came from

an attic on South Street, the net-loft of a fishing-boat supply house, where trawler nets that have been dipped in tar vats are hung beside open windows to drain and dry. And I could distinguish the oakwoody smell of smoke from the stack of a loft on Beekman Street in which finnian haddies are cured; the furnace of this loft burns white-oak and hickory shavings and sawdust. And tangled in these smells were still other smells— the acrid smoke from the stacks of the row of coffee-roasting plants on Front Street, and the pungent smoke from the stack of the Purity Spice Mill on Dover Street, and the smell of raw-hides from the Swamp, the tannery district, which adjoins the market on the north.

The joke here is that Mitchell is parsing the odor like a delicacy, knowing full well that many of his readers in polite society would have simply found it revolting.

Foreign travel writers also reported back to their readers about this strange, fascinating place they had discovered in their post-midnight rambles. One of the best, the French poet Paul Morand, wrote in his 1930 book, *New York*:

I catch sight of large salmon, transported on ice, visible like Spaniards in their glass coffins. They are arriving at the old Fulton fish-market, one of the spectacles of abundance that this city offers in plenty. . . . As for the New York market, it is like an oceanographical museum: from the Poles to the Equa-tor, from pale scales to colored scales, fish of every latitude are found in the Fulton Market, arriving with their huge eyes and prickles by the Key West express from the Gulf of Mexico, so scarlet that they seem to have been cooked in the Gulf Stream, arriving by refrigerator trains from the Pacific and British Columbia, and the plump, insipid fresh-water fish, from the Great Lakes fisheries. New York puts twenty trainloads a day in her stomach.

This kind of writing relies heavily on anthropomorphic metaphor and the power of place names. Enumeration and alliteration also come into play. Consider this guidebook entry by the sublime Kate Simon, in her *New York Places and Pleasures*:

When the Fulton Fish market, diminished, but still gutsy, breaks through the silences with a tremendous roar, it is time to put on your rubbers against the ice spilling and melting all around. From Fulton Street to the Brooklyn Bridge on South Street, under the highway and to the edge of the river, stream stalls on stalls of red snapper, of endless sacks or scallops, of dried slabs of cod in soldierly rows, of silver threads of smelt glittering in gilt cans, of ice nests holding mounds of shrimp and a strayed starfish or two. Weathered men in high boots and heavy sweaters weigh out fish in suspended 100-pound scoop scales. Two men drag and carry a grouper twice their size, its face still set in the common fish expression of blustering anger. A row of cod, each in its own basket, stands head down with tail fins spread up and out, like precision divers in a water ballet.

Amid the plenitude and bustle, the writer, a lucky interloper, knows what a privilege it is to take this all in. Sometimes he is made brusquely aware of not belonging, like the English story writer–essayist V. S. Pritchett, who noted in his 1965 *New York Proclaimed*:

If you go down just as dawn breaks to the Fulton Fish Market and consider the relative human silence and rapidity of work there as the fish is crated, carried, loaded onto the refrigerated trucks, sliced, weighed, and sacked, there is the same speechless briskness. The essence of any market, of course, is the early start, and the small hours are not the genial ones: but I don't recall a joke, a sentence from outside the fish trade, even a comforting stream of bad language there, no glimpse of sin, slackness, or delinquency. Perhaps I was only half-awake. I spoke to a man unloading those light punch-ball sacks of scallops from one of the baymen's "draggers," as the boats are called, down from Stonington in Connecticut. He was an Italian, as many of these men are, and he, in the chatty Italian way, was about to tell me something about the fishing grounds when a voice in the team said "O.K., O.K.!" by which one understands one's head has been bitten off. It is a very serious misdemeanor to speak to any New Yorker while he is working.

It is instructive to compare the point of view of the admiring belletrist with that of the civil servant or public health official. A 1920 report for the New York–New Jersey Port and Harbor Commission was appalled at the same spectacle that so charmed Paul Morand: "Conditions are not attractive at the fish market. The cramped quarters and complete lack of protection against flies in the bulkhead sheds, the frequent emptying fish on the unclean floors of the piers, the repeated pitchforking, causing the breaking down of the flesh tissues and the beginning of decay, are all factors in the unattractiveness."

What excited the writers—the hands-on approach to labor, the casual way that two men might drag a grouper along the sidewalk or poke a fish with a knife while cigarettes dangled from their lips—made others, perhaps more fastidious, alarmed. A 1958 report prepared by Jules S. Cherniak for the New York City Department of Markets ("The New York City Fulton Fish Market: A Survey to Determine the Present and Needed Space Occupancy of the Industry and Other Related Problems") cited the same unsanitary conditions as the 1920 report, and demanded: "How long can our consumers tolerate such filth?"

In a sense, the two groups were at cross-purposes. These writers were looking to the Fulton Fish Market as a symbol of hope that at least some fragments of a once raffish, human-scale New York would survive in a more sterile technological age. They saw the market as a piece of the eternal city. But others, including some who made a living there, viewed it very differently. Robert Smith, an owner of the Arrow Seafood Corporation and Vice President of

the New York Wholesale Fish Dealers' Association, was quoted in the *Times* (May 14, 1999): "The conditions we work in are primitive. It's great for writers to be nostalgic about this place, but this is an industry, not a museum."

In fact, the workers and owners of the Fulton Fish Market were very much aware that they were in a living museum, a time warp. A newsletter, the *Fulton Fish Market Information Services Sheet*, issued February 7, 1986 suggested that "now may be an excellent time to take stock of the market's historical artifacts so that they can be preserved for everyone's benefit. Many wholesalers still have artifacts from the early part of this century in their market store rooms. These include tools of the seafood trade such as baskets, hooks, and scales, and old shipping tags, stationery, letters, and photographs. . . . These can be lent to many of New York's many museums for exhibit."

The Proposed Move to the Bronx

From time to time, schemes would be floated to move the Fulton Fish Market; then, in the nature of all such grand New York City planning fantasies, they would drift off like soap bubbles. But serious pressure to relocate the market may be traced to 1956, when David Rockefeller, chairman of the Chase Manhattan Bank, which was headquartered downtown, organized a group of area businessmen, bankers, and the president of the New York Stock Exchange to consider the future of Lower Manhattan. This group, which merged with the old Downtown Manhattan Association to form the Downtown–Lower Manhattan Association, issued a master plan in 1958. One of its key proposals "called for the removal of the Fulton Fish Market to create a major new landmass that, in combination with the expansion of the island out onto the pierhead line of the East River, would permit the financial and insurance districts to expand to the east. This new land would also allow for the development of significant enclaves north of Fulton Street and near the Battery between Pearl and Water Streets" (New York 1960).

Though the plan was not immediately acted upon, it paved the way for another monumental downtown landfill development, namely, Battery Park City. It also lined up the business community

to accept a vision that would subtract Fulton Fish Market neatly from downtown New York's future. The result would be a spiffed-up Manhattan where real estate would be too costly to support anything but residential and corporate uses, and where there was no longer a place for industry, manufacturing, the port, and smelly maritime-related operations such as the fish market, especially south of 125th Street. This vision has largely become reality. The transformation of New York from a major manufacturing city to an office-corporate-finance center, with sweat labor chased off Manhattan, has been no accident but a determined, methodical, coordinated effort on the part of the city's major players.[6] Whether it was the wrong thing to do or was inevitable, given global economic factors such as the search for cheaper manufacturing labor in developing countries, or whether it could have been achieved in a more nuanced way, re-moving the Fulton Fish Market to another borough was part of a larger plan to transform the island of Manhattan into a postindus-trial, corporate-residential enclave.

Concurrent with the city's loss of some 500,000 manufacturing jobs, the Fulton Fish Market had itself been shrinking. In 1940, wages at the market averaged $30 a week, and there were 2,000 employees in about 200 firms. In 1957 the average wage was $90 to $110 a week, but the labor force and the number of firms had de-clined, to 1,185 workers and 125 firms. In 1948, 179 million pounds of saltwater fish were sold, and in 1957, 167 million; in 1948, 18.5 million pounds of freshwater fish were sold, and in 1957, 14 mil-lion. These figures were borne out by anecdotal testimony; the old-timers complained there were far fewer fish in the market than there used to be. Some of this decline may have had to do with the dramatic increase in availability of canned tuna and frozen fish, just as the arrival in supermarkets of prepared gefilte fish in glass jars seriously ate into freshwater fish sales.

Throughout the 1950s and 1960s, when the neighborhood was left to deteriorate while being primed for gentrification, a strange thing happened: artists moved in, taking advantage of the emptied lofts around the Fulton Fish Market at Coenties Slip, and estab-lished one of the most stellar centers of creative expression in the twentieth century. The painters Ellsworth Kelly, Jack Youngerman (and his wife, French actress Delphine Seyrig), Robert Indiana, James Rosenquist, Jasper Johns, Agnes Martin, Malcolm Morley,

and Cy Twombley, and the composer John Cage, were among those who fled the trendy, clannish 10th Street scene, with its moneyed gallery openings, for the fish market area. John Cage recalled: "'It was comfortable there. Even though we were poor, we lived with such a view—from Brooklyn and Queens across to the Statue of Liberty—that life was enjoyable and not oppressive.'"[7] If the artists liked the fact that it was a gritty, nonresidential neighborhood, the fishmongers were just as content to see it remain derelict, with no one but them around, no one to challenge their rituals.

In 1969, the city announced with much fanfare that the fish market would move to Hunts Point in the Bronx. Reactions within the Fulton Fish Market were unenthusiastic. *Daily News* reporter Frank McKeown noted, in an article dated April 16, 1969: "One employee called the present market 'archaic,' but other workers were angry over the long bus-subway ride to the Bronx, the prospect of job-cutting automation and the slum area in which they will be working. According to the dissidents, 'some politician' made a big buy of Hunts Point property and the administration has 'forced' the move on the fish dealers."

In 1973 John L. Hess, in an opinion piece in *The New York Times*, compared the proposed removal of the Fulton Fish Market to the Bronx to the relocation of Les Halles in central Paris to the outskirts, Rungis, and predicted that in the end, New Yorkers would be paying more for fish that would not taste as good. Hess at least understood the New York situation as part of a developing global pattern, in which open markets were being pushed out of central cities.

As it happened, the move was temporarily forestalled by fishmonger opposition and, more importantly, put on hold by New York City's bankruptcy scare in the mid–1970s. The city simply did not have the cash to build a new facility for the market in Hunts Point.

In the 1980s the neighborhood surrounding the Fulton Fish Market was dramatically transformed into the South Street Seaport, a quasi-maritime historic district theme park. This massive effort, under the leadership of the Rouse Corporation, which had already perfected its "festival marketplace" formula in Boston and Baltimore, aimed to restore the decaying old brick buildings and clean them up for adaptive reuse. These handsome, symmetrical federal-style buildings in the market district, "made of hand-molded Hud-

son River brick, a rosy-pink and relatively narrow kind that used to be turned out in Haverstraw and other kiln towns on the Hudson and sent down to the city in barges," often graced with fetching details such as "an ornamented tin cornice and slate-covered mansard roof" (Mitchell, "Up in the Old Hotel"), would be turned into quaint stores, boutiques, eateries, and the Seaport Museum. A new structure overhanging the East River, dubbed Pier 17 and looking like a massive red barn, would be added to the mix, "essentially a shopping mall on stilts despite its nautical trimmings," quipped the naturalist John Waldman.[8]

At community meetings, efforts to persuade the Rouse Corporation and city officials to retain elements of the old commercial district, such as docks and icehouses, were to no avail. In 1984, the Fulton Fish Market signed a 50-year lease with the City of New York, which would ostensibly ensure that it could remain in situ until 2034 (so much for leases). Its coexistence with the South Street Seaport would depend on certain conditions, however: every day, the fish delivery trucks had to be gone by 10 a.m., in time for their places to be taken by tourist buses, and the market cleaned and shut tight behind metal grates. It was more than ironic that the seaport, an operation ostensibly dedicated to historical preservation, should set itself at odds with the one part of the old port still functioning in its midst. But hostility between the Rouse Corporation, with its intent to attract middle-class tourist families, yuppies, and financial district singles to the docks for shopping, eating, and cocktail hour, and the fish market, with its stubbornly gritty ethos, seems in retrospect unavoidable. Paul Harnett, then general manager of the Seaport Marketplace mall, was quoted as saying: "The Fish Market does nothing for our neighborhood. You come to our area, you hear people complain about the odor" (*New York Daily News*, April 16, 1969). The fish workers were equally unfriendly, dismissing the newcomers walking though the neighborhood as empty suits.

The Last Act

The fishmongers fought to keep doing business on the Lower East Side as they and their fathers had, enjoying the historical resonance of centuries and traditions. It was no small thing, either, that the

Fulton Fish Market existed in the heart of the old city, where it was still possible for, say, a hostess throwing a party in Chinatown to walk over in the early morning hours and buy ten pounds' worth of fish, blurring the line between wholesale and retail. It would not be so easy for her, or for the sleepless flâneurs, latter-day Joseph Mitchells, to saunter over to Hunts Point in the Bronx.

Nevertheless, there were inarguable disadvantages to keeping the market where it was, which even the most staunchly nostalgic, if honest with themselves, might admit. Getting eighteen-wheelers into and out of the narrow streets of Lower Manhattan was not easy. The Bronx would be better for the truckers, and, arguably, for their cargo. At the Fulton Fish Market the seafood sat out in all weather, and putting ice on fish is not the most efficient way to keep them cold. Human error enters in. True, there were on-site inspectors thrusting thermometers into boxes and barrels, but the chance of bacterial contamination was greater than with uniform indoor refrigeration. City officials cited the temperature/refrigeration issue most often as a reason for moving the market to the Bronx, because they had health laws to back them up. By itself, this may not have been an insurmountable problem (some observers argued that the fishmongers used copious amounts of ice), but, together with the market's other site disadvantages, it made the argument to move seem more powerful. Even if the Fulton Fish Market were to be refurbished with the most up-to-date refrigeration, the old pink brick houses on the west side of the street were not conducive to extensive mechanical work, rewiring, and drainage modifications. An alternative, of course, would have been to start all over and build a state-of-the art contemporary structure on South Street, with all the bells and whistles, but how much would that have been a way of holding onto the historic Fulton Fish Market? At least moving it to a modern facility in Hunts Point, where a fruit and vegetable market already existed, would be more convenient for restaurant owners, who could then do all their shopping for the day in one area.

Of course, if some fish had continued to arrive by water, a much stronger case could have been made for keeping the market where it was. The last trawler to dock at the Fulton Fish Market was the *Felicia*, in 1979. The fish caught in the New York Bight were already being trucked in. The last boats to dock at the fish market were those

from New England (New Bedford and Gloucester) that wintered over, such as the *Felicia*. Regrettably, the waters of New York Harbor had been so long polluted that an idealistic effort to construct "a New York City–based port for fishing vessels to unload their holds efficiently to the New York markets—was an utter failure. Although Fishport, built by the Port Authority in the mid–1980s in Brooklyn's Erie Basin, was a state-of-the-art processing and distribution facility, few boats visited it; there just weren't enough fish to catch anymore in the once-rich waters of the nearby New York Bight" (Waldman, *Heartbeats in the Muck*).

The deterioration of the piers alongside the fish market was part of a citywide pattern during the 1960s and '70s. The entire port was picking up and relocating to New Jersey, and no one had the heart or the foresight to take care of the abandoned piers. Instead they were left to the predations of shipworms. Still, the piers attached to the Fulton Fish Market should have been better maintained for the future day when the rivers would be cleaned up, as indeed they have been. Now people are crabbing and fishing for groundfish in the harbor again. "Piers are orphan structures," says Jack Putnam. "They belong to the city, so the city's got to keep them in repair. When the piers around the Fulton Fish Market were deteriorating, the city was fixated on containerization and moving the port to New Jersey, and what energies they had were put into the Atlantic basin and Red Hook."

Naima Rauam, a painter who has long lived in the area and made the Fulton Fish Market her subject matter (in 1983 she started visiting there, and she opened a gallery/studio with a sign that said: "Art in the afternoon, fish in the morning," which lasted for fourteen years), sees it differently: "The city did nothing to fix the piers. Then it would complain: this is not up to code, this is dirty, look at the hole in the floor." Asked why the workers didn't band together and fix the piers, she replied, "The fishmongers didn't want to sink money into repairing them because a) it would cost too much, and b) they were constantly being told that the market was going to be moved anyway."

The fishmongers might be seen as divided into three groups: the die-hard loyalists, who were obstinately against leaving the old marketplace grounds on any terms; the futurists, who looked favorably on the transfer to new facilities in the Bronx; and the realists,

who appeared to be in opposition but were merely stalling, cocking an ear, waiting for a better deal that would make it worth their while to move.

Had the commitment been there on the part of the city, it might have been possible to keep the fish market in its historic setting, modernizing as necessary. However, at times, attachment to the past and historic preservation comes to seem an overly elaborate, expensive, self-defeating exercise: easier to sweep away the old and start over with a clean slate.

As for the now shuttered Fulton Fish Market, that ghost town, what will replace it in the next incarnation? Already, many of the old brick buildings in the immediate area are being renovated and converted into pricey condominiums. The Seaport Museum, ever worthy but chronically underfunded, may eventually be able to expand into a few of those buildings. Someday the elevated section of the FDR Drive may even be torn down: the loop of the highway from the Battery to the Brooklyn Bridge is not heavily trafficked, and the removal of that eyesore would be a boon to the neighborhood.

On the East River side of South Street, the old Tin Building and the La Guardia–sanctioned facility that opened in 1939 are both protected by landmark preservation, so they cannot be torn down and replaced by high-rises; nor will the environmental impact review laws allow for structures at the river's edge tall enough to cast shadows discouraging the fishes' customary movements. General Growth, which bought out the Rouse Corporation, has the first option to develop the two landmarked structures and might be expected to push for wholly private commercial uses, in keeping with the festival marketplace/shopping mall character of the South Street Seaport. Already some community groups are lobbying for both buildings to be turned over to a mix of nonprofit, commercial, and cultural uses. Jack Putnam envisions the Tin Building divided into a fish market museum, a retail fish store, a seafood exposition center in which culinary and hospitality professionals could learn how to prepare different fish, maybe a small branch of the aquarium, and a fancy seafood restaurant. The avant garde–friendly Drawing Center would like to take over the 1939 art deco–lettered building, but its underpilings are compromised by water damage and marine borers and would need extensive, costly structural work before it could be occupied. Pier 17, the big red postmodernist barn

that opened in the 1980s, leaks and has other problems, and there are already plans to raze it and replace it with a new and better shopping mall or (if the community has its way) some nonprofit institution or public space.

The irony is that the South Street Seaport has never been an unqualified moneymaker; shopkeepers and restaurant owners have learned that its magnetic capacities are highly erratic and seasonal, so it can be jammed with tourists one day, deserted the next. The executives keep tinkering with the formula, but the seaport has so far failed to become an organic, functioning necessity in the daily life of the city. Native New Yorkers tend to give it a wide berth, as an ersatz theme park with the same franchise shopping mall clothing stores that have popped up every twenty blocks in Manhattan, and few compelling lures. And now that the fish market is gone, it seems even less authentic.

One way to breathe more life into it would be to revive that part of the waterfront for actual transportation. "Instead of putting these old ships in the harbor, which the museum doesn't have the money to keep in repair, why not have real tugboats docked there?" suggests Naima Rauam. Meanwhile, the odor of the Fulton Fish Market is expected to remain for many a year, along with the gulls and the stray cats.

The Hunts Point Fish Market in the Bronx, an $85 million facility, is fully operational. It may yet turn into a colorful, distinct New York institution, with its own legends and characters. For the moment, it has all the personality of a suburban supermarket warehouse—as Rauam put it, "Costco with fish."

Seen from a pragmatic perspective, the removal of New York City's wholesale fish market from its historic site in Lower Manhattan to Hunts Point in the Bronx was inevitable and even made sense—in any case, it was not such a tragedy. Dynamic cities do have to change and grow, or else they stagnate. Seen from another, broader urban perspective, the pattern looks more ominous. The Fulton Fish Market is but one of a number of specialized business zones, along with the 47th Street diamond district, the Chelsea flower district, the 23rd Street toy district, the Times Square theater supply district, and the Gansevoort meatpacking district, that are hanging by a thread or about to go under. One of the glories of New York used to be that you could find a street for every commodity:

ties, radios, lamps, aquariums, buttons, you name it. Why should such once-thriving activity centers be disappearing—what in the waters of Manhattan is endangering their fragile ecological system? The most immediate answer would seem to be the rising value of real estate, which dictates only the most profitable uses for each lot. But as these areas fade, Manhattan may be losing valuable parts of its soul: the more efficient it becomes at marketing its fun-gritty image to the world, the less it may find in the way of authentic remnants to celebrate.

Maeve Brennan, a short-story writer who frequently contributed to *The New Yorker*, may have summed it up best in her March 23, 1968 "Talk of the Town" piece:

> Manhattan is an island, and so she has two horizons—the architectural horizon, impermanent and stony, and the eternal horizon, constantly changing, that is created when water and sky work together in midair. It may be that the secret of Manhattan's hold over us is lost somewhere between these two horizons, the one hard and vulnerable, the other vague, shifting, and implacable. All we can be sure of is that she has a secret that binds us to her—something unresting and restless, something that she shares with us even though we are not allowed to understand it. . . . New York is a mystery. What is this place where Chaos stretches and sits down and makes itself at home? We live here, and we become part of the mystery. With Chaos, we make ourselves at home. We find our way about and establish a daily life for ourselves. But more and more the architecture of this city has nothing to do with our daily lives. The Office Space giants that are going up all over Manhattan are blind above the ground, and on the ground level they are given over to banks and to showrooms, and to businesses run by remote control by companies and corporations rich enough to afford the staggering rents.

The Fulton Fish Market was a piece of that Chaos that nurtured the mystery of Manhattan. But its funky, smelly, sweaty presence threatened the order of the financial district skyscrapers that towered over it a few blocks to the west and the shopping festivities of the South Street Seaport surrounding it, and in the end it had to

go. A pity, yes. Now we have no recourse but to turn to the photographic record for reminders of what we have lost.

The Photographs of Barbara Mensch

The Fulton Fish Market has always been photogenic. A lot of Hollywood movies, commercials, and even fashion shoots have used it as a location. From the photographers' point of view, the market told its own story; it was *real*, it was *authentic*, you just had to show the men in their traditional garb, the fish, the night sky. The fish workers liked it, because they got paid as extras and could ogle the models. Amateur snapshot enthusiasts and newspaper photographers also clamored to portray the market: sometimes it seemed as though it were impossible to take a bad picture down there. On the other hand, it was probably equally difficult to capture a distinguished image that expressed an individual style. Lisette Modell, the great Viennese–New York photographer, told of sending Diane Arbus, who was then studying with her, down to the Fulton Fish Market to shoot, an assignment she often gave her students. Arbus, she said, kept lifting the lens to her eyes and then putting it down. In the end she took nothing: it was picturesque, but just not her material. That, more than anything, convinced Modell that Arbus had her own unique vision.

When the photographer Barbara Mensch began living and working in a rough-hewn loft in the area in 1979, she represented the last wave of artists, urban pioneers, who had taken up residence in the Fulton Fish Market's shadow. As she reveals in her vivid, funny, candid, and personal account, it took quite a while for her to earn the trust of the people in the fish market. What makes her photographs of the place so unique is that she had clearly established a connection, even an intimacy, with her wary subjects. These are not the usual off-kilter snapshots of the hurly-burly around the stalls, the marketmen staring down at their fish, taken unawares: there is an eye contact, a commitment to see and be seen, a complicity between photographer and subject that makes all the difference.

Mensch says she was unaware of the work of August Sander when she took these pictures, but she readily admits that his exemplary portraits of people posed calmly in their workplaces may

have filtered into her subconscious from the zeitgeist. That said, consider the differences between Sander's images and hers: Sander brought a cooler, more clinical, sunlit laboratory tone to his portraits, while Mensch's hard-bitten subjects are swathed in nighttime shadows and seem more romantically defiant and forlorn as a result; their conditions are harsher. Sander's purpose was encyclopedic, to gather all the occupations in Germany, moving on after a day or two's shoot, but Mensch stayed for years, capturing the interconnections of a single community.

Because she came to know so deeply the ways of the fish market and to grasp the stresses the workers and fishmongers were enduring, she was able to incorporate that insight into her images. The implements the men carry, whether grappling hooks, carving knives, cigars, or guns (a playful assertion that all the worst things the D.A.'s investigators said about the market were true), all add to the story. One can read these photographs as a sequenced graphic novel or as stills from a classic feature movie. The beautiful young man wearing a cap, standing with *contraposto* insouciance before the East Bay Fish sign, a grappling hook dangled over his shoulder, could be a character in Visconti's *La Terra Trema* or *Rocco and His Brothers*. The older man with a cigar and plaid shirt and slight grin, his clawed hand at his side, also posed before the East Bay sign, seems a potential extra from *On the Waterfront* or *The Godfather*. They bring with them a drama and a dignity, an understanding of who they are that is, for want of a better word, archaic. Mensch's photographs sometimes give the impression of dating from another, much earlier era, although she used no antiquing tricks to achieve that effect: it is simply that the tribe she portrays seems a throwback. Their faces and bodies express an almost ancient awareness of the price that must be paid to be a man, to hold one's ground, especially in a society less and less respectful of working-class culture.

Some of these photographs capture the moment of transition: the new office towers rising about the old fish stalls, the docks being demolished, or the tired nocturnal workers eyeing the women clad in office attire and heels, on their way to work in the morning. The messages of opposition to eviction, scrawled on the grimy walls, are as touching as they are useless. Even the sites that are emptied of human figures throb with a drama of resistance and displacement. Above all, these pictures convey resilience and continuity, even in

the face of eradication. What other choice is there? the men seem to say.

Because Mensch is such a powerful, gifted photographer, many of her single images are knockouts. Cumulatively, this work is magnificent—an anthropological trove, an aesthetic vision of the highest order, one of the great modern sequences of the life of a community, which belongs on the same shelf with W. Helen Levitt, Bruce Davidson, and Brassai. Now that we have these portraits collected between covers, not having them would be unthinkable. From a photography lover's standpoint, they bring the consolations and delights of all great urban photography. And from an urbanistic point of view, they compensate, however bittersweetly, for the loss of the Fulton Fish Market.

I would like to thank some of the people who gave so generously of their time and expertise in helping me prepare this text: Norman Brouwer, Naima Rauam, Jack Putnam, and of course Barbara Mensch.

NOTES

1. After his death in 1815, practically everything got named after Robert Fulton, whose steamship, the *Clermont*, had made its maiden voyage from the Beekman Slip in 1807. Ironically, this invention would help undermine the East Side as a port, since the Hudson was deeper than the East River and could better accommodate steamships.

2. *The Diary of George Templeton Strong, 1835–1875*, ed. Allan Nevins and Milton Halsey Thomas (New York: Macmillan, 1952), vol. 2.

3. These fish cars continued in use until 1945, when increasing awareness of the polluted state of the East River combined with improvements in refrigeration to make them obsolete.

4. "Old Mr. Flood" (1944), collected in *Up in the Old Hotel* (New York: Pantheon, 1992).

5. The loading racket "operated this way: When goods were left on a pier-shed floor, truckers needed a helper or mechanical forklift to get the shipment onto the truck. Those who performed this task—the equivalent of public porters in a train station—came to control all movements on the pier. Lower Manhattan's narrow piers and antiquated cobbled streets near the waterfront exacerbated the congestion, as did the vast increase in trucking of freight. The greatest expense in shipping through New York became the waiting time for loading. Truckers in a hurry agreed to pay an extortionate fee to jump the line. In this way a group of middlemen ended up dominating the docks, with thugs and organized crime families fighting for the privilege" (Phillip Lopate, *Waterfront: A Journey Around Manhattan* [New York: Crown, 2004]).

6. "Manufacturing employment in New York City reached a peak of 1,073,000 workers in 1947, and had declined 12 percent by 1960. In 1970, a further 121,000 manufacturing jobs had been lost, and by 1977 another 280,000. In 1950, manufacturing jobs had accounted for 30 percent of payroll employment; by 1980 the figure was 15 percent" (William K. Tabb, *The Long Default: New York City and the Urban Fiscal Crisis* [New York: Monthly Review Press, 1982]). And these figures do not include the port-related jobs lost during the same period.

7. Robert A. M. Stern, Thomas Mellins, and David Fishman, *New York 1960* (New York: Monocelli Press, 1995).

8. *Heartbeats in the Muck: The History, Sea Life, and Environment of New York Harbor* (New York: Lyons Press, 1999).

~~mitag.5of~~

3.95 turbot 150

.175 hak 80

 catfish filus 68

 10 brook

Norweg

A SOUTH STREET STORY

Barbara G. Mensch

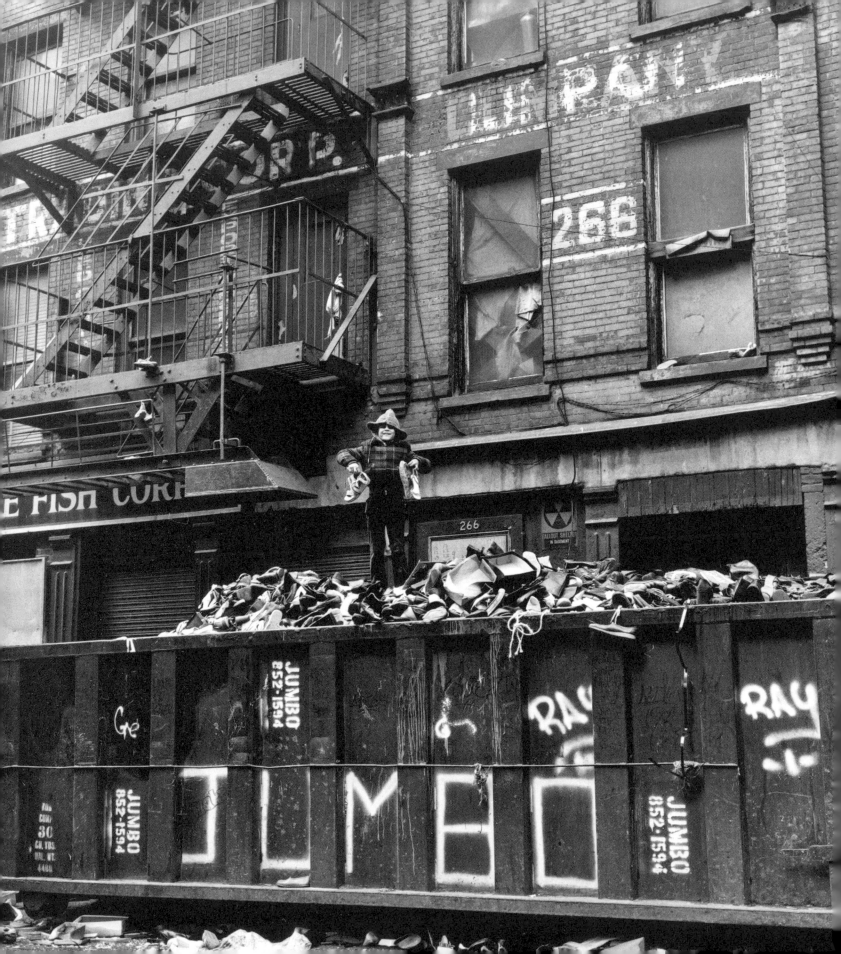

"WHAT'S A NICE GIRL

LIKE YOU DOIN' IN A

PLACE LIKE THIS?"

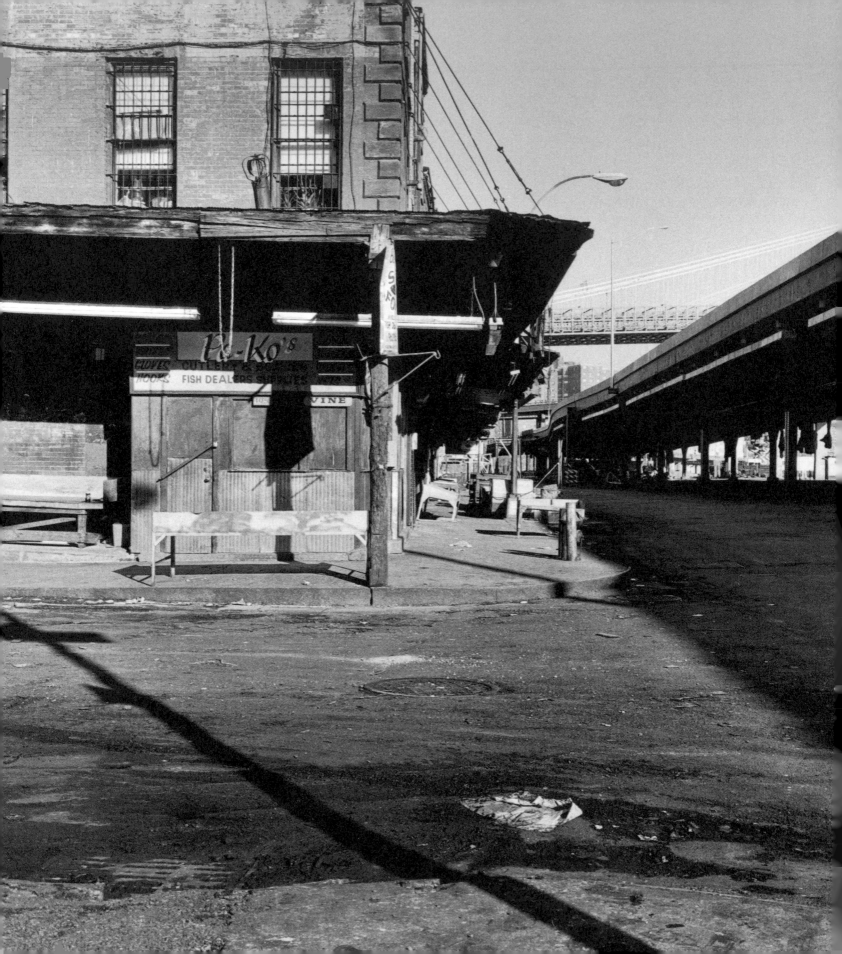

DURING THE SUMMER OF 1979 I was looking for a new place to live. I noticed an ad listing a loft for rent in the South Street area of Lower Manhattan. For three weeks, I dialed the phone number frequently but had no luck in reaching anyone. On what I'd decided would be my very last attempt, someone finally answered. He agreed to show me the space the next day.

It was intriguing to walk past the Brooklyn Bridge looking for the street address. I knew that since the days of Melville and Whitman, this waterfront had been a vital maritime center bustling with trade and commercial activity. Now, the heritage of the area was reflected in its rude, decaying storefronts, potted cobblestone streets, and weirdly tilted commercial lofts. With the exception of a small group of artists living in the run-down warehouses, the waterfront was largely unpopulated.

I located the ancient brick building and rang a makeshift door buzzer, its wires haphazardly dangling down the side of the build-ing. After a short while, a wiry young man greeted me at the front door. I followed him up five flights to the top of the shaky stairwell, and he opened the door to a loft illuminated only by a single light bulb hanging from the ceiling. As my eyes adjusted, it was possible to discern large black circular imprints on the wooden floor, sug-gesting that at some time in the building's past, rows of barrels had stood there. The brick-walled room was musty and damp.

There was also a set of broken stairs leading to the roof. Curi-ous, I climbed up and unlatched the door. Outside, the view of the

Brooklyn Bridge was astonishing. The towers of the bridge, bathed in the late afternoon light, were breathtakingly beautiful. From another vantage point I could see the East River, the abandoned docks under the bridge, and the sheds of the Fulton Fish Market. An old man with a hunchback was busy feeding pigeons in a makeshift wire coop on the adjoining rooftop. With a broad smile showing his corroding dentures, he waved in my direction. Standing on the roof, I felt inspired by the bridge, and at peace being in such an out of the way, off the beaten path place. I knew in an instant that this was my new home.

My first friend in the neighborhood was a former sailor from England turned ship restorer and carpenter. He lived around the corner, in a decrepit three-story brick dwelling with a sloping roof. My neighbor had a great interest in the maritime history of the area, and insisted that the origins (foundation) of his building could be traced to the Dutch settlers. Once in a while he would spin romantic tales of the nineteenth century, recounting stories about the waterfront when it was filled with hotels, dance halls, brothels, and saloons, where gamblers instigated fights between dogs and rats.

My friend walked with a limp and had a thick British accent. When we took walks around the neighborhood, he would often carry a copy of Herbert Asbury's book *Gangs of New York* and would read aloud:

A famous Water Street resort was the Hole-in-the-Wall, at the corner of Dover Street, run by one-armed Charley Monnell and his trusted lieutenants, Gallus Mag and Kate Flannery. Gallus Mag was one of the most notorious characters . . . a giant Englishwoman well over six feet tall so called because she kept her skirt up with suspenders or galluses. She was bouncer of the Hole-in-the-Wall and stalked fiercely about the dive with a pistol stuck in her belt and a huge bludgeon strapped to her wrist. It was her custom after she had felled an obstreperous customer with her club to clutch his ear between her teeth and so drag him to the door, amid the frenzied cheers of the onlookers. If her victim protested or struggled she bit his ear off . . . she carefully deposited the detached member in a jar of alcohol behind the bar in which she kept her trophies in

pickle. . . . She was one of the most feared denizens of the waterfront.

The dive was finally closed after seven murders had been committed there in a period of less than two months.

When we sat by the piers, there were rare moments when the wind blew the smell of salt water off the river. Then, it was easy to imagine South Street when it was known as "The Street of the Tall Sailing Ships." My friend would spin maritime tales like "The Mystery of the *Mary Celeste*," the ship that set sail from South Street in November 1872 for the Azores and soon afterward was found drifting in the Atlantic with no one on board.

As a young photographer, I would wander the neighborhood, exploring and photographing simple "events." At the time, I was fascinated by the art of Walker Evans and Berenice Abbott, whose approach to image making was powerfully direct. That seemed appropriate for capturing the area's hidden beauty.

A few steps down from where I lived was a rag shop. Once a month, the proprietor would place a Dumpster on the street filled to the brim with cast-off inventory. People would climb in to look for pieces of fabric, articles of clothing, or a pair of matching shoes to wear.

The ancient buildings that lined the streets all had crumbling brick façades, windows that were mysteriously boarded up, and weather-beaten hand-lettered signs announcing such businesses as Mon Ark Shrimp, Seacoast Fish, and Variety Fish. In the daylight hours, the doors were closed and there was never anyone around.

My intriguingly "undiscovered" neighborhood was about to undergo monumental change. Beginning in the 1970s, the press reported plans to demolish the piers of the fish market and restore the surrounding Schermerhorn Row, one of the oldest streets in downtown Manhattan. A new, expansive shopping mall complex filled with chain clothing stores, novelty merchandise shops, souvenir vendors, and fast-food eateries would be built in their place. I read in the New York *Daily News* that "The City planners are talking about glass and spindled steel and a quaint replica of New York's long ago harbor that will rise up like Disneyland out of the

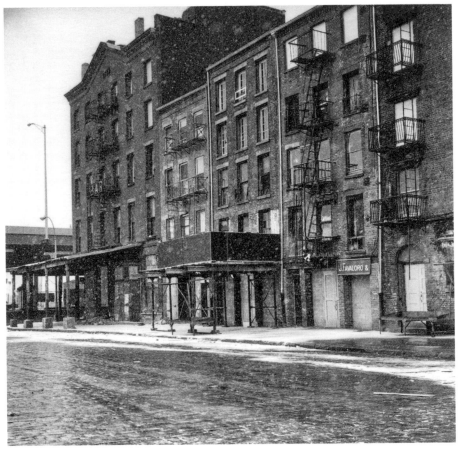

ashes of the market." Inevitably this would cause problems for the Fulton Fish Market. There was talk of moving the market to Hunts Point in the Bronx.

The spokesman for Local 359 of the United Seafood Workers of the Fulton Fish Market, Carmine Romano, was quoted: "We've offered to match them with 10 million dollars of our own money to renovate and improve the market as it is right here, but they don't want to talk about it. If they move us, they're going to put 200 of my men out of work and put a lot of the smaller wholesalers [fishmongers] out of business."

A neighbor mentioned that Meyer's Hotel and the bar located on the ground floor of the building had recently been sold. The hotel, on the corner of South Street and Peck Slip, had been open since 1873. The bar, called the Paris, served food and drink to the waterfront crowd and was open all night.

Meyer's Hotel had a noble history. For years, it accommodated the bay men who worked the fishing boats (smacks and trawlers), the draggermen (fishermen who specialized in catching shellfish), the lumpers (men who unloaded the fishing boats), the longshoremen who unloaded the tramp freighters (ships that traveled around the world picking up and delivering different cargoes—"tramp" was a reference to a "female tramp," or prostitute), sailors coming to port, and the men who worked the "double headers" (unloading the boats during the day and then working in the fish market at night).

During and after World War II, the hotel served as a place of refuge for sailors in the merchant marine, veterans who had fought the Germans in the Atlantic. Recently, a friend who grew up in the area recounted: "It was an old man's hotel, subsidized by the government. There were guys walkin' around with no legs, or their arms missin', blown to bits when their ships were torpedoed. . . .

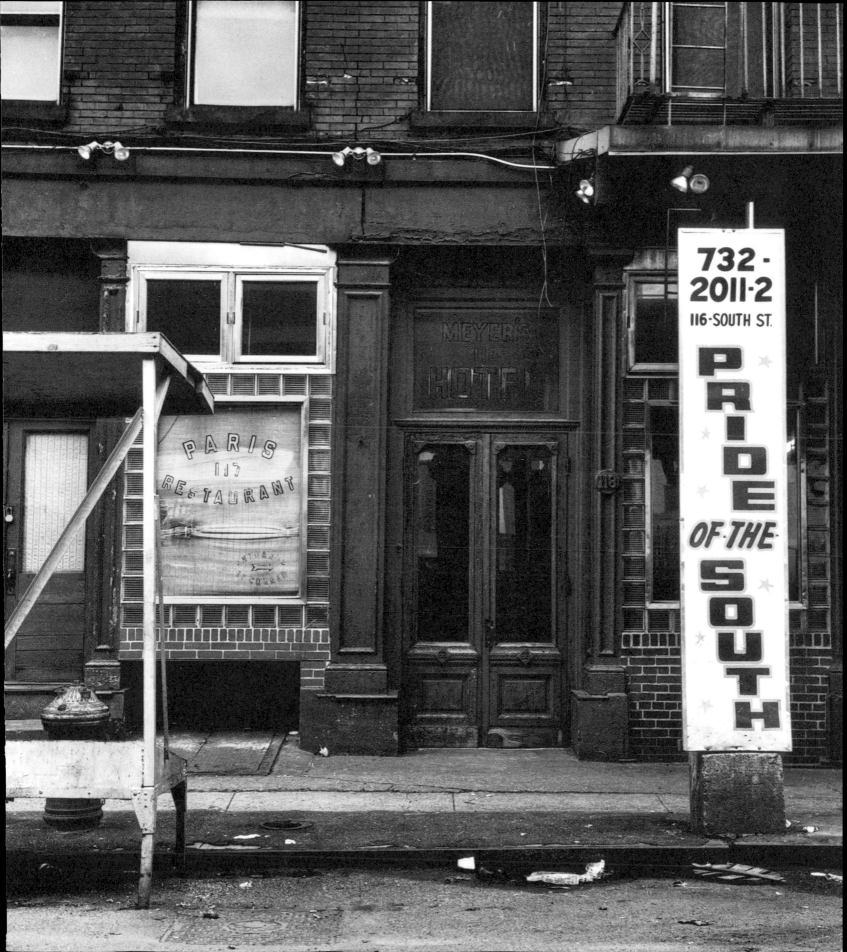

They were all remarkable men and they served their country with honor."

One day, as I stood watching the workmen emptying the top floor of debris, I met the new owner. "What are you going to do with the building?" I asked. He appeared to be uncomfortable with my question. He remarked that he was eager to convert the hotel into residential apartments, and the Paris into a daytime bar. "I want to make a beautiful place to attract the intellectuals," he responded, then walked away.

The past, the sense of the area's long history that so intrigued me, was slipping away. I wanted to photograph the workers from the time-honored Fulton Fish Market who still congregated late at night in the old Paris. They remained in the last of the waterfront jobs.

It was the middle of winter, about 4 a.m., when I first went down to the Paris Bar. Nothing could have prepared me for what I saw as I pushed open the swinging doors.

The large interior had a fluorescent lamp hanging from a rotting tin ceiling. Its glare pierced thick veneers of smoke, through which I could make out faces of the toughest-looking men I had ever seen. They were leaning over the bar, drinking and eating. The group sported heavy jackets; most wore pea caps or wool hats. Metal grappling hooks dangled from their worn jackets, and some of the men leaning over the bar wore blood-encrusted aprons. The stark overhead lighting cast intense shadows across their hardened features.

Suddenly, a large man stepped forward and advanced within an inch of my face. Fixing me with an icy stare, he said, "Get the fuck out." I was overcome with a deadly fear. That ended that. I was out on the street. The whole event took less than a minute.

For hours afterward, I couldn't block out those unforgettable images. The ambiance inside the bar was tough and serious. It was an intense experience, even for a few moments, to be around those men. They were from another era in New York history when men had to earn a living in the most dire of circumstances, when the waterfront itself was shrouded in mystery. As a photographer, I had discovered gold.

The following night, I couldn't sleep and decided to go back to the Paris. After midnight, I walked down Dover Street, a narrow street bordering the Brooklyn Bridge. A strong wind blowing from

the river forced the metal shutters on the large anchorage windows to bang open and shut against the granite pillars. The sounds were unsettling. Then I came to South Street. The pale fluorescent light emanating from the bar windows cast deep shadows out into the street.

A bartender with sad eyes and a cigarette dangling from his lips looked up as I pushed open the doors once again. Noticing a camera tucked inside my unzipped jacket, he shook his head disapprovingly. Waving his hand, he signaled for me to approach the bar. He was well aware of the hostile looks from the men. Leaning over the shiny hand-carved wooden surface, he whispered in my ear, "Ya can't stay, uh, it ain't such a good idea. Come back durin' the day."

In the morning I went back. The bartender was still there, but the only customers were two old men hoisting a few whiskeys. While they drank, they were making lewd jokes. Then a few other men came in. They all seemed to know one another and took their places at the bar or sat at the 1940s-style tables and started drinking. I remember bits of conversation: "Well, Mikey, I'm up to no good today." One of the men wore a nautical captain's hat. He shouted some incoherent words as he kept drinking shots of whiskey. The time was approaching 9 a.m. A few more old-timers came in. They called each other by their last names. One was named Falzone, the other was called Lombardi.

"What's a nice girl like you doin' in a place like this? Hey Falzone, she wants to take your pitcha!"

After I'd shot several rolls of film, two men wearing expensive leather jackets and gold jewelry entered the bar. Instinctively, I stuffed the roll of exposed film deep into my pants pocket. Without saying a word, the men looked at me, then turned to the bartender; one of them said, "Mikey, what the hell is she doin'?"

Mikey the bartender, my angel and protector, responded, "Nah, she just wants to take some pitchas of the bar before they rip it up . . . that's all."

The two men threw a quick stare in my direction, but left without saying another word.

Later that morning, as I packed up my photo gear, the bar was empty of clientele. Mikey explained, as he lit up a cigarette with a grace and poise reminiscent of Humphrey Bogart, that "pitchas"

were not allowed. If anyone tried to photograph in *their* bar, the Paris, that person would surely end up with a broken nose, a broken camera, and the rolls of film ripped out. I took his comments seriously and continued to photograph the old waterfront only in the daylight hours, scrutinizing its physical character.

Months later, a fishing trawler was docked by one of the old piers. It was daytime, so I went over and began asking questions. The captain of the vessel, who told me his name was Kenny, had done business in the fish market on a regular basis. He said that upon the trawler's return in a few weeks, the fishermen would unload their last catches; then the pier would be demolished.

Soon after, construction cranes, wrecking balls, and other demolition equipment were brought in to the neighborhood piers by barge. Streets were already being closed off, and local buildings that didn't fit into the new development plan were razed.

Some time passed, and the trawler returned to the pier. The unloading would take place very early in the morning, around 3 a.m. It was time to gather up some courage and go out and take pictures.

But with which camera? I decided on my Rolleiflex, a type of camera widely used in the 1950s and '60s. Rollei images once graced the covers of magazines such as *Life* and *Look*. This manual camera operated with a crank, so was not dependent on batteries, and performed well in all kinds of weather. The shutter was very quiet, which was a good thing if you did not want to draw attention to yourself. In addition, South Street was very old, and my camera matched!

The air was still chilly when I left my loft building. At the end of the dimly lit street, bright orange flames were leaping up from an oilcan. The fire lit up a silhouette of a lone figure warming his hands. The man by the barrel was not wearing traditional work clothes or boots and sported no hook; rather, he had on designer jeans and a pea cap. With a wry smile, he asked what I was doing out at this ungodly hour.

Although he sounded friendly and had a beautiful face, the situation made me suspect some kind of subliminal violence. Nervously, I responded that I was about to photograph a boat docked by the pier. "Ah, that's nice," he replied. He asked if I wanted coffee and after I said, "No, thanks," he stopped warming his hands. He then walked a few steps, leaned against a street lamp in front of a peeling

storefront sign that read CIRCLE FISH, and said, "See ya when ya get back."

I walked toward the river, relieved that nothing untoward had happened. I had no idea that in a year's time he would become a very trusted friend.

The decrepit pier was pitch dark. At the foot of the dock was a shack containing blocks of ice, which a large machine was grinding into small chunks. The contraption was fastened haphazardly together with sheets of metal and made a funny *humm-humm* sound when the motor was running. The operator of the ice machine, standing inside the shack, peered suspiciously at me through the window.

In virtual silence and with blank stares, workers lined up at the shack watched as mounds of crushed ice spewed forth from the machine into their draft boxes. The long, deep wooden containers reminded me of coffins. The men leaving the pier were straining to pull their hand trucks, now laden with boxes filled to the brim.

I saw a few homeless men in the shadows of the ice house. One of them was sitting on the edge of the pier cleaning fish in a bucket of water; another was pushing a shopping cart. These cast-offs seemed not unlike the discarded fish they were collecting to eat.

Captain Kenny, smoking a pipe, looked up as he directed the unloading of large burlap bags of scallops. He nodded in my direction.

At the time, I was also influenced by the work of photographer Darius Kinsey, who created large group portraits of lumberjacks in the Northwest from astonishing perspectives. In that spirit, I wanted my own group picture of the last fishing boat. Included in the background would be the piers destined for destruction.

In the low, ambient light, it was a challenge to make a picture. If I used a strobe, the bright bursts would only draw more attention from the workers nearby. Instinctively, I opted for a tripod and slower exposures. I preferred to follow nature: the available light would determine my photographic decision making. My subjects would have to remain relatively still for my method to work.

When I asked the crew if they would pose in a group, the response was condescending laughter. They continued to work. I waited and waited. Time was running out, as the crew had only a few large bundles of scallops left to unload. I had to think fast. "If you stop what you're doing and look at the camera, I'll do a striptease."

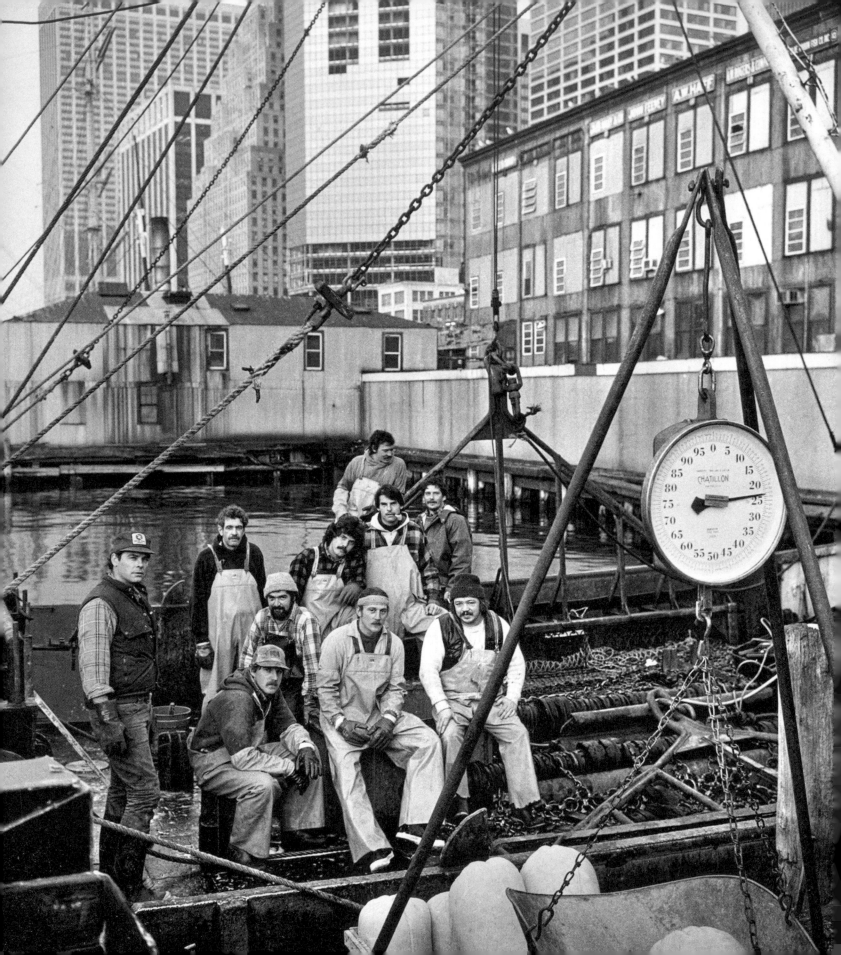

Instantly, they formed a group for a few moments, and the picture was made. In haste, I pretended to look at a wristwatch (that I didn't have), shouting, "I gotta go." The fishermen became really angry and started cursing and throwing pieces of ice. Some of the workers from the New Market Building left their open-air stalls and came to the pier to see what was going on.

A burly worker with a frightfully large hook slung over his shoulder approached me. He said that he was impressed with my "ability to get the job done." Thinking quickly, I asked if I could come down, stand near him, and take pictures of the pier before it was demolished. He paused and thought about it for a few seconds, nervously focusing his gaze on South Street. Then he looked at me and said, "Yeah, uh . . . yes . . . ya sure can."

A couple of days later, I positioned myself near this man in the early morning hours and photographed Beekman Dock, one of the remaining two working piers. Workers hauling crates of ice would stop in their tracks just to stare at the enormous wrecking balls and other demolition equipment waiting on barges in the East River. The end of an era of maritime activity below the Brooklyn Bridge was imminent.

Many of the workers referred to the Fulton Fish Market as simply "the market." They spoke in a street vernacular that had a unique beauty. I tried to overhear a little of what they were saying. These men, I thought, particularly the old-timers, were the keepers of remarkable stories, not only about their own survival but also, I suspected, about significant and dramatic historic events that had taken place on the waterfront. It was written all over their faces. I began to record snippets of their conversations in a little notebook.

An Open Book

I now had my own spot on the old pier, but no one would let me take their picture. Many of the workers would turn their backs when they saw the camera. I felt a group hostility that was as dense as the fog that settled on the river in the early morning hours. Soon I came to understand the root causes of their rage.

Coinciding with weekly stories about the South Street development plans, the name of Carmine Romano, the head of the United

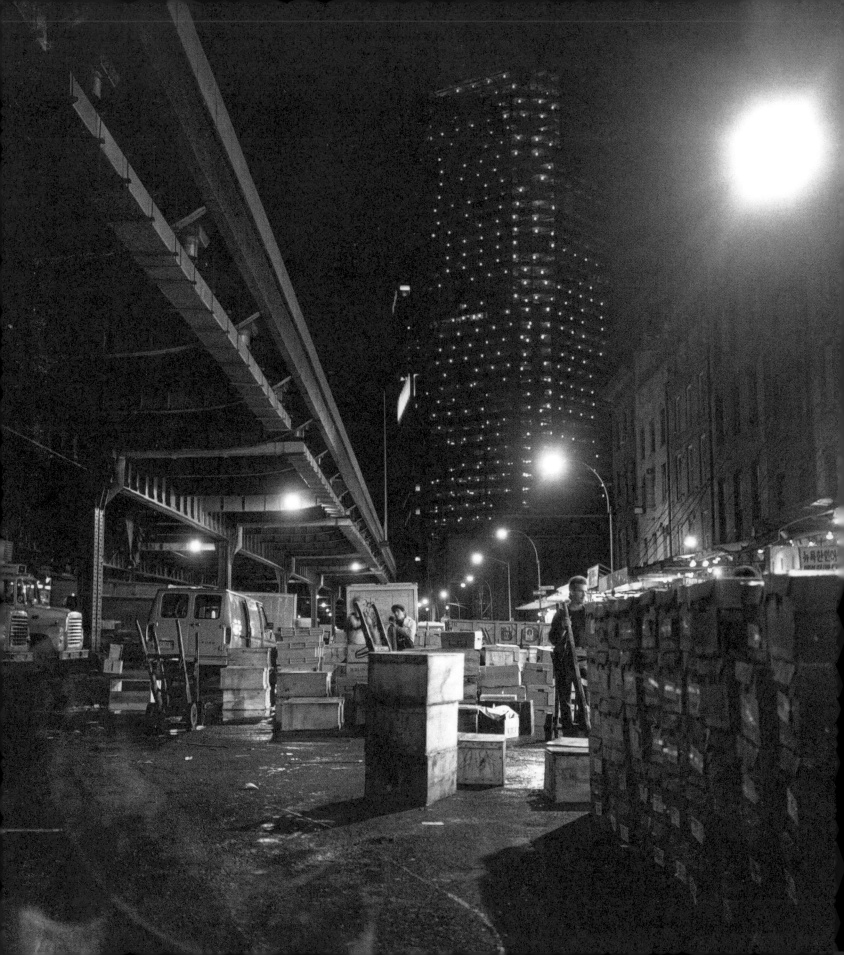

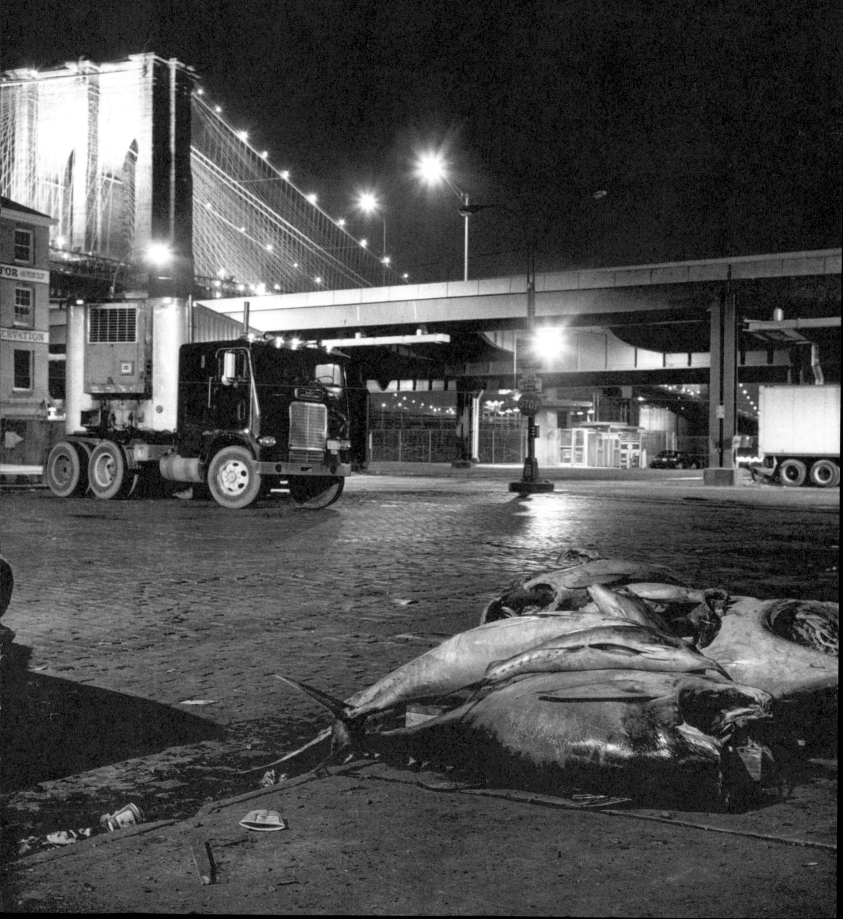

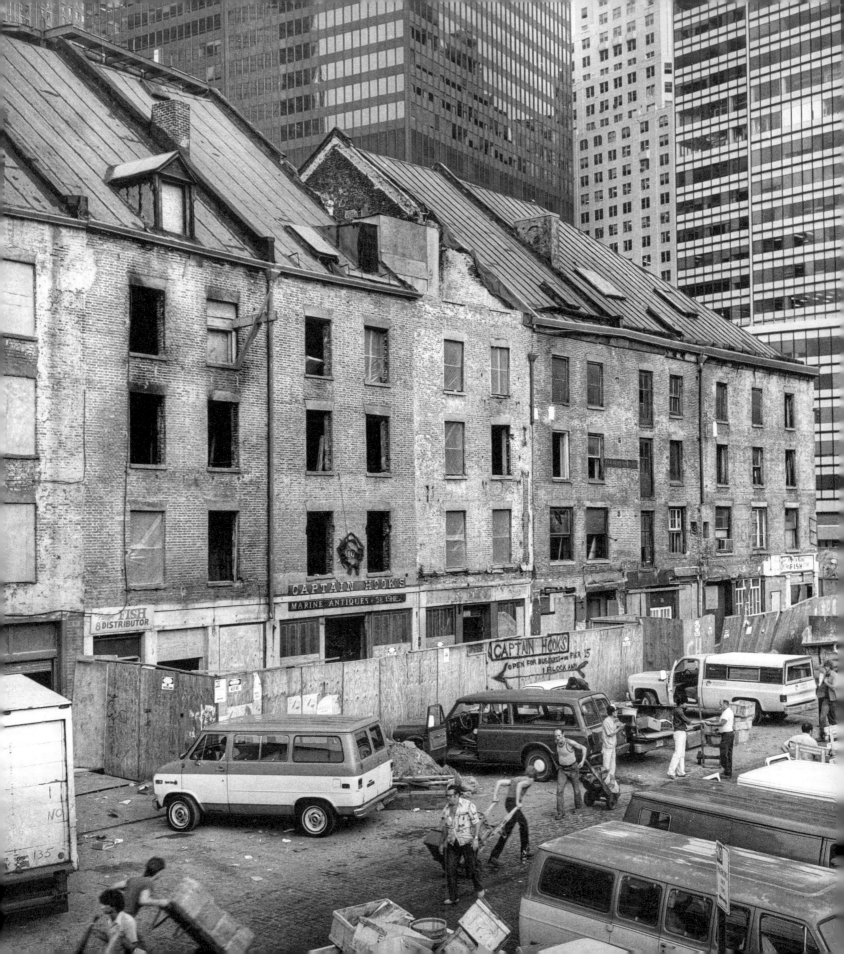

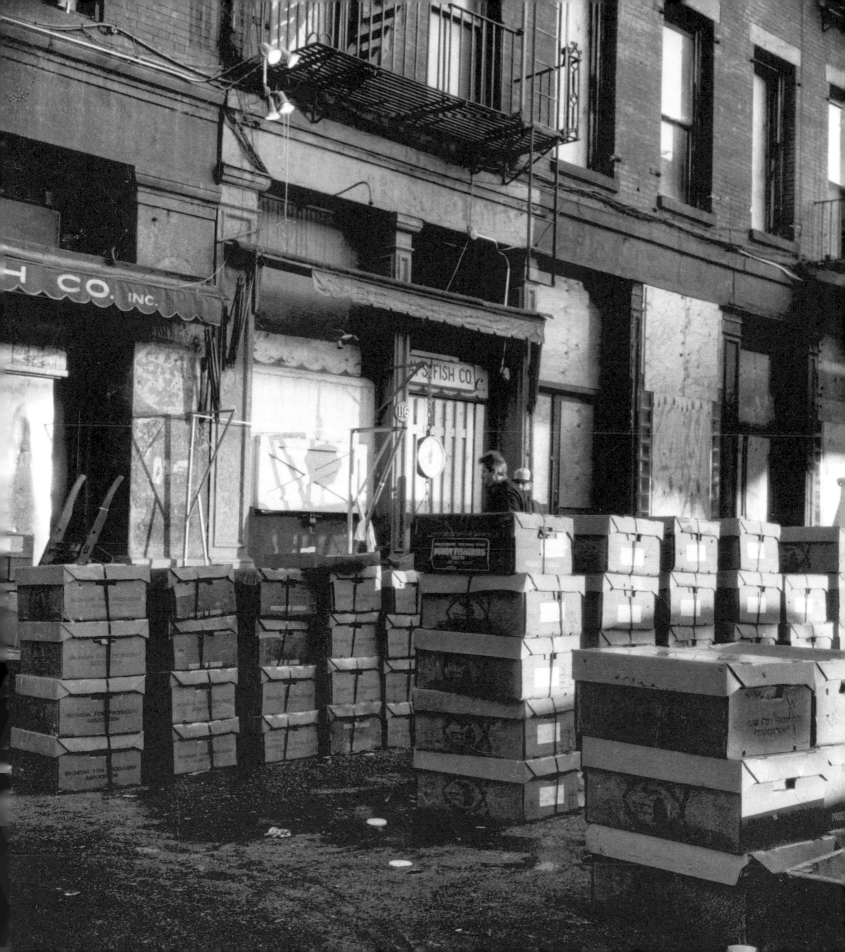

Seafood Workers Union, began to appear in the news. He had been arrested and jailed as part of an ongoing investigation into the mob's influence over the wholesale seafood industry by federal agents, members of the New York State Task Force on Organized Crime, and local law enforcement officials. New York Assistant District Attorney Daniel Bookin, and subsequently federal prosecutor Rudolph Giuliani, was in charge. The many allegations stated that

> Since the rise to power of Joseph "Socks" Lanza in the 1930s, the Fulton Fish Market's operations were dominated by organized crime. Using evidence collected by Operation Seaprobe, a joint federal–local investigation, U.S. Attorney Giuliani filed a civil RICO [Racketeer Influenced and Corrupt Organizations Act] suit against twenty-nine individual defendants, including officials of the United Seafood Workers Local 359 and the Genovese crime family, and sought a federal court trusteeship over the entire Market.

Most of the defendants entered into an agreement that allowed for a court-appointed administrator for the market. While this administrator had wide-ranging powers to inspect records and implement rules and regulations, he made clear that some form of sustained municipal regulatory oversight would be needed to expel Cosa Nostra from the market. But the investigation had gotten some results. The three-year federal probe, begun in June 1979, had led to the convictions of eleven owners and the closing of their fish businesses. Local 359 unloading operations enforcers Carmine and Peter Romano were convicted on charges of racketeering and manipulation of union pension funds. The two men were big fish indeed. "All the fish coming into Fulton Fish Market is unloaded by a half-dozen unloading companies that have been granted monopolies by the mob," said one assistant U.S. attorney, adding that millions of dollars' worth of seafood was being stolen each year during unloading. (Later, as mayor, Giuliani would succeed in persuading the City Council to pass his measure to more tightly regulate the food markets.)

After the relentless investigation of a long list of allegations including loan sharking, extortion, tax evasion, and thefts by unload-

ing companies, every worker in the market was aware that images of themselves could wind up in yet another FBI file. The paranoia level was high. The threats were not a joke. "If I find out you're a fed, I'll personally kill ya, myself."

I had yet, however, to photograph inside the market. A friend suggested I take a man along as my chaperone. That was out of the question. I was very competitive with men and wanted to prove my fortitude.

Getting up in the middle of the night, I once again put on an oversized jacket and tucked my twin-lens camera inside. I headed toward the Paris, which by now was closed and all boarded up. However, down South Street, the sidewalks were illuminated and alive with all kinds of activity. Men with serious expressions threw giant fish onto weighted scales. The warped steel bins, which stood empty during the daylight hours, now overflowed with fish and ice. Old men, some of them with tobacco-colored saliva dripping from their cigars, were bending and straining as they handled and analyzed each crab or flounder. Nervously, I walked around. I felt the men "stripping me down" with their stares and heard lewd remarks from the workers pushing the hand trucks.

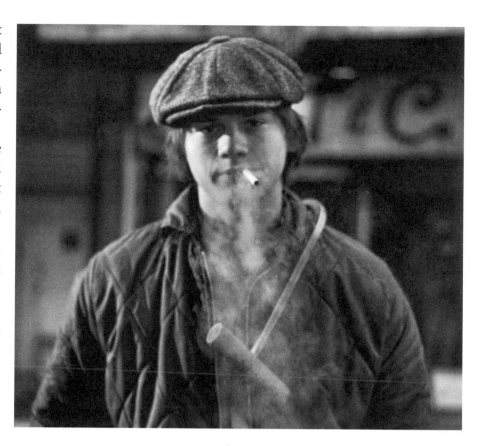

Many of the workers had classic New York faces suggesting Italian, Irish, and Jewish descent. They wore suspenders with their overalls and pea caps on their heads. The old-timers, their faces wizened and hardened, their bodies warped with rheumatism and arthritis from working outside in the elements, were a throwback to another era. They addressed each other in street vernacular using words like "dem," "dese," "dose," and "youse."

Overhead lights made the many varieties of fish look shiny and surreal, lying dead as could be in bins and crates that spilled out onto the sidewalks. Names of businesses were advertised on hand-painted signs: PRIDE OF THE SOUTH, FAIR FISH, FRED W. MULLAN & SON FISH, ARTIE BEHRENS, FISH CO., EAST BAY FISH.

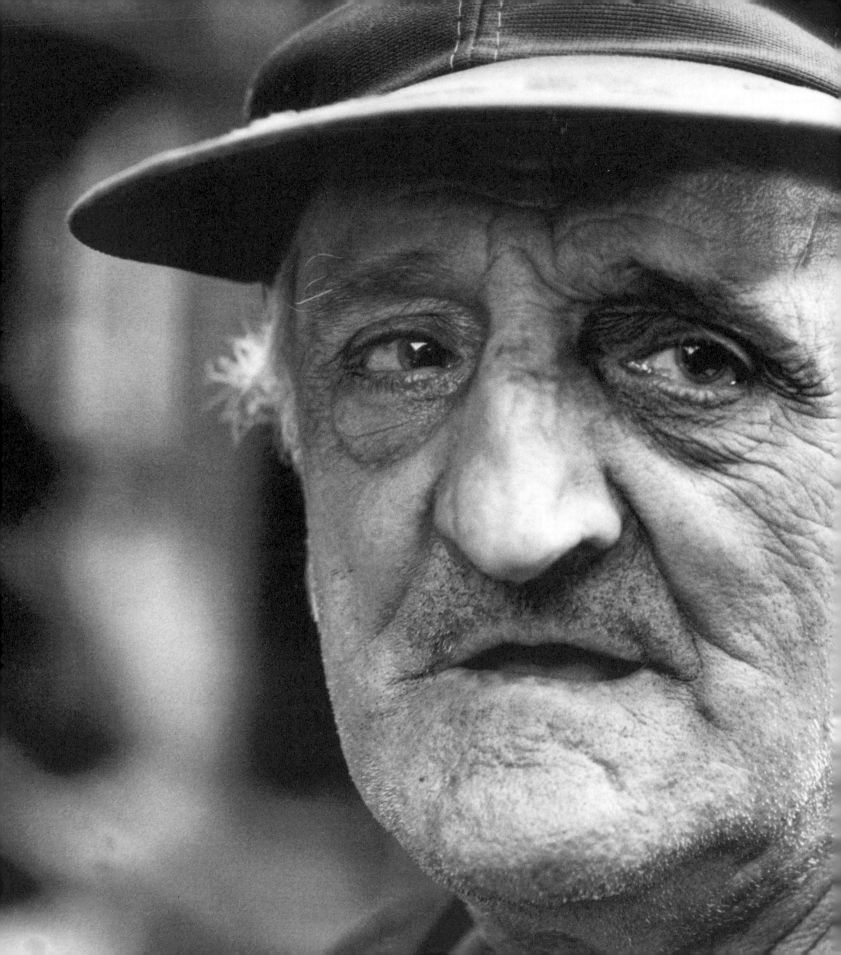

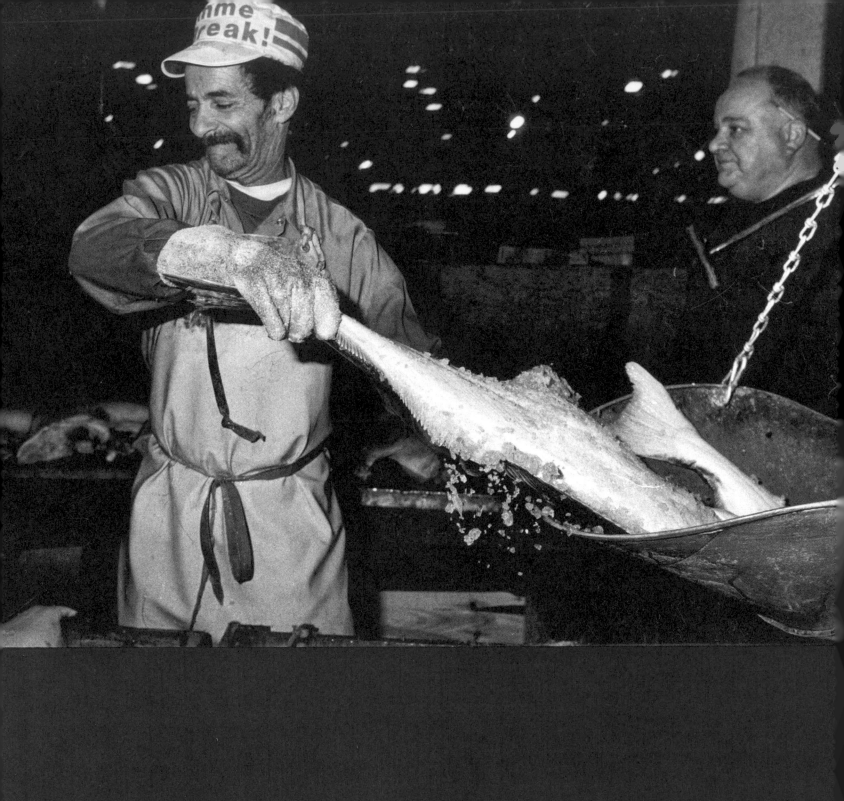

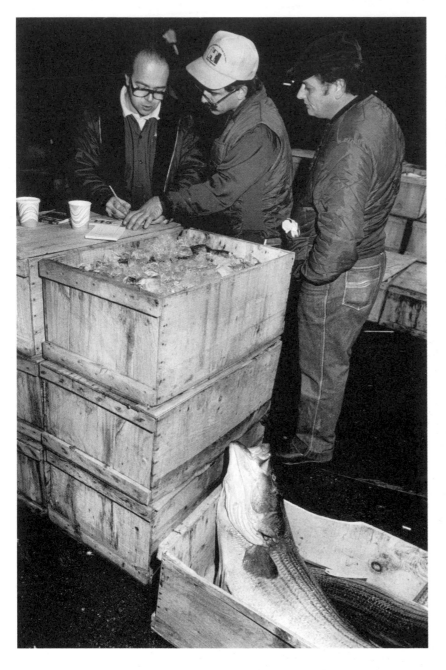

Near the intersection of Beekman and South Street, a humorous sign, HOLLYWOOD AND VINE, was painted on a street-corner kiosk. The kiosk, "Pa-ko," was open for business, selling cigarettes, candy, new grappling hooks, and ice picks, among other items. A group of men standing off to the side darted suspicious and hostile looks in my direction.

Crossing the street, I almost tripped over wooden pallets piled high with headless swordfish and tuna. (Much later, I learned that the men referred to them as "pups.") South Street was wet, with giant puddles everywhere. Pungent smells of salt water and seafood wafted into the air.

Each sound was amplified in the biting cold night. Walking toward the large sheds by the East River—the Old Market Building and the New Market Building—I was alert to a cacophony of shouts, jeers, and heckling that blended with the distinct thumping sound of the wheels of the wooden hand trucks bouncing over the cobblestoned street.

South Street functioned like a sieve most of the night. Only a few cars at a time could weave through in either direction within the boundaries of the bustling fish market. Unsuspecting drivers were cursed by men pushing hand trucks through traffic. I saw several workers aggressively bang the sides of passing cars with their long grappling hooks. Truck drivers, pulling in and out from under the viaduct, had to pay attention so as not to crush men on foot carrying boxes and baskets. The scene looked like chaos.

The protective canopy of the highway overpass, the derelict area under the Brooklyn Bridge, and the piers where the boats docked were shrouded in darkness. Together, they served as parking areas for tractor-trailers and utility vans. In the predawn hours, the vehicles could obscure a robbery, a fight, an illegal transaction, a rape,

or even murder. There was an element of secrecy and intrigue, and a feeling that someone was always watching your every move.

As the sun rose over the Brooklyn Bridge, I came face to face with a group of grizzled-looking men smoking cigarettes while standing next to their hand trucks. Looking like a pride of lions, they huddled around flames rising from large oil cans.

Still feeling triumphant from my victory in the Paris Bar, I started to take pictures. At that moment a chunk of ice about the size of a baseball hit my face. Since the busy street was filled with men at work, it was impossible to identify who had thrown it. The impact was like suffering a rock-hard boxer's punch. It also served as a big dose of reality. Photographing on South Street was not going to be so easy.

I changed my plan yet again. I would take pictures in the late morning hours, after most of the workers had gone home for the day.

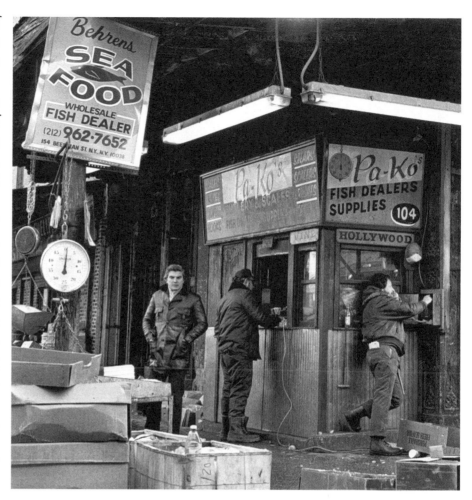

Dirty Ernie's was about to go out of business. This favorite all-night eatery was located a few steps from the corner of Beekman and South Street and had serviced the waterfront crowd for decades. The day it closed, I photographed Ernie locking up his restaurant for the last time. Packing up my photo gear, I almost bumped into another fishmonger on the corner of HOLLYWOOD AND VINE. He wore red suspenders that held up his dark green work pants. A grappling hook was swung over his shoulder.

With a dark Sicilian stare he asked, "What're ya doin'?" Since the ice incident, I'd harbored enormous anger and frustration, but I tried to rein in my emotions and answer politely. His interest was sparked, and he asked a few questions about my work. Then he gestured, inviting me to walk a few steps toward his fillet house. The metal roll-up gate was wide open.

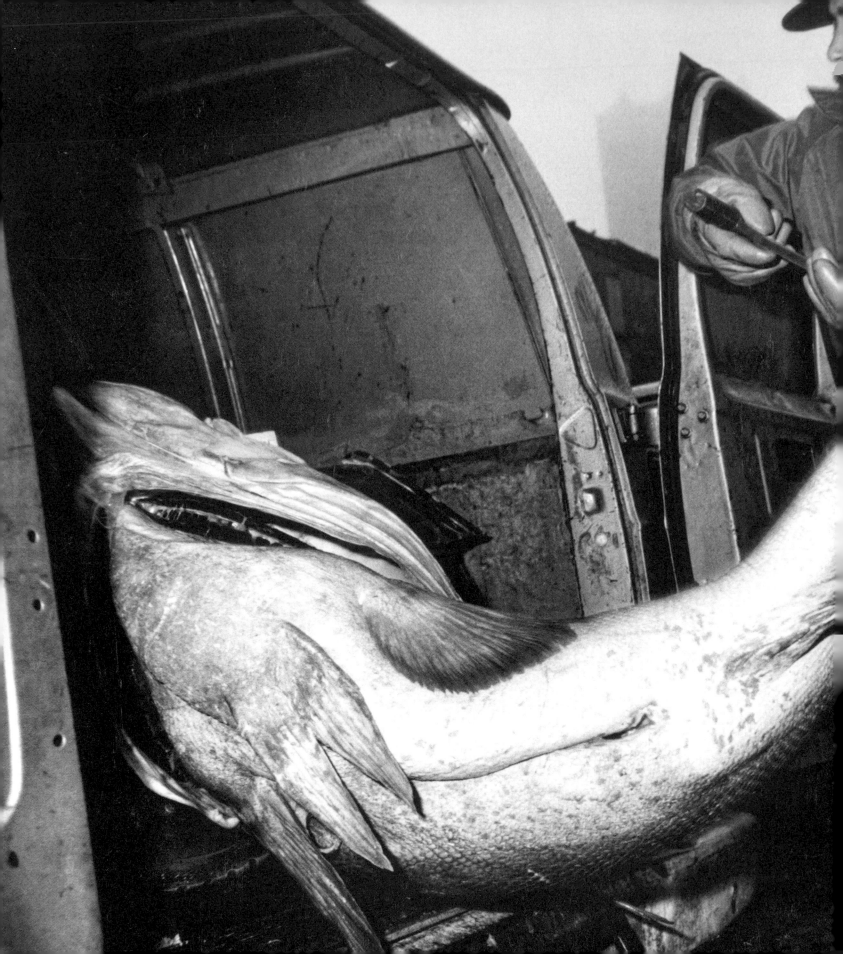

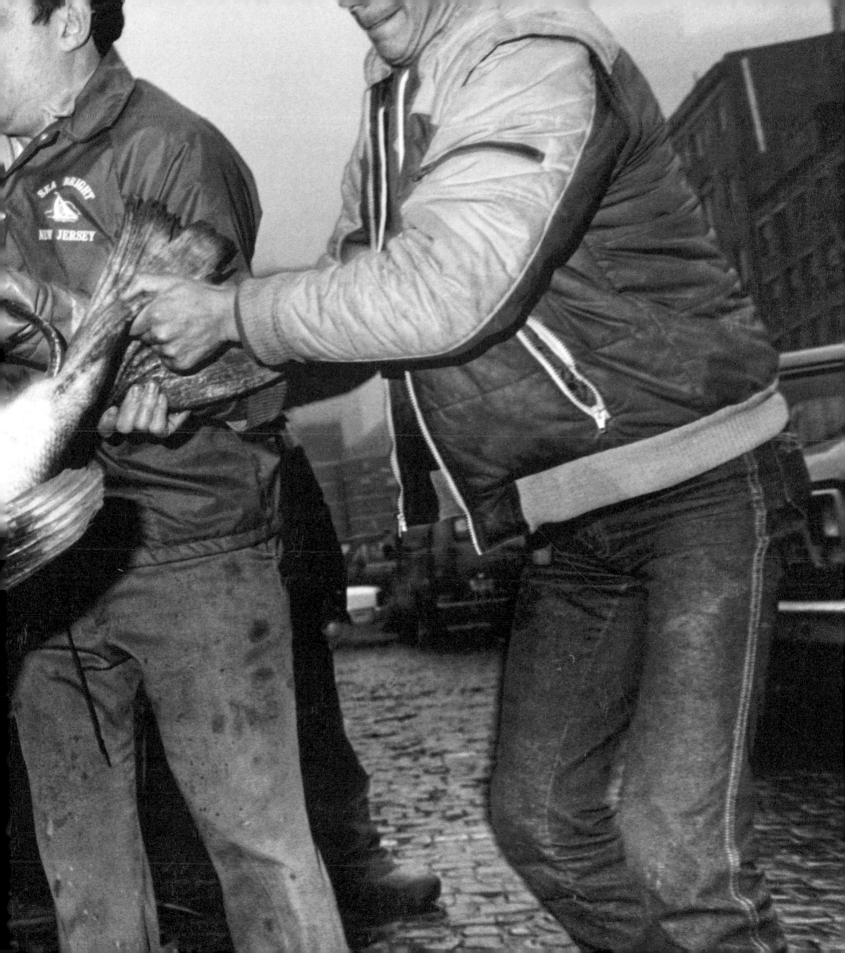

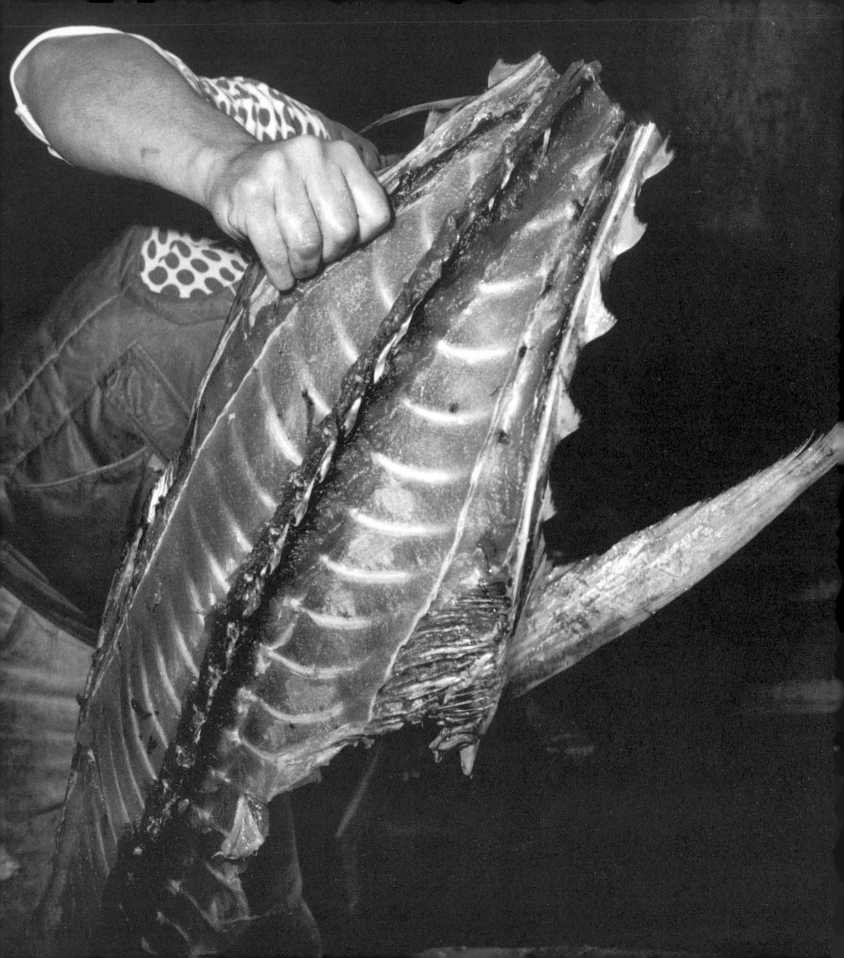

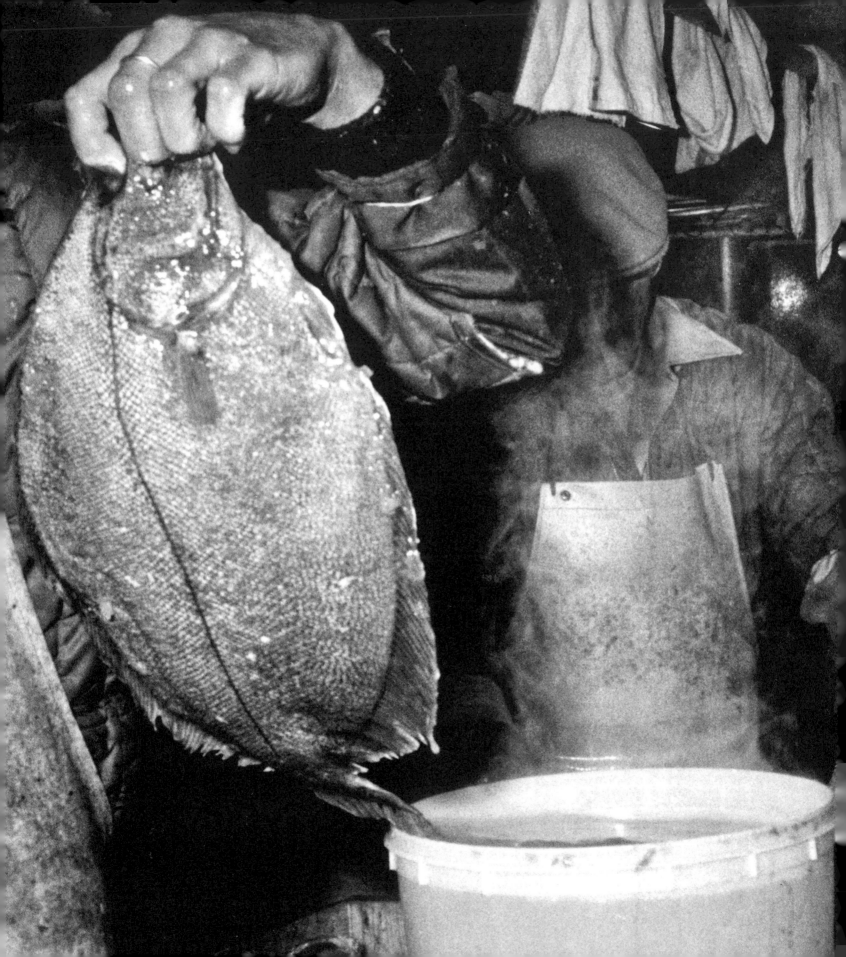

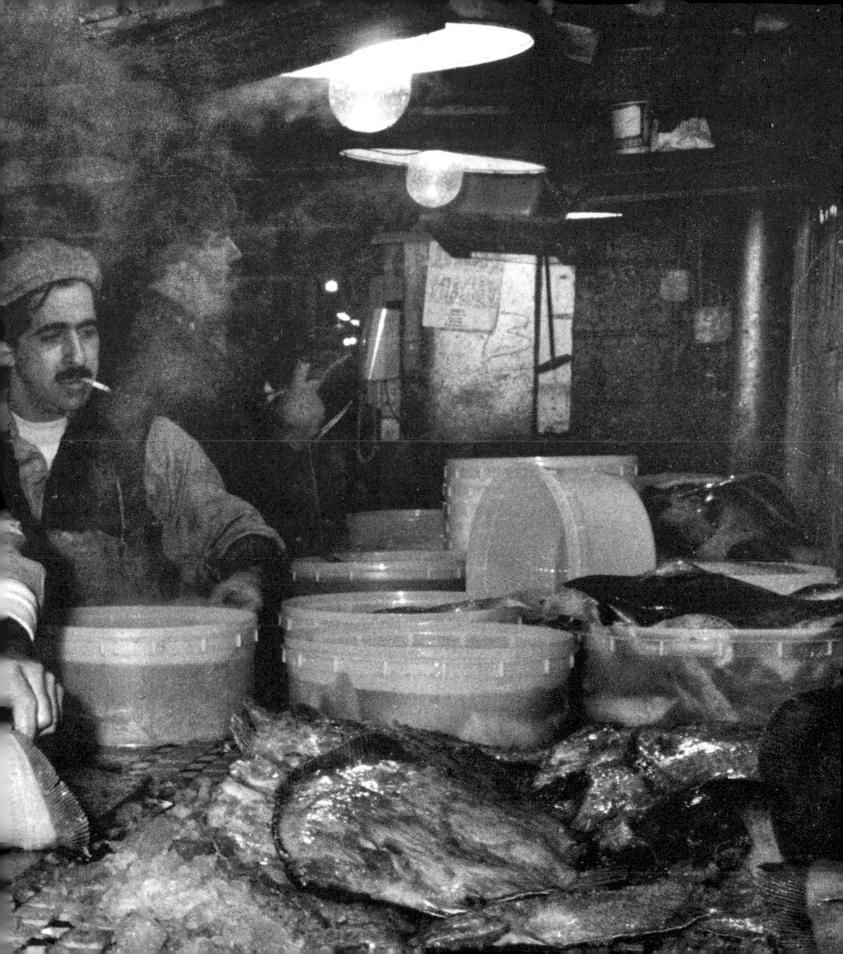

Inside "the cavern," workers were standing in rows of seven or eight at long tables, cutting fish. Using incredibly sharp knives, most with cigarettes between their lips, the young men were meticulously filleting.

Late spring was a traditional time of year, the owner proudly explained, for fishmongers to offer boned shad to their customers. The fillet men would separate the precious shad roe from the rest of the fish by hand. The roe, similar to caviar, was considered a delicacy. The more fish that were boned, the more roe could be gathered. He said that each of his workers was especially skilled at boning shad by hand.

The young fishmonger was no longer suspicious. With a twinkle in his eye and with great emotion, he was eager to share some of his knowledge of the market. He had little or no formal education, but he spoke with the confidence of a scholar of urban history.

My new friend said that for more than a century, men of English descent were doing business on the waterfront (which was reflected in the names of some of the oldest and largest fish businesses on South Street). At the turn of the twentieth century, Irish, Jews, and Italians, most from the "*mezzogiorno*" (southern Italy and Sicily), poured through Ellis Island and settled in the enclave below the Brooklyn Bridge.

This area was historically known as the Fourth Ward. (Wards were voting districts in Lower Manhattan set up by Tammany Hall in the nineteenth century.) Its old waterfront streets, including Cherry, Oliver, James, Madison, and Monroe, were in the shadow of the bridge. The new immigrants supplied the adjoining piers and the market with a new labor force. The men worked as longshoremen, fishmongers, and local fishermen, occupations they already knew from their homelands. Many of these poor immigrants fiercely preserved traditional values, including the importance of and respect for hard work, and passed on their spiritual and moral beliefs.

The young fishmonger went on to say that the immigrants who worked at the market in the early twentieth century lived in poverty and had little or no ability to assimilate quickly into American culture. They remained trapped, with no opportunity to move up the social and economic ladder. As a result, working at the market was "all they knew," and their notion of strong family bonds was expanded to include a larger meaning of the word "family." In fact, for

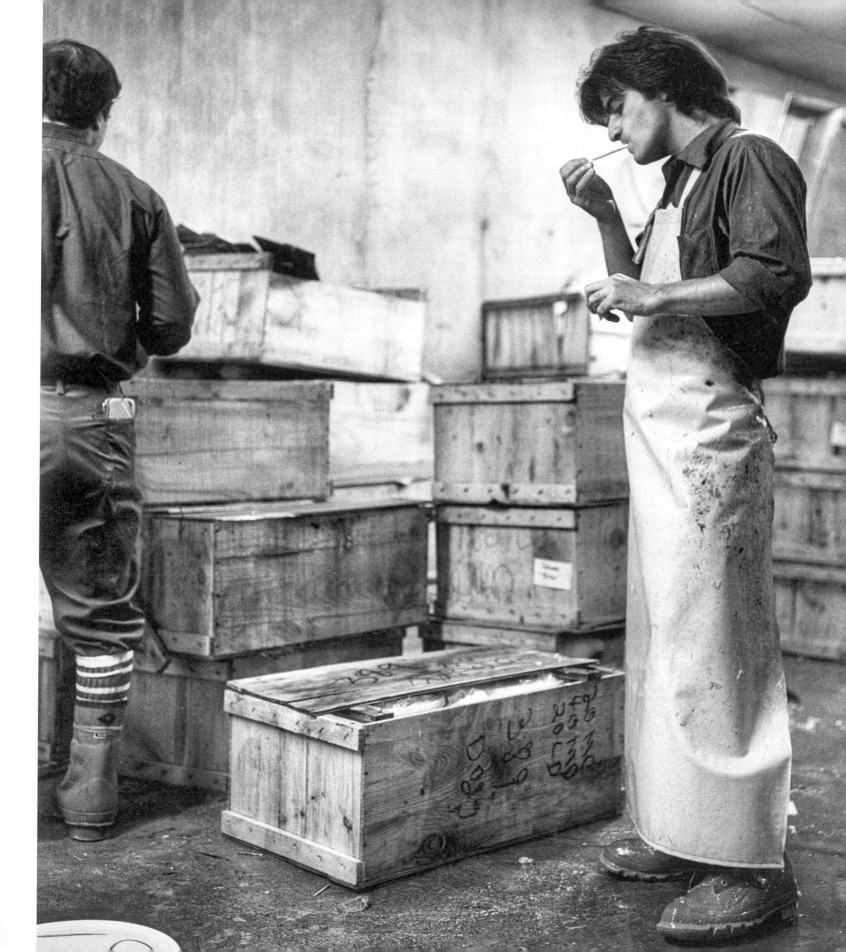

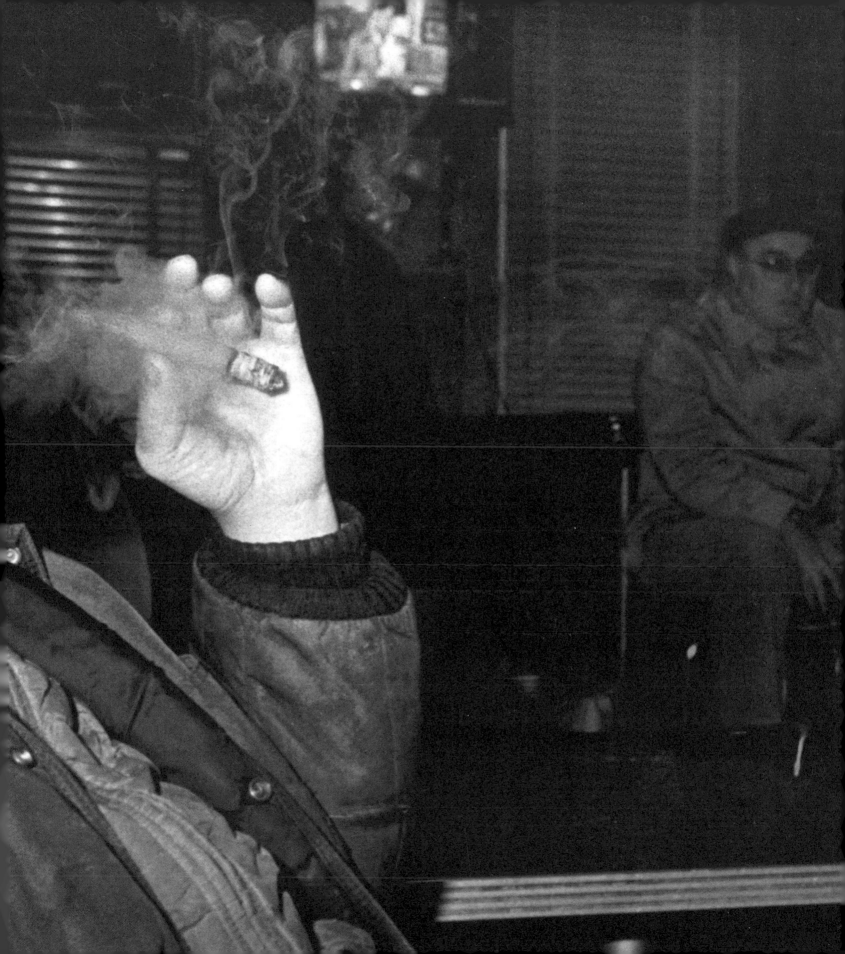

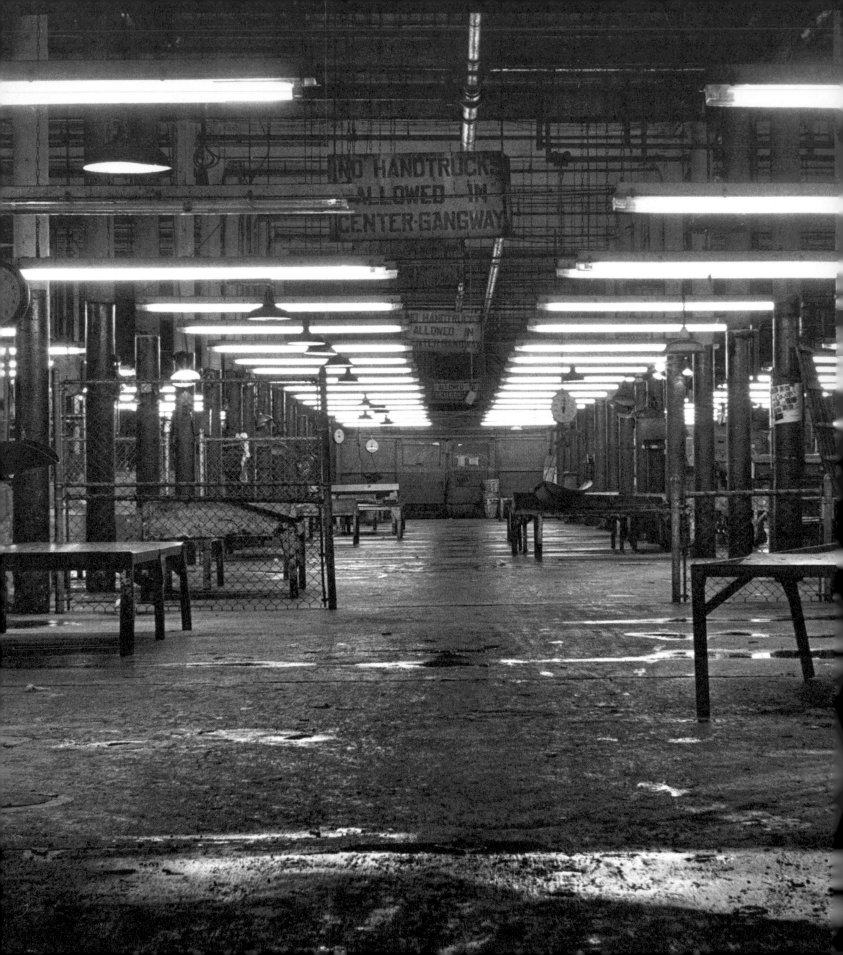

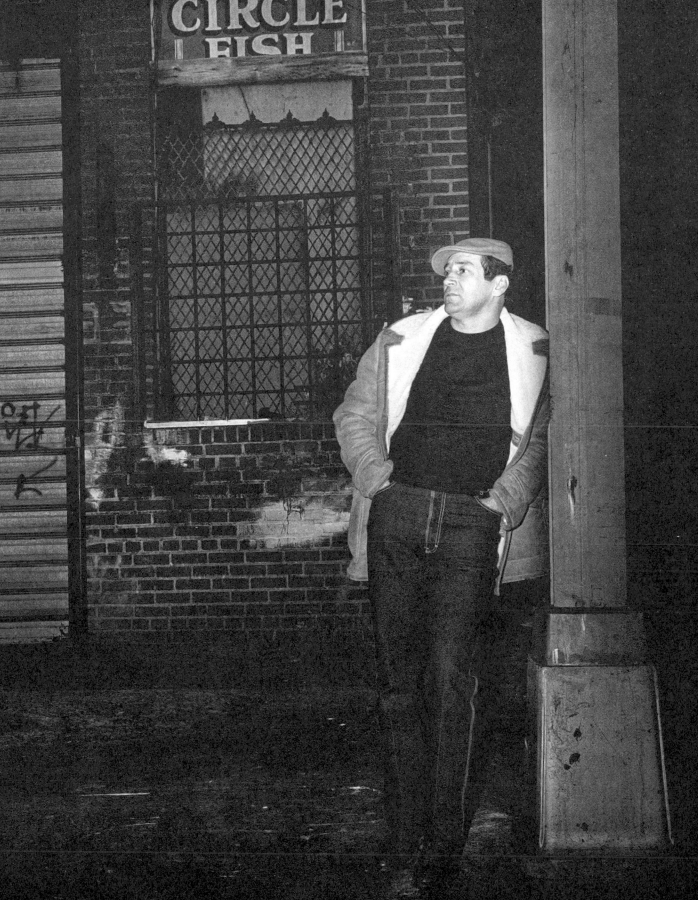

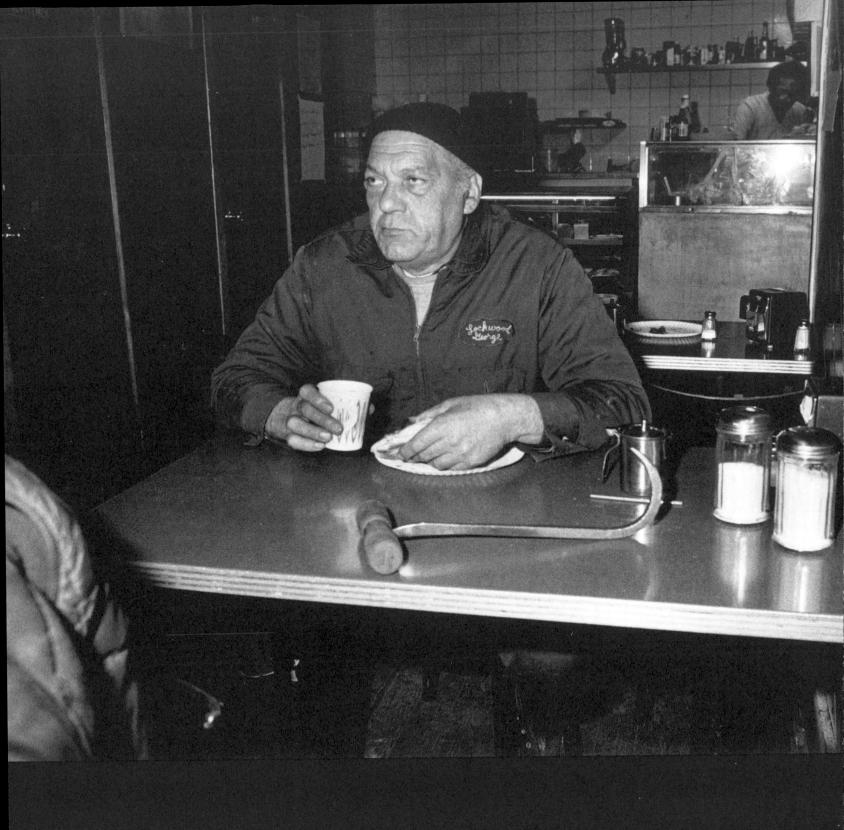

years it was not possible to get employment on South Street unless one had a blood family member already working there. In many instances, sons would replace their fathers at the same job.

My friend also reported that Sweets Restaurant, Sloppy Louie's, McCormack's Tavern, and the Square Rigger, all famous on the waterfront for decades, were about to close forever. He knew about the latest news concerning the development plan for the area. There was a series of meetings taking place, and in this time of crisis the fishmongers had banded together to protect their "turf." Ironically, their respected union leader, who was also the chairman of the Committee to Save the Fulton Fish Market I'd read about in the papers, had recently gone to jail! I grew very curious and decided to attend the next gathering.

On a hot summer morning, the meeting was held on a barge docked under the Brooklyn Bridge that was serving as temporary headquarters for the Rouse Corporation during the revitalization project. Although the corporate representatives allowed me to attend, they asked me not to take pictures.

Representatives of the Rouse Corporation and city officials, dressed in suits and starched white shirts, entered the conference room first. In a short while, the fishmongers entered, still wearing work overalls and boots damp with fish water, and with hooks resting on their shoulders. The officials presented maps, blueprints, and many pages filled with numbers, statistics, charts, and graphs. The representatives of the Rouse Corporation used words like "rezoning," "reconfiguring," "renovation," "restoration," "relocation," and "rejuvenation." Sitting at the other end of the shiny table, the fishmongers looked baffled, forlorn, uncomfortable, and angry. They were being outmaneuvered. The problem was clear: how could these disparate groups coexist on the same waterfront property now becoming more valuable than gold?

The conversation became heated as the issue of relocating parking areas vital to the market's operation was raised. A corporate official with a smirk on his face responded that "the move was only temporary." One of the fishmongers, directing an angry stare at one of the officials, snapped at him: "What guarantees can you give us . . . what guarantees?" The official kept dodging the question. All at once, the large, burly fishmonger stood up, threw his grappling

hook on the table, looked the representative straight in the eye, and said, "You come in here and make promises, but you don't honor your promises. In the fish market, our word is our bond. But you, you lie through your teeth."

Then he walked out, leaving his hook on the table.

A fishmonger who had stopped attending such meetings said to me later on:

> I don't have four hours to sit with these assholes and listen to the same bullshit, and hear them change. That's irresponsible on my part because why does Eddie from Wallace Keany and Lynch or Vinny from Carter have to be there all the time? I respect them both. They're really there 'cause they're protecting something. They are protecting themselves against these [corporate] guys that come in with the fuckin' Ipana smiles and the ninety-nine-dollar suits they bought from the guy on the corner who told them they were Italian, but they came from Taiwan but they think they look good. . . . At least these people from the market believe in something. . . . Right or wrong, they believe in something.

Since I was a local resident, I would notice some of the workers lingering in the off hours of the market's operation. Like clockwork, every day at approximately 2 a.m., the handsome man who had observed me as I went to photograph the fishing boat appeared around the corner from where I lived. His official title, as he told me later, was "Watchman." What was he watching, and who was paying him? These were questions I kept to myself. The man was an enigma.

One night, I went down to visit him. The watchman leaning against his street lamp on the deserted corner nodded in my direction, seeming very aware of my presence. I felt a rush of confidence and took his picture. Eventually, my friend invited me upstairs to a place called The Club. There were no signs displayed to advertise the new establishment. The need for another all-night bar and eatery had become crucial after the closing of the Paris and Dirty Ernie's.

Smaller and much more makeshift, The Club could not possibly capture the classic old-time feeling of the Paris. However, cigar and cigarette smoke still wafted through the air as men gambled

at high-stakes card games, drank at the bar, or ate sandwiches and hot soup.

The watchman was also a cook. He prepared simple menus of hot meatball hero sandwiches and cooked sausage and peppers. While he was at The Club, I could go up there. I could ask questions. I could take some pictures. I could even take home a meatball sandwich.

"Where were you born?" I asked Bootsy, another old-timer, one night.

He responded: "Hamilton Street. It's not there no more. They built ova that . . . they got rid of that street."

Then I asked, "What year were you born?"

He responded, "1913."

My friend, the watchman, would encourage him to keep talking. "She's not gonna ask you nothin' except about the neighborhood, how it's changed and how you feel about it. . . . She wants to write a book."

Bootsy then responded, "I could write a book. If I ever wrote a book, I'd have to go to Honolulu. If I ever wrote somethin', I'm scared myself."

On many occasions, I watched a man sitting at the back table take enormous piles of money and divide them into stacks. He would number each bill separately, all the while conversing with me and sucking on a toothpick. After a few months, when we'd become familiar, he nicknamed me "Barbara Darling."

"Got any good pitchas today, Barbara Darling?"

When some of the men were in a good mood, we would engage in serious conversations about morality, good and evil, and definitions of criminality. Rocky the waiter would serve everyone a complimentary anisette.

"We have scruples too. We ain't creeps. These people risk their lives for that fish, we understand that, but they didn't mind us takin'. . . . You wanna know what they minded? The taxes weren't being paid on the money. Everything's gotta be taxed. Pretty soon, they're gonna be taxin' if ya wanna get laid, they'll wanna put toll booths on our wives' tunnels. Pay the entry fee, pay fa this, pay fa that. It's terrible."

"Our only crime down here is that we take a few fish outta a box, or a few mussels, or a few clams outta a bag. I'm not talkin' about

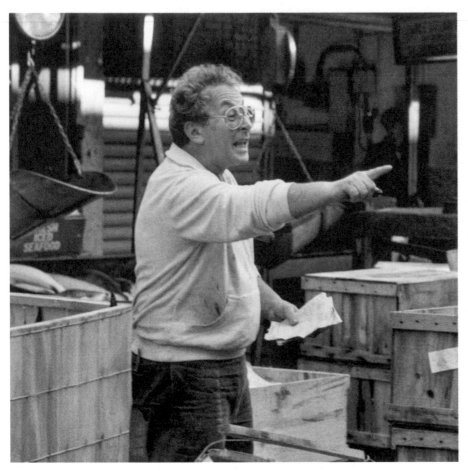

rippin' off a woman walkin' down the street and draggin' her into an alleyway, beatin' her, takin' her money, and rapin' her, or beatin' up a priest. I'm not talkin' about that. That's crime. We're talkin' about make the box a little lighter. All right, it was 128 pounds, now it's 123. We wind up with the other 5 pounds. Why should they have it? We're the ones out there sweatin' and sufferin' for it. We're the ones that take it off the boats, off the trailers. We're entitled to that extra weight, I feel."

"We have to make our expense money for the day, besides our salaries."

"Why rob a poor guy that's got to feed his family? Rob a big corporation. They can swallow it."

For a long time, every step I took on the street was met with questions, suspicion, fear, and hostility. I learned to be patient, particularly when it came to making pictures. There was another aspect to the challenge: South Street was a place of work. During the long night hours, every inch of the street was taken up by boxes and cartons and men prying them open or nailing them shut with axes or the tips of grappling hooks. Hand trucks whizzed by, and men standing around discussing business had to jump out of their way. Everyone moved quickly: each minute of the long working hours was worth money. I was very mindful of that and tried to be quick too. Ultimately, I needed a total of four years to document the market.

On South Street, the word "protection" meant many things. For me, it was someone who would offer me access. I could get in and take pictures, if only for a few moments. To have some of the fishmongers allow me to stand in their midst sent a message to the other members of the community that this person was okay. I hoped that the men were impressed with my ability to deal with them one on one.

So I had to prove myself. As a result, the nature of my work became something of an open book. I had to constantly show people what I was doing and explain why. I would read to the men some of the "conversations" I was scribbling in my notebook. They would remark, "Oh, that's the truth," or "Ya can't write that," or "Hey, it's not nice what you're writin'." Sometimes the men would borrow the pictures and/or the written material. Weeks later, the work would be returned and on occasion, by someone I did not know.

When I brought my pictures down to the market, I gave copies to the workers. Approximately 600 men worked there, not including the customers. Crowds would gather around when I took the 8 × 10s from my envelope. With hooks on their shoulders, cigarettes dangling from their lips, eating hot dogs and sipping Cokes on their early morning lunch hour, they would point with great elation to the photographs and identify friends or other members of the community—"Hey, look at so-and-so," "Geez, where's my pitcha?"—or offer comments like, "If we work like horses, we might as well look like 'em."

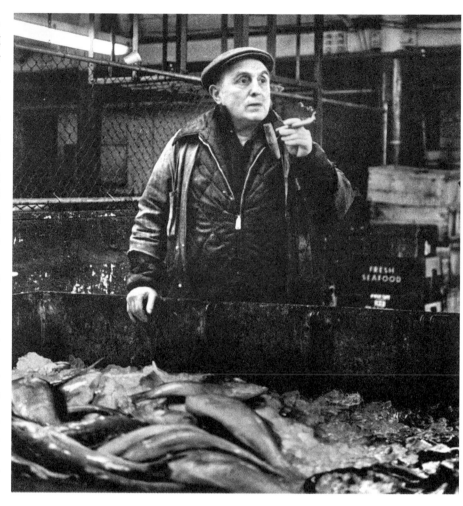

Over time, as some workers and their bosses came to know me, I was able to move around a little more freely. However, the prominent fish businesses in the market located in the old Tin Building, on the west side of South Street, were still off limits. They were too big and too busy to bother with me. By instinct, I stayed away in the beginning months and didn't explore their side of the market too much.

One morning very early, the owner of one of those companies approached me. He had a pained expression on his face and in a barely audible voice asked, "Do you have any pictures of my son?" His eyes

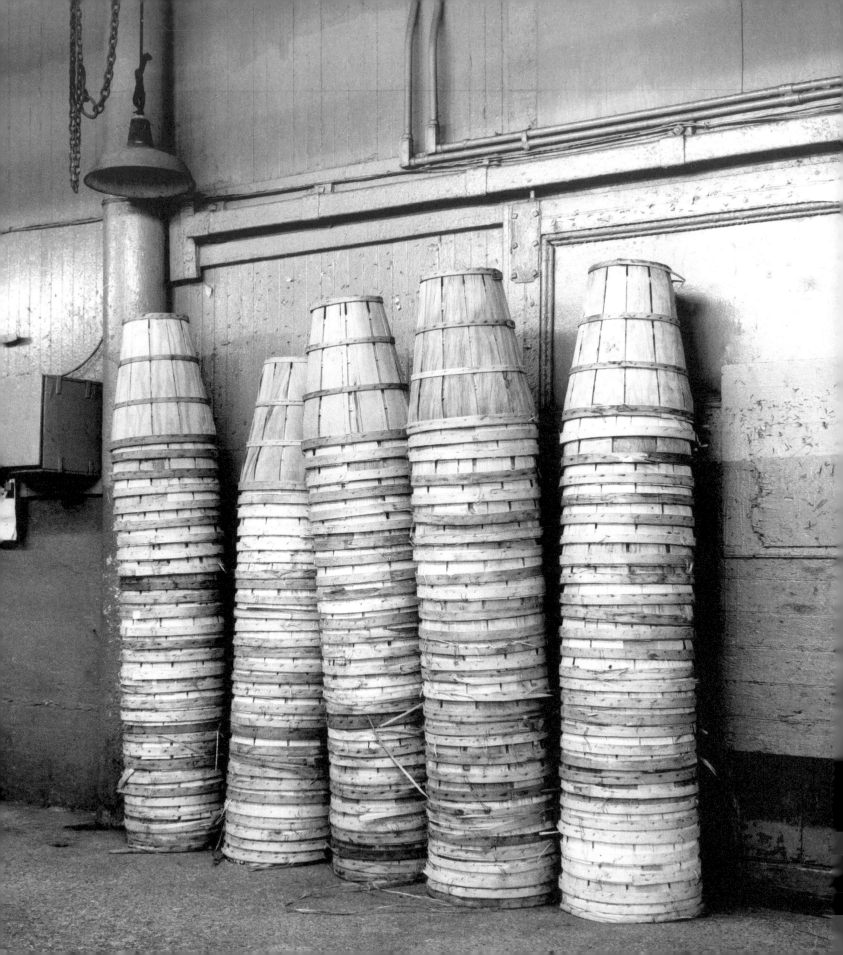

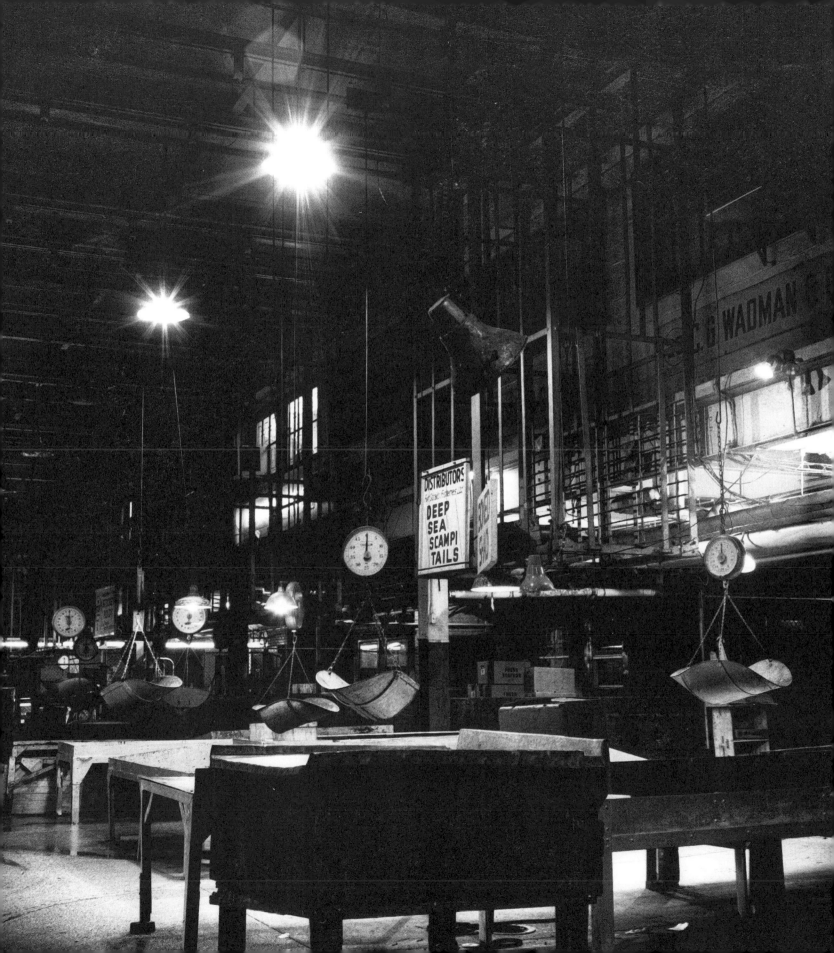

were tearful. I responded, "I'm not sure, uh . . . no, I'm sorry, I don't think so." Later that day, I learned his son had died in a car crash. After leaving his job at the market, the young man fell asleep at the wheel. The vehicle hit an embankment and veered off the highway; he died instantly.

I thought about the market's hours of operation and the impact such a schedule had on the many men who worked there. Wasn't working at night a readjustment, a biological upheaval? How did it affect people's health, lifestyle, relationships with others, and general psychological well-being?

One night, I went to bring an old-timer his portrait. He was not at his usual stand, so I began wandering through the open stalls of the nineteenth-century Tin Building, looking for him. One of the journeymen (by now, I knew the names and job descriptions of many workers) stopped pushing his hand truck, leaned close, and whispered in my ear, "—— was killed over the weekend. What ya gonna do? There's reasons fa everything, ya know." Then he grabbed his hand truck and walked away.

My blood ran cold. That was the first time I experienced a strange disappearance on the street. Just a few days before, I'd jotted down some of the old man's words in my notebook. He'd spoken about the duplicitous nature of human beings. "There's a difference between being honorable and being honest," he told me. "Being honorable means you can trust me. But there's a weakness in honesty. A person can break down, and one day the devil will be behind you."

No one on the street seemed that upset by the news.

During this time, another sinister incident occurred. I encountered my English neighbor, appearing quite shaken up, as he walked toward home one afternoon. A body had surfaced, floating in the East River near where he was working on the pier.

I also read accounts surrounding the attempted murder of a worker at the market: "[Two men] were arrested last month immediately following the attempted murder of Anthony D'Andrilli. . . . D'Andrilli was walking to work at about midnight when the two hit men stopped him outside union headquarters and shot him four times in the chest, side and face. D'Andrilli tried to crawl into Carmine's Bar & Grill but one of the gunmen put his weapon to D'Andrilli's head and fired again. . . ."

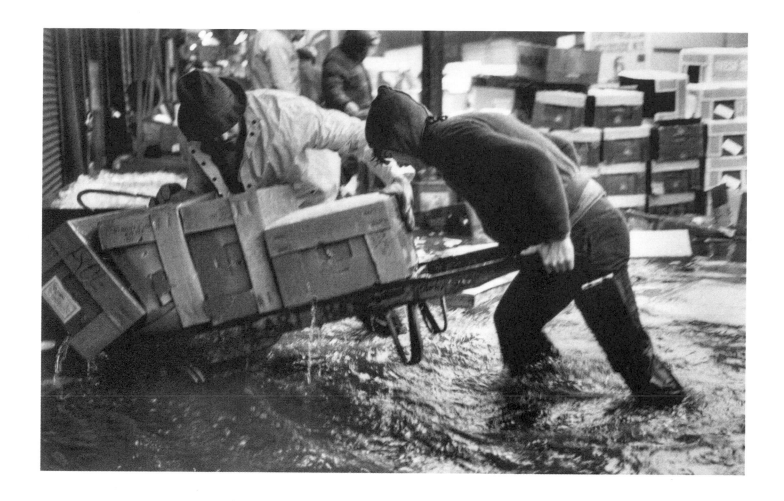

Many times, members of this all-male community, fearful of being seen on the street engaging in serious conversation with me, perhaps fearful of repercussions, would meet me outside the market to share their life experiences. In some instances, I would visit an individual at home.

I learned that one of the men had some "family" connections. He worked under the viaduct, overseeing the retailers' vans parked in that area. He was very moody, and very loud. One morning, we went away from South Street, to a locker room on the upper floor of Carmine's Bar, one of the infamous waterfront haunts, to talk in private.

"How long does your family go back in the market?" I asked.

"Would you believe since about 1920?" he responded.

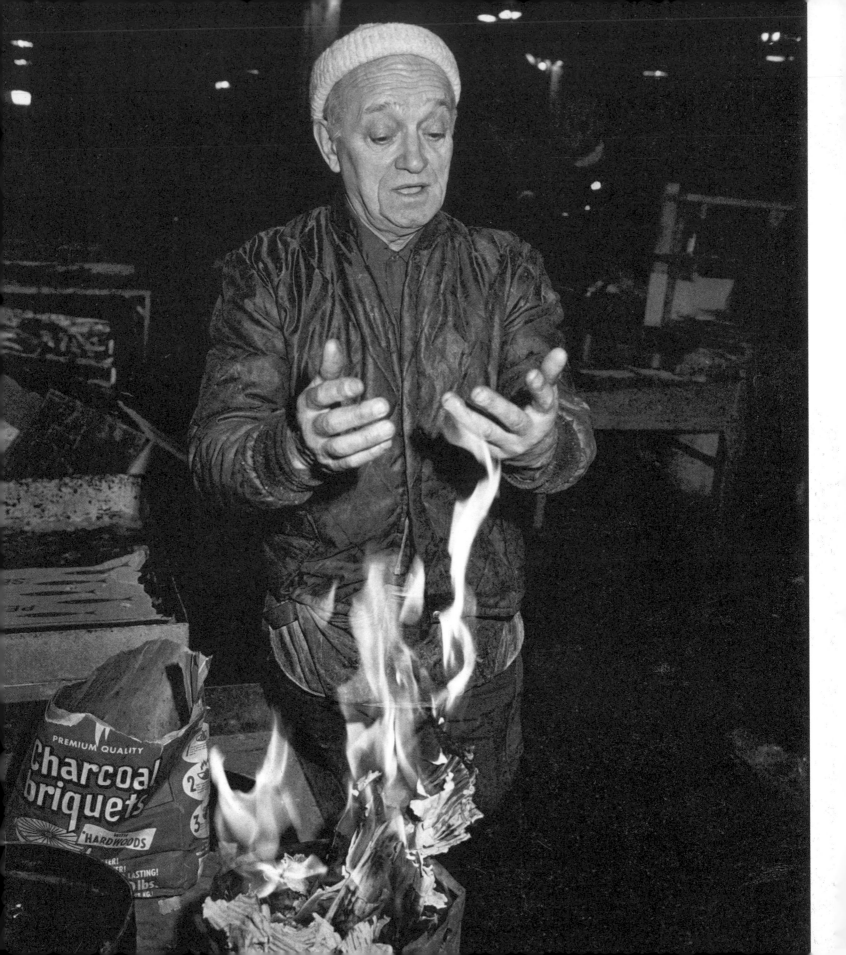

"Okay." I went on to the next question: "Who in your family worked here?"

Again he responded enthusiastically: "My mother's brothers."

"Their names?" I asked.

Then his expression became more serious. In a softer voice, he said, "Joseph 'Socks' Lanza and Harry. . . ."

I jotted down his answers. "What does 'Socks' mean?" I curiously asked.

He replied, "It was a nickname Lucky Luciano gave him."

We talked and talked about his uncle. "Uncle Joe worked for Lucky, he was a captain. . . . It's a position in the mob. He was a captain like in the army. He started to organize the men in the Fulton Fish Market."

By the end of the conversation I felt very uneasy. Unfortunately, my friend must have shared too much information, because soon after this he was thrown out of the market, forbidden to make an income on the street ever again. In hindsight, his situation may have always been tenuous. I heard rumors that this person suffered from drug and alcohol abuse, which could not be tolerated in this serious work environment. Maybe our interview at Carmine's was simply "the straw that broke the camel's back."

During the early 1980s, for the first time in many years, natural disasters such as flash floods and fierce rainstorms descended on South Street. The turbulent East River flooded its banks and destroyed the sheds, stalls, and storefronts of the market. Crates of fish were floating everywhere. Men stood waist high in water, trying to salvage whatever was left of their precious inventory.

Many nights, the bitter cold winds blowing off the river made the temperature dip below zero. In that severe cold, work in the fish market was grim and difficult. As one boss said, this market was serious business. The harsh reality of these men's lives became more vivid to me.

"Ya stand on that pier all night, out there all night, it gets cold, you're soakin' wet. in the wind an' rain . . . your pants are frozen around ya from standin' in one spot. How many days me, Buck, and Chubby would be out there. Whooh!"

"Sugar barrels weighed 250 pounds, loaded down with ice. I can't believe we had to load them things on the backs of the flatbed

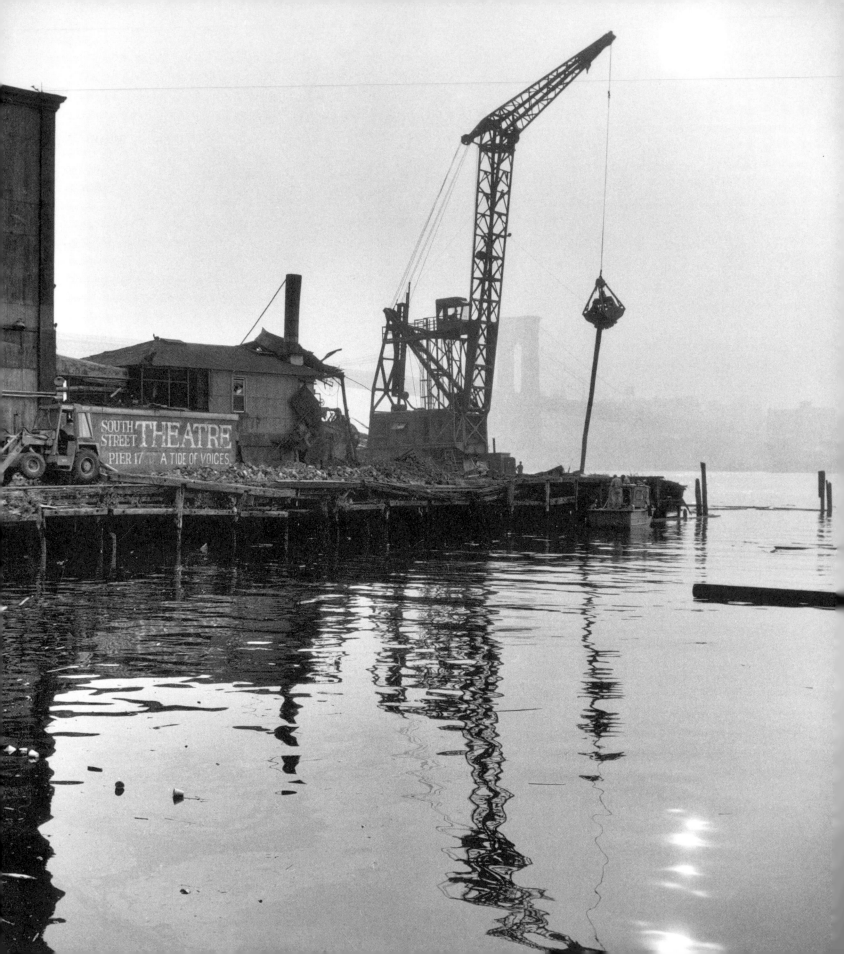

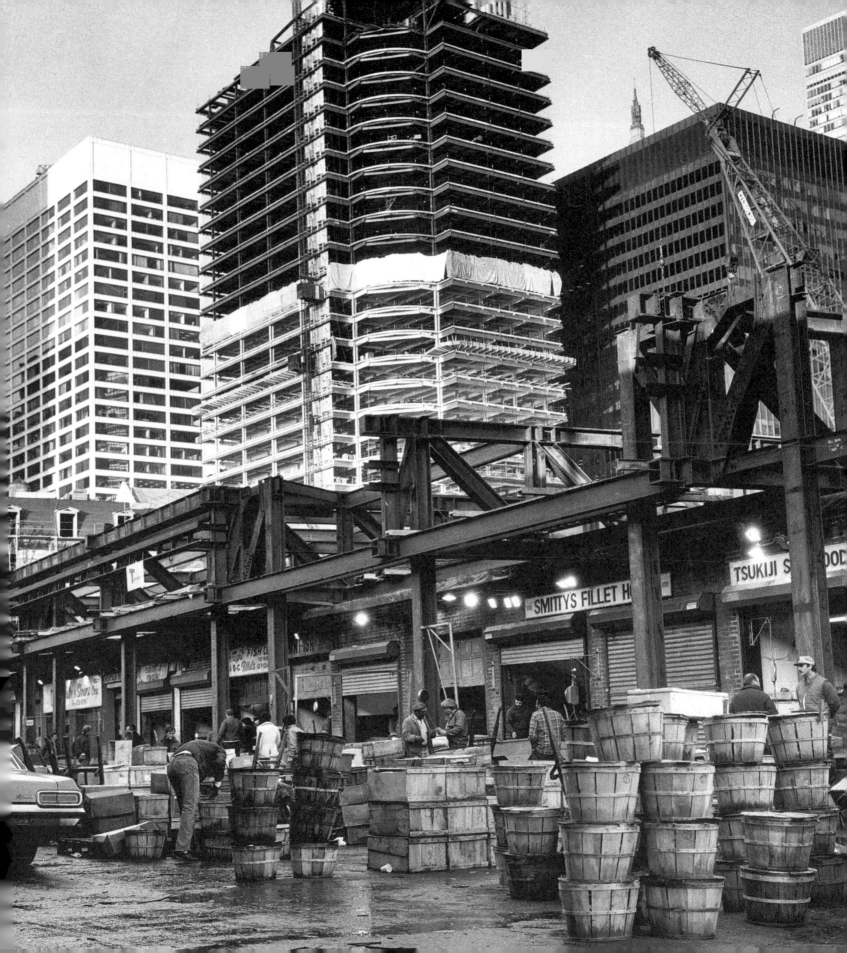

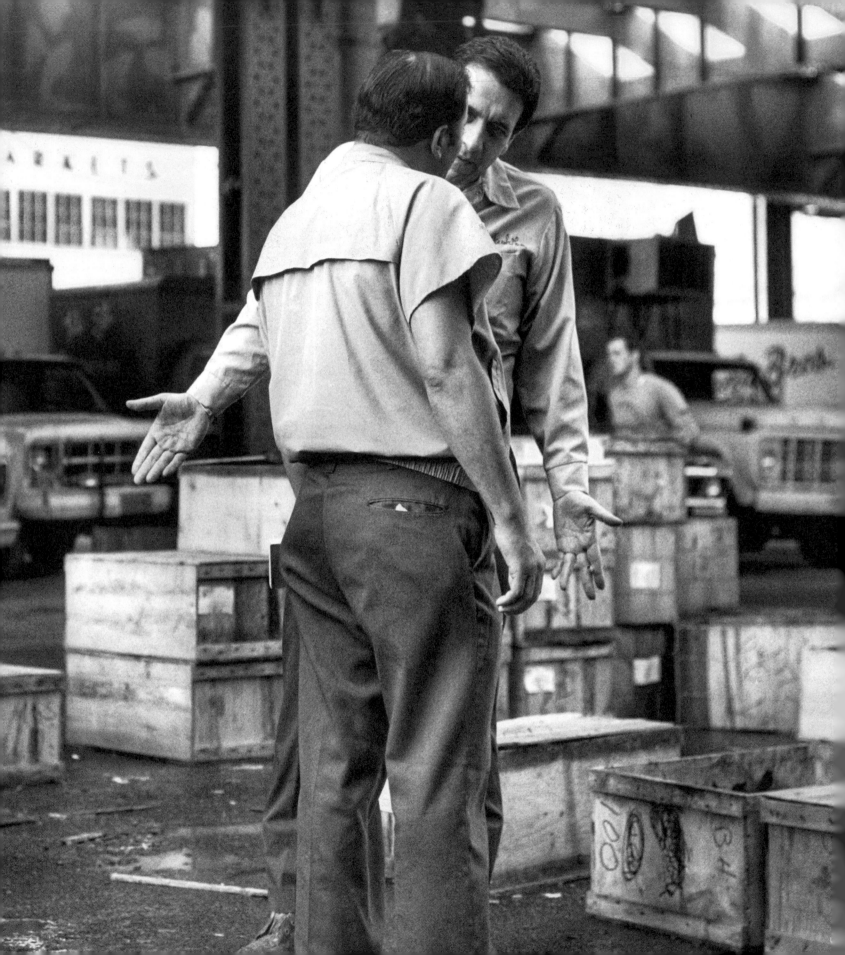

trucks. . . . Ya had to be like a fighter in the ring, when he throws them punches. Ya had to have that snap in your arms."

"I kept tryin', I kept pushin', I never let it get to me. You know— gettin' up at two o'clock in the morning, the cold and the damp, and the water and the conditions of the whole job, which in a word was lousy."

"My uncle's leg was destroyed from the friggin' arthritis. The dampness gets all through you and your body. I got it [arthritis] and I'm only twenty-two years old."

I came to understand the unique camaraderie, and the strong ties that bind people together under extreme circumstances.

"If somebody is in trouble, or he gets hurt—if he's loadin' a hand truck and his back hurts, you get another guy and you help. You don't turn around on him."

I met Mikey about fourteen years ago. He was a great guy. We became very, very good friends. We worked together in snow-storms, rainstorms, and in ninety-degree weather. We sweated it out together. One thing about Mikey, he always gave you a fair shake. After that he retired. As a gift outta friendship, I got Mikey's hook. I've had this hook for seven years and I won't part with it. He said, "Don't lose it." It had a lot of sentimental value. One time somebody stole the hook. Somebody stole Mikey's hook. Well, maybe he "borrowed" it. They painted it, and a month later I found it. When I picked it up, I just knew from the feel that it was Mikey's hook. I never let it out of my sight again.

"It's somethin' I can't explain. . . . I grew up with the old-fashioned ideas. Today, they don't have old-fashioned ideas, like loyalty to friends . . . friends that ya did things with. . . . Ya had just as much on them as they had on you. Loyalty there, a bond there."

Very, very slowly, I was convincing this community of weather-weary men of my commitment to record their working life. Even federal agents stayed away from South Street in storms and sub-freezing temperatures! But I had been there during the floods, and that seemed to make a difference.

"Trust, that's the whole thing."

As the construction of the Seaport mall progressed, the market continued to shrink in size, with the very small businesses suffering the most. There was a general gloom and doom taking hold on South Street.

"A lot of people aren't sensitive to what is going on. We needed a million dollars to fix up the piers and to keep the fishing vessels coming into New York Harbor. The city allowed the docks to deteriorate. At one time we had four piers, and now we're down to none. Today it's a dog-eat-dog situation . . . we're goin' further and further down the hole."

"At one time there were 187 fish houses, now there are about 100. They're takin' the whole heart outta this market."

"'Deter-or-or-atin'—is that the word?"

One morning, standing in front of my friend's fillet house, I struck up a conversation with the stand man for the fish company next door. The man's skin was like leather and was severely wrinkled from working outside. His dark, piercing eyes were set in deep sockets, suggesting many years of sleepless nights. He smoked constantly.

I began, "How long have you worked in the market?"

"Forty-three years," he replied.

"How did you get started?" I asked.

"I didn't want to go to school," he answered.

"Where did you grow up?"

He replied, "Yeah, on Cherry Street."

Suddenly, a dark-haired man with a towering physical presence, somewhere in his forties, stepped into the conversation. He was wearing a company work shirt with a name embroidered over the pocket. "Do you want his *real* story?" he interjected. "You see, it works this way," he said, gesturing to the man I was talking to. "He's a hoodlum by chance. And he—" he went on, pointing to a man unloading crates in the shadow of a tractor-trailer, "he's a hoodlum by choice. There's a difference."

"Oh yeah? What's the difference?" I asked.

"A hoodlum by chance," he explained, "is someone who's born poor. If you come from a family that's poor, sometimes you're

forced to steal. But a hoodlum by choice is somebody who doesn't have to steal to support anybody."

In between the stacks of wooden crates and open boxes of fish, customers often stopped to converse with this imposing figure. By looking people straight in the eyes as he spoke, making demonstrative gestures, and pointing his fingers, the man who confronted me seemed to overpower and intimidate others. My gut feeling was that he was the boss. That was later confirmed.

The crew was comprised of brothers, sons, cousins, and nephews. One time, one of the cousins who appeared sympathetic and interested in my work opened up. Like a sponge, I absorbed his story.

My father worked down here years ago, unloading. He was the son of a Sicilian immigrant. I never knew my grandfather; he died before I was born. I think he came here and worked as a longshoreman. My father was part of a breed of men that didn't fear life. He was his own man. He believed that providing for yourself and your family was the most important. When he was growing up, my father had some very, very close friends. . . . Back then they did all types of things to survive. In those days people were very well bonded, it's not like today where ya have all types of rats. Anyway, they grew up to be wise guys, ya know . . . big shots. . . . I was a kid when he was murdered. He got shot tryin' to protect his friends. He was a very brave man in my eyes. I grew up believing that about him. After he died, things got very rough. So I learned to take what I needed for my family. I thought to myself, what was good for my father should be good for me. I started rippin' off stores in my neighborhood when I was about ten, eleven years old. I remember one time we were havin' a surprise party for my mother and I ran out an' ripped off a store and brought back party hats. I never wanted to hurt nobody by it. I just kept doin' it as I grew up. I was arrested about ten times.

The real tough guys, I think, were from the older generation. You knew exactly where they were comin' from. They treated you differently. They treated you like a man. In other words, it's not how much ya got, how much money ya got in your pockets, but it was what ya got. *If you could be trusted, if*

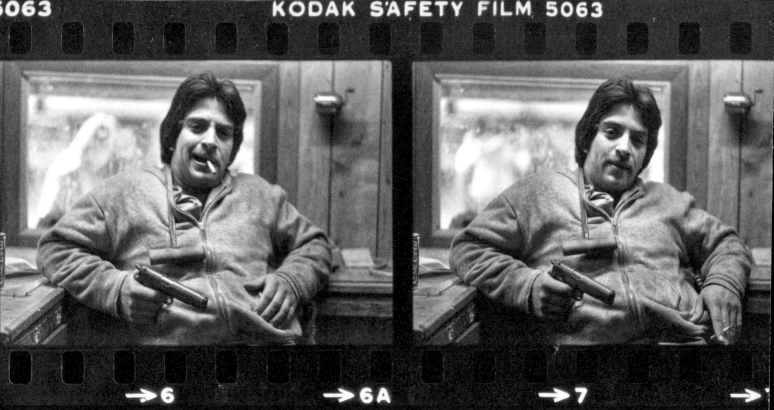

KODAK SAFETY FILM 5063

→ 6 → 6A → 7 →

your word meant something. If you could deliver, make good on your word. In the older generation, there was a lot more individuality, they were more like my father.

Other family members who worked intermittently for the business had also been back and forth from prison. They carried guns, and I attempted to keep a healthy distance from these "visiting" cousins. Nevertheless, we would cross paths quite often, as by now, I was storing my photography equipment in the company's upstairs office.

There were many nights when this crew tolerated my presence. While doing business on the street they demonstrated "playful" behavior, often shouting racial slurs at one of their crew members, as my acquaintance described:

Once in a blue moon when Ira gets drunk and loud, we beat him up. He gets very annoying. He just gets drunk and loud. One day, we said to him, "Shut up, or we'll nail you into a box." He kept on keeping it up, so we nailed him into a box. Ira is a drunk. A drunk gets no respect. He's like the court jester and he really gets annoying. I remember during the wintertime Ira went up to the locker room, put on bits and pieces of everybody's clothing—B.J.'s coat, T's long johns. When the other guys finally came to work, there was Ira the bum wearing everybody's clothing. They followed him back upstairs and made him take everything off, and they tied his hands over his head, and then tied him to a pole in the middle of the floor and left him hanging there. Then they beat him with a pipe, not a real big pipe, a little pipe.

One time, I had a chance to talk quietly with this poor soul. He was black, very short, and very underweight, and usually walked around the market with a swollen eye—he was always getting beaten up. Most of the time he had alcohol on his breath. "It's a tragic, magic world," he said to me, "and I got the best of friends." He was referring to the crew members who had severely beaten him. One day, another worker who was eavesdropping on our conversation remarked, "What are you talkin' to a black bastard like this? He doesn't know if he's dead or alive."

Such was your place in the hierarchy on South Street if you were an African American. One man, however, was an exception to that rule. He was referred to as Mr. Miller. Mr. Miller was responsible for overseeing a group of parked customer vans and trucks—the loading zone—under the viaduct, although years before he had worked on the piers. He was the most silent individual I had ever met. But he didn't have to say anything; his countenance and hands told his story.

I pondered what this man had possibly seen and experienced in his lifetime, unloading the fishing boats that came to port. He would have worked among some of the toughest white men who were gainfully employed on the waterfront. It must have taken a lot of courage and guts to survive and later gain their respect. For three years I tried to photograph him, but for three years he refused. Until one day, after yet another request, he just relented. He dropped what he was doing. Still smoking his cigar, Mr. Miller swung his grappling hook over his shoulder and proudly stared at the camera.

Another day, at about 6 a.m., the sun cast its soft early morning light against the old counting houses, the stacks of wooden and cardboard crates, clam baskets, and street activity. The pile drivers and other sounds of construction had begun for the day. I was walking toward the stand where all the cousins and relatives worked, to retrieve some photo equipment and head home for the day.

Amid all the mayhem, there was a party going on. The crew was openly displaying affection, hugging, kissing, and embracing. All of a sudden, the boss appeared on the street, holding a sharp fillet knife in one hand and a whipped cream cake with lit candles in the other. He placed the celebratory cake on top of the fish crates. Then his son blew out the candles. Watching the big, tough men laughing and celebrating together, I was struck by their camaraderie, but even more by a sense that they felt comfortable with themselves.

Several in the group explained what kept them bonded together, as they ate birthday cake and wiped whipped cream from their faces with their shirtsleeves: "Trust, that's the whole thing . . . your word of honor means something. Either you can be trusted or you're scum."

Not long after the street party, I gained permission from my young fishmonger friend to climb up on the roof of his fillet house to shoot the ongoing demolition. This particular building looked

like a garage and housed several fish businesses. It stood on the site of the original Fulton Market building, erected two hundred years earlier. The Rouse Corporation, after failing to dislodge the business owners and build directly on the site, reached a "compromise" to build right over their heads!

When city officials offered the fishmongers new leases for this property, one of the owners told me,

The wholesalers turned around and said, "We're not stupid men, we're not going to stand in the way of what you want to call 'progress,' but just don't interfere with our business." The officials turned around and they're still trying to fuck us. They took a letter of intent, which was 12 pages long, and converted it. The only two books that are longer than this are *War and Peace* and *Gone with the Wind*. A 12-page letter of intent was converted into a 600-page lease. We had to pay our lawyers $125 an hour to read this bullshit. And then they [the government officials] turned around and changed everything they promised. So let's get back to the D.A. [Bookin]. Who's fuckin' immoral? He came in here, he was going to defend the world, and he blamed all the fishmongers for all of the crimes of the world, in New York and everywhere else. He represents the city and federal structure, and they turned around, they made their promise, and they broke it. If a guy in the market tells you he's gonna charge you a dollar ten, he charges you a dollar ten. They took a lease intent and they broke it. In the letter of intent it says we will give you a street permit to extend 30 feet and there will be no changes, as had been in the past. Now, the latest thing is they'll give me a lease for 20 years and the street for 5. After the street [lease] runs out in 5 years, what am I to do? "Bye bye Dolly Gray," I got nowhere to go. So then they turned around again and said, "All right, we'll give you more than 5 years but we want"—I don't remember the exact figure—"$1,000 for the street." Now all of a sudden, it becomes a separate rent issue. What happened to the letter of intent? Everyone turns around, looks at the market, turns their noses up in the air. Then they turn around and break a basic promise without flinching an eye. And that's the thing that really disturbs me. . . .

I used to think government officials were working for the people. But city people con you. They come in with their jackets and ties, they come in with their three-cent education and they talk nicely, and they're very good at smiling. And in the beginning I used to think: they're nice guys, they don't curse at you, I don't have to worry about getting into fights with them or anything like that. You stand there and talk to them, and then you realize there is nothing behind them and they don't care. That's the one thing that bothers me. Be a liar, be a thief, be a crook, be whatever you want, but at least be honest about who you are and what you are doing.

Roy's coffee truck was parked every night in a central location on South Street. Roy, who looked like the comedian Lou Costello, was always talkative and friendly. Late-night visits to the truck provided all the caffeine, hot dogs, and other fast foods one needed in order to keep awake at 4 a.m. The bosses, salesmen, retailers, and journeymen would swirl around Roy's like bees at a beehive, hastily giving their orders: "Roy, two fuckin' regulars, no sugar."

Hanging around the coffee truck, I had numerous opportunities to learn about the market. One night, two men were talking about the latest robbery. Roy smiled, turned toward me, and said, "People from the outside don't understand. If something gets stolen, you go to see these guys. You'll get it back. Everything is under control. It's better for everybody's business. Now, if you go to a cop or something and report something stolen, you'll *never* get it back. This is the fish market, we make our own laws. Down here, if you lie to somebody, if you cheat, you'll ruin your reputation. If you do it once too often, you're gonna catch a beatin', and worse, if you keep doin' it, you'll get thrown outta the market."

I never wanted to know the identity of the men who were then operating clandestinely on South Street. Those were the individuals who kept the market's crucial infrastructure glued together, who had the power to "settle the problems." They were also making very good incomes from the market. Their role in its daily operations was indisputable. The old-timers said cryptically, "The street is paved with gold; the smart ones know how to bend down and pick it up."

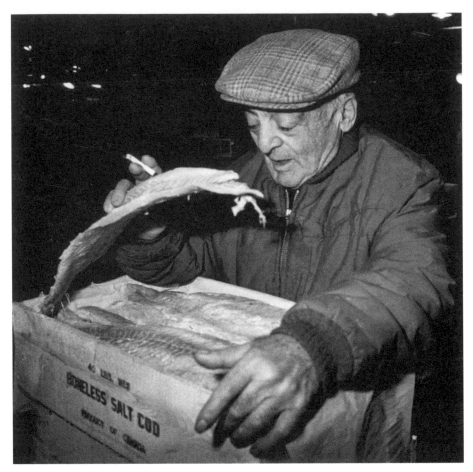

I observed how these men carried themselves, their body language and facial expressions. With a few little hints here and there, it was easy to imagine who they might be, at least the ones who were down there every day. But never, ever could anyone address them by their real names or reveal their identities. I thought it must be like the old days on the waterfront, when keeping your eyes and ears open and your mouth shut was the way to stay alive.

"Technically, I was told what to do in order to survive; I was told, you can do this, but you can't do that. In the market, nobody trusts you until they get to know you. They ask you indirect questions, they test you, and they see how you react. I learned quickly: you keep your mouth shut, and you build a reputation."

The "wise guy" philosophy, as explained to me, was that business in the market was done in a traditional way, and as long as the market was left alone to settle its own problems, nobody would starve and everybody would have work.

"One time, a guy came down here lookin' for information. He came over to me and asked if I knew this one guy and to point him out. I said, 'I'm only here a coupla months, I don't know who you're talkin' about.' Meantime, the guy he wanted was standin' right across the street."

During my time on the street there were several men who "went away" to prison. After they were released, they returned to their jobs. In the modern world, in general, if someone left their place of work, it would be filled immediately by someone else. In the market, the job was voluntarily left open for that person upon his return.

"I was away for only three months. I was fortunate. I was not convicted—there was no jury—on manslaughter. They call it 'copped out.'"

I was away for about four years. I had to stay in the old Tombs until I went to court. Then they sent me upstate. Being locked up was horrible. In those days, it was more "lock-in" and they would keep you in these little cells, and *no faggots*. I spend my time reading; they had them prison liberries. I read all the Joseph Conrad adventures. I used to love the books about sailing and the sea. I also read *A Tale of Two Cities,* and then that book came out, *Gone wit' the Wind.*

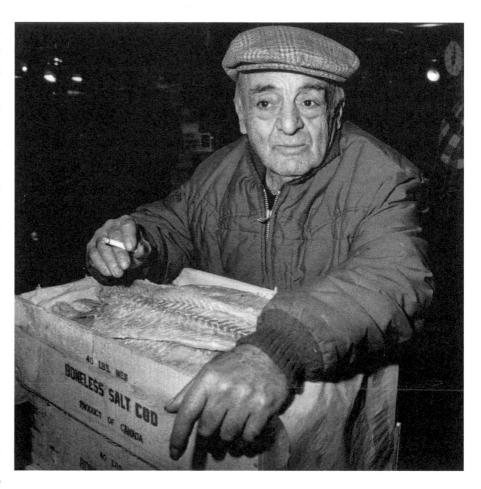

"It was really the only thing I knew. They say once you're in the fish market, you go away and come back. There's always someplace to come back to here. . . . It's a 'family' thing. Somebody's always here. You leave for five or six years, but there's somebody down here that has ties to you in some way."

"It's our way of life. It's something's that inbred in you. I've seen guys come here and leave, an' come back, an' leave, an' come back. . . ."

"No applications necessary."

One morning a fish dealer presented me with several giant flounders. I offered to pay, but the man would not accept money. In return he asked for photographs. This was my first experience with the barter system. In other instances, in return for pictures, I received frozen boxes of jumbo shrimp that seemed to have "fallen off the truck." I would simply say, "Thanks." These arrangements helped me to gain access to more areas where I could shoot.

At the time, my interest was mostly in the men at the market and their relationship to their physical work. The daily complexities of the fish business, factors involving supply and demand, pricing the different types and quality of seafood, and identifying the various species of fish fell outside my attention. There was one aspect, however, that sparked my curiosity. Many of the men doing business at

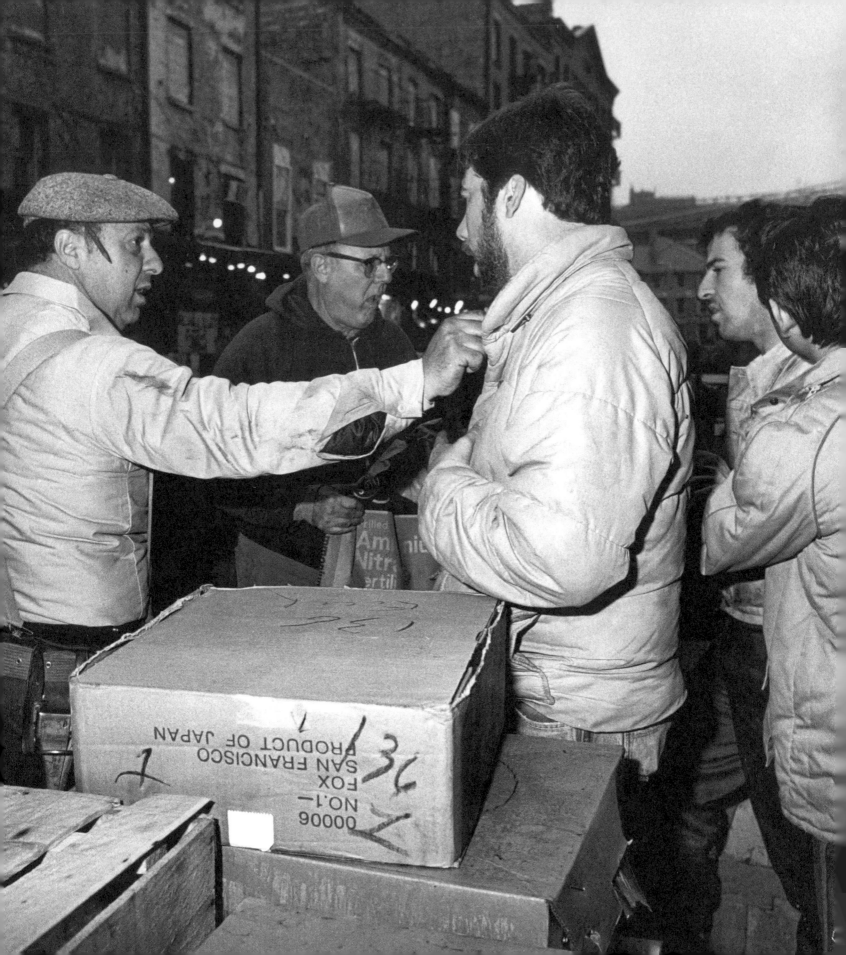

the myriad of companies on South Street were related to each other. An uncle, for example, could work at one company, his nephew at another.

"If the right guy dies, there will be no one around to run the market, because everybody is related, somehow. You got uncles, cousins, people related by intermarriage . . . godfathers . . . they'd all be at the funeral."

"There's nothing wrong with being a shrewd businessman. Competition is part of it. Whether or not the guy around the corner is my brother, you're all competing. You're all out there tryin' to get the same money. There's only a certain amount of money and we all want it. . . . That's why it is so competitive."

I observed the customers coming down to the market anywhere from 4:30 to 7 a.m. Their personalities were as varied as the kinds of seafood that they came to purchase. The buyers represented all aspects of the food business. They were retailers and restaurateurs from places as far away as Connecticut or as close by as Chinatown or the Essex Street Food Market.

There was also a hierarchy among the buyers. Restaurateurs or their agents, representing the finest eating establishments in the tri-state area, would visit the market every night, as would representatives of retail fish stores, big and small. I particularly enjoyed watching people known as "one-carton-a-week customers" going through a similar ritual. There was usually a particular kind of stock set aside for them—"carried" fish from the day before, or fish that was plentiful and cheap. Sometimes the box of fish that they bought was not necessarily the box of fish that they received.

The nightly buying and selling was like scenes from a theatrical play, with the fish as the props.

We all have our steady customers, they'll come to my stand first, but that kind of relationship comes after a long time. You have to get their trust. Once a guy is on your stand it's like he's married to you. That's money in the bank. Whenever this guy comes down, make sure you have what he wants. You don't want him walking around the market asking other people what they have or for how much. With steady customers, you have to take care of these people because they are your bread and butter. They come in every week and pay their bills. I've got guys,

they come up to me they don't even ask the price: "Just give me three cans of this, is it good today?" They don't even look at it. They trust me. Then, on the other hand, you got these guys, they come around, they shop. "How much are these?" "They're a dollar eighty." They'll look at it, they'll wreck a whole can of fillets, they'll stick their arms in there, or their elbow. "Oh, I'll think about it," they say. "Go think about it over there," I'll say. Then later on, he'll [the customer] come back. You have to put up with it. That's part of the game. You know that [the supply of] fish will tighten up one day, and then this guy can take a walk. That's when you'll really rape the guy. You'll put an extra half a buck on it. They start taking advantage sometimes when they know you need the sales . . . but it comes a certain time when you gotta decide, how badly do I need this sale? Then comes the time when you throw the guy off your stand.

Every night the customers and fishmongers argued over prices. Walking around the market, I would hear the words "respect," "disrespect," "you have my word," "you have my trust" uttered frequently.

"If I holler at a guy and call him all kinds of four-letter words, it doesn't matter, he'll be back again the next day to buy fish."

Business was transacted based on verbal agreements. The dispatchers wrote down orders by hand, and would add and subtract prices per pound and weights of fish without using a pocket calculator. The fishmongers also gave out credit. In fact, the whole industry, including buyers, fish dealers, and their shippers, revolved around the concept of credit. Lists of customers who'd failed to pay their weekly bills were displayed on the walls near some stands. The market was one of the most symbiotic places on earth.

"A handshake is better than a contract."

Similar to Darwin's theory of the survival of the fittest, the true test of success in the market was the ability to move the seafood that had a shelf life of one day. The idea had philosophical implications.

"Today you're worth something, tomorrow you're worth nothing, it's the importance of *today*. Ya don't even have four hours to sell fish. In reality ya got two, three hours, tops. . . . I get psyched. Excited. It all starts from the afternoon before, when I'm on the phone with my shippers. I really love the business. The day before, if I

know I'm gonna have a lotta fish, I can't sleep sometimes when I have fish comin'. I'm like a tiger in a cage."

"In doing business I was taught to have self-confidence. If you don't have your own self-respect, if you don't have the confidence, the pride in what you're doin' an' enough respect about yourself, they'll pick up on it. They won't take ya serious. How can they take ya serious?"

The market was a very physical environment. In doing business, the men patted each other on the back, shook hands, or sometimes poked or took friendly jabs at each other. Occasionally, though, disagreements became serious.

> I remember this guy named Tarzan. He used to work for Eastern Commission [Fish Company]. He was built like a brick shithouse. He was a real Amazon. He was about 6 feet tall and weighed about 240 pounds. He was bald and had a real ruddy-looking face. He worked down here for at least 15 years. . . . I remember that Tarzan had a real temper. One day, Tarzan got in a fight with somebody [a customer]. Tarzan turned around, an' that's when he got hit. Not when he was looking, somebody struck an axe right through the middle of Tarzan's head, that the blood was gushin' out. I heard he got mentally retarded.

The larger businesses in the market were built on crucial interpersonal relationships between the owners and their trusted employees. It was often the stand man who would be positioned next to the fish bins for hours on end, selling as well as dispatching the fish.

"My boss is a very, very smart guy—he's made me the best by picking me! The customers, when they see us on the stand together, they call us 'dynamite and nitroglycerin.'"

I heard many descriptions of the different personalities who had worked at the market.

> My first job was for Louie B. Louie was the greatest salesman this market ever seen, in my opinion. Here's a guy throwin' the fish, with cigar juice drippin' down his face, baldheaded, standin' there with his pot belly. . . . He'd get guys, call 'em over to the fish bins, "C'mere ya cocksucker, I got some nice

blues here." Everybody in the market had bluefish, but they'd buy from him. . . . How could ya work with a guy [with] snot on his cigar, spittin' all over customers? But he was a nice guy; he had a way about him. If you were in trouble: "Louie, I need a thousand dollars, I'm in trouble." Louie would say, "Come up an' see me in my office later, stupid son of a bitch, ya got caught?" That's the way he was. I seen a kid come to him once: "Mr. B., I need a job." Ya know what Louie told him? "Son, have ya ever been arrested?" The kid says, "No." Louie says to him, "Son, you was never in any trouble?" The kid says, "No." Then Louie says, "You can't work here, I can't use ya." . . . That's the truth, that was Louie B.

He [my father] was a very physical man. He was very chesty. My father had spindly legs; as a matter of fact, so do a lotta guys in the market. I think that's from pushin' the hand trucks. You see these guys with big guts and then they have these thin legs. My father had a great head for numbers. [He had only a third-grade education.] I used to listen to him talkin' to customers and you would think that they were so much smarter, then eventually he would say, "You're crazy, you're losin' thirty dollars an hour or twenty cents a pound." His best gift was his warm personality. People liked him. He knew his limitations and he knew where he was strong. He had this innate intelligence.

One time, there was a guy around here they called Truppo. I remember he had one hand that was all crippled up. We told him, "Ya better not show up at work Sunday night drunk." But he didn't listen. So one night, the loaders nailed him into a box. A halibut box. Then they put the box on the trailer, closed the door, and sent him up to Boston. . . . When the doors were swung open, on the other end, the guys heard, "Let me out! Let me out!" I heard he was up there for the weekend [overnight].

The historical practice of "shaping up" on the waterfront was still in place. Men without steady jobs would walk from stand to stand or company to company, hoping to be hired for a night of work.

"It said something about a person just to be able to get up at two or three in the morning, put your work clothes on, and *get going*. If you really wanted to work, you'd have to walk that whole market. You could go from left to right, to both sides of the street. Chances are, if there was any decent amount of fish there, you would get work."

Ya can't get discouraged. Ya go to wherever ya see the most fish and ask them if they need an extra man. I went over to Blue Ribbon and met one of the brothers and asked him if he needed a man. He eyeballed me from head to toe . . . up an' down. . . . "Did ya ever work before?" So I said, "No, but I can do it. I'll work half a day, I'll work fa nothin'." I just wanted him to let me try. So he said, "Oh, all right, go get a hand truck." I remember the time I first grabbed a hand truck. They were so big. The wheels were enormous, the handles were thick wood, and ya had to have a big hand to get around it, it seemed. When you're workin' with a hand truck as a journeyman making fish deliveries up and down the block, ya have so much time to think. You can be a very solitary person. The moon and the Brooklyn Bridge was like my God, my soul.

Crew members could become very familiar with one another. They expressed it through hugs, embraces, kisses, backslapping, and in some instances, lifting someone up and hurling them to the ground. Many workers also communicated in whispers. Virtually everyone had a nickname, such as Ray the Rebel, Abie the Jew, Patty Wild, Tommy Ears, Johnny Deadman, Football, Jimmy Fishcakes, Joe Baldy, Jake the Snake, and Wobbo. Men would reminisce about friends who had passed away, referring to the deceased as Louie

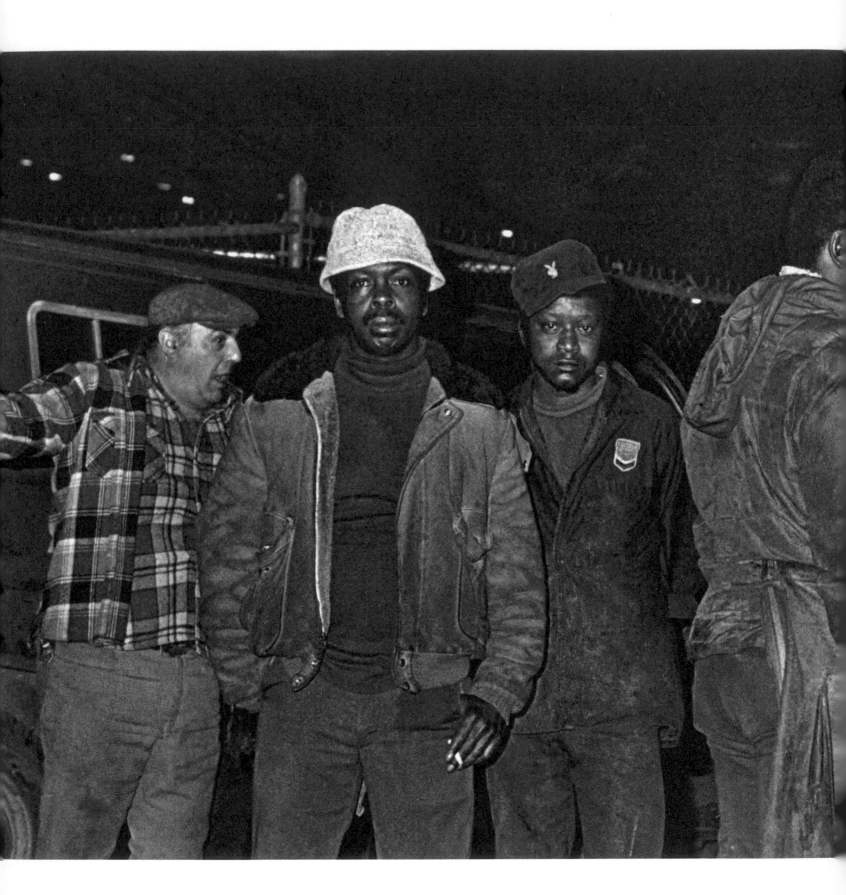

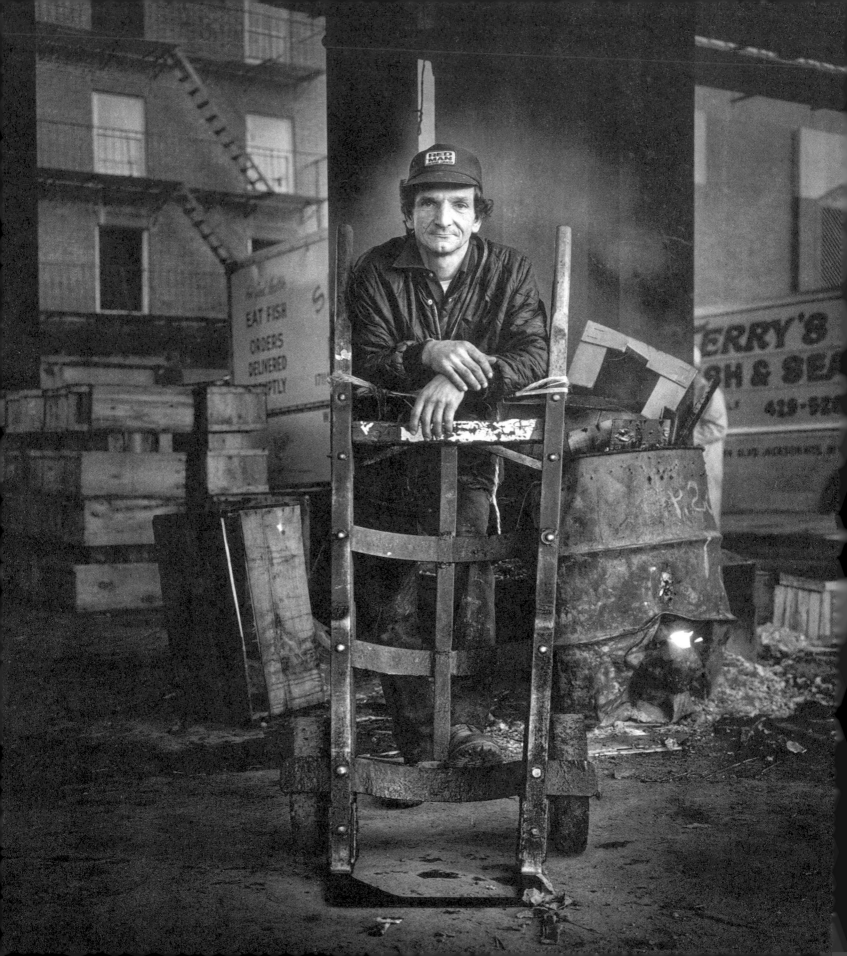

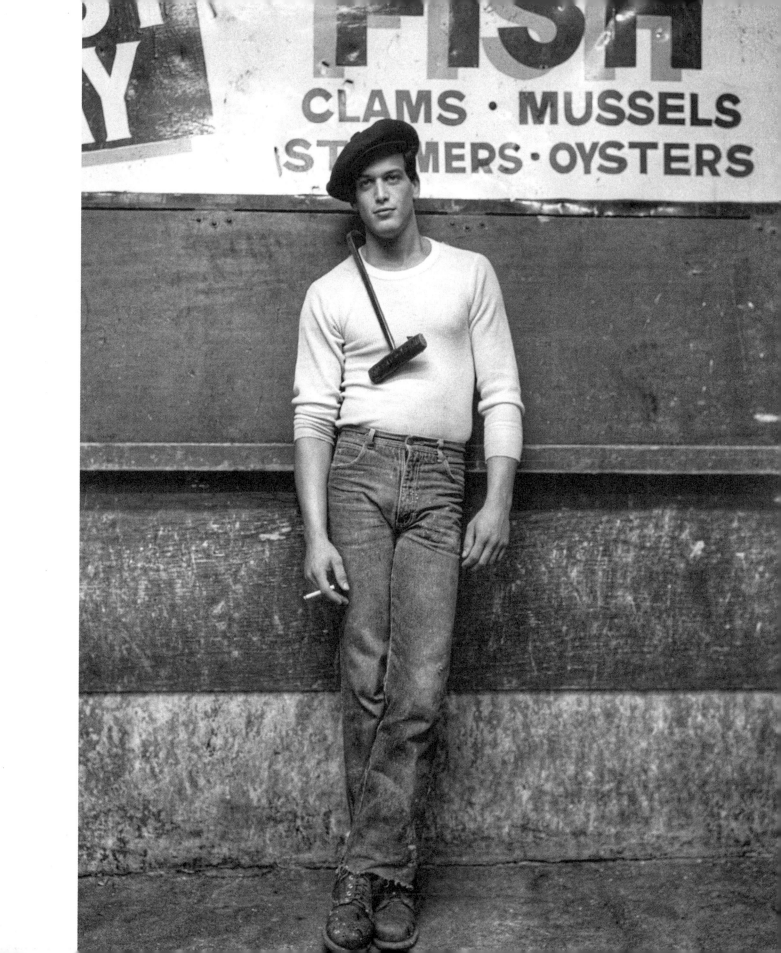

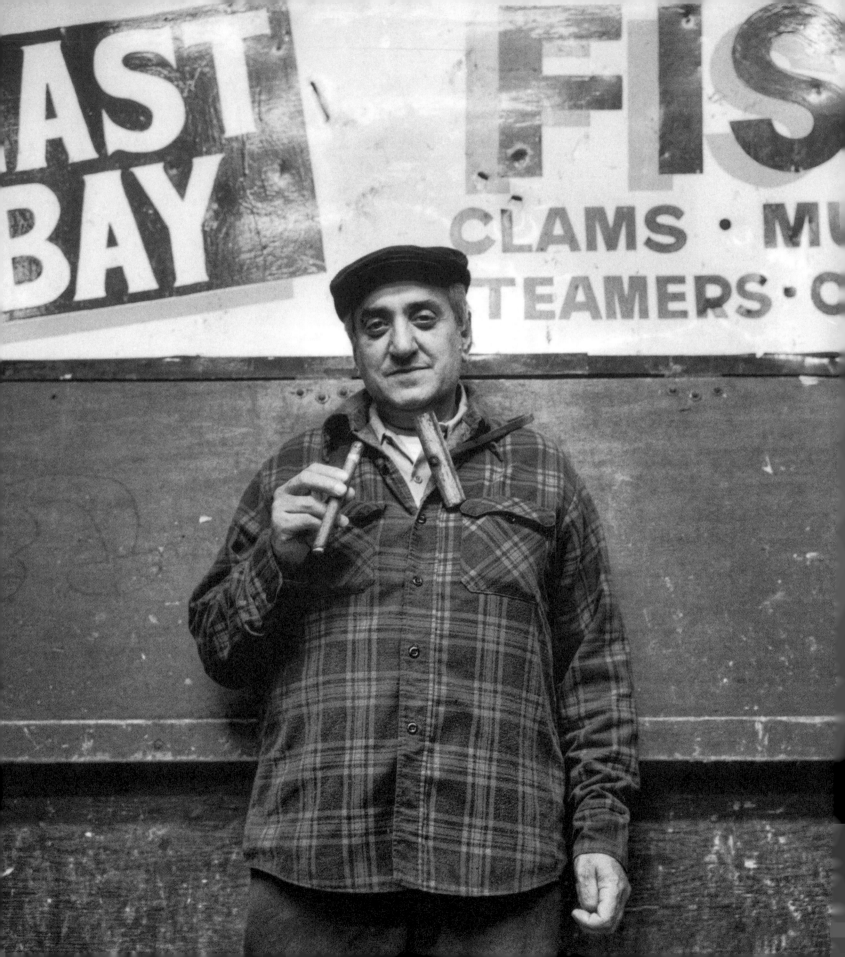

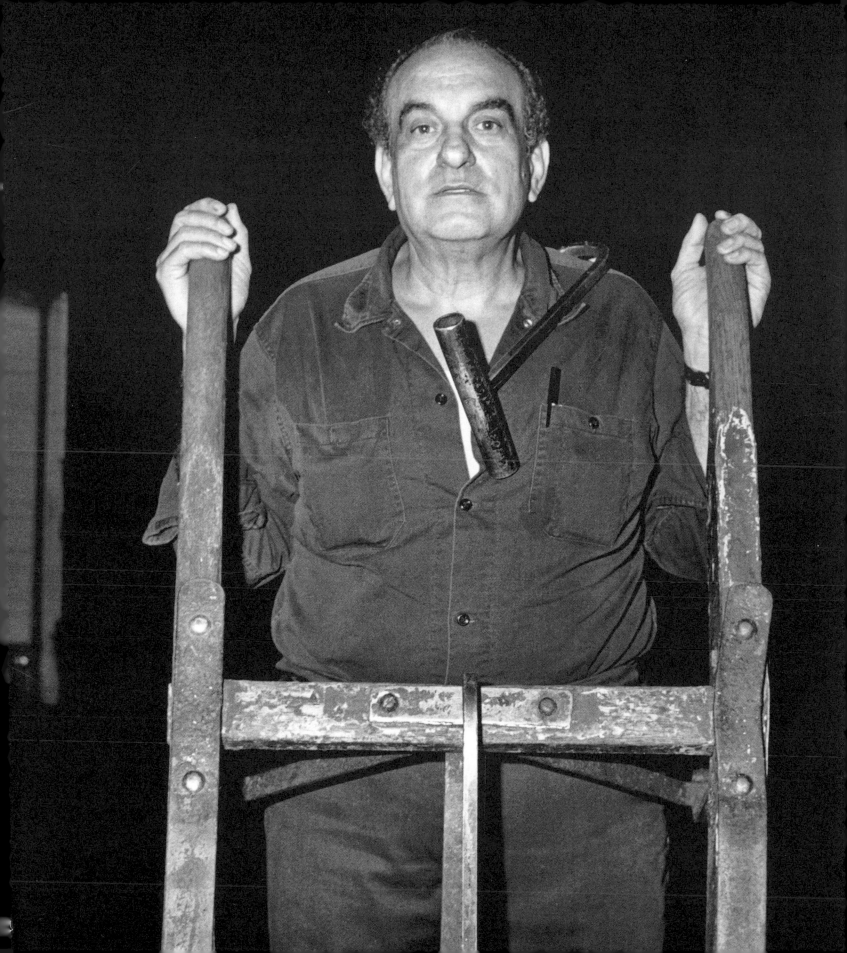

the Lug, Skinhead, Freddy Gigi, and Babe. Sometimes, I would ask about their nicknames and how they got them.

"You want my nickname? They call me Pain in the Balls, Pain in the Ass, Aldo Ray, and Crazy Butchie!"

Others replied, "On account of my hair," "Because of my big ears," or "Well, uh, he lollygags."

One night I asked Johnny Deadman how he got his name. He answered, "Do ya want the truth or a fake story?"

"The truth," I said.

He responded:

Okay. Maybe it was fifteen years ago. There was a colored guy they found dead on Fulton Dock. Ya know Fulton Dock? It ain't there no more. So a group of us rushed out there. Then the cops came. Then a few years later in front of the Paris, two colored guys were killed. So I rushed ova to see what happened. Then the cops came. After that, one day I was makin' a delivery to Peck Slip, and there was this tractor-trailer parked. There was a bunch of guys around it, so I ran ova to see what was goin' on. Someone had got locked inside the trailer and died. The same cops came down to cover the incident. When the cops saw me again at the scene of the crime, they said, "You must be a dead man." So that's how I got my name Johnny Deadman, it just stuck.

On South Street the workers and owners dressed alike. Many of the men sported rings, necklaces, and sometimes bracelets. Many wore pea caps or baseball hats. Because of the nature of the outside work, they wore similar sturdy jackets, most with the familiar shredded hole in the back where the tip of a grappling hook was positioned. The men's names were burned into the wooden handles of their grappling hooks, as were company names onto the wooden parts of the hand trucks.

There were historically certain forms of entertainment on South Street. Gambling and playing the numbers was still a serious way to make "extra income." One of the workers remembered:

My father and his brother were gamblers, like most people down here. My father gambled away a lot of money. The cash was so readily available in the market, so everybody gambled.

. . . The shylocks were down here. . . . My uncle gambled too, but he sort of put a limit on it. I remember they used to bet somebody would come in and want a 50-pound piece of fish. My uncle could cut that guy a 48- to 52-pound slice of fish and they would bet on it. Everybody would pick the "right" weight. They would throw the money into a pile. . . . Most of the time my uncle would walk away with the money.

But there were other pastimes on the street. The waterfront had always been a place where prostitutes "hung out." In fact, the building across from where I lived was infamous in that way: the existence of that particular brothel could be traced back to the 1800s. It was no surprise to learn of women walking South Street in the middle of the night engaging in one of the oldest professions on earth.

I heard several colorful stories about such women, including a prostitute with a peg leg who had appeared on South Street decades earlier and would hop from stand to stand servicing the men. In that spirited tradition, other females followed.

During my time at the market, there was a woman who fulfilled a similar role, but I can't recall whether I met her in the coldest nights of winter or the hot and humid nights of summer. She appeared on South Street almost every night. Loud and boisterous and with long, flowing hair, she knew all the men at the market by name. She was, in fact, very street-smart, just like them.

Her familiarity with the members of this all-male community was expressed by deep physical affection. She would hug and caress the workers, the customers, and whoever else stopped by the fish stands. She also pulled a shopping cart, overloaded with novelty items like handkerchiefs, cigarettes, and sometimes newspapers for sale.

"See, I sell things. . . . I raised a family and supported them without welfare."

Occasionally we would bump into each other on the street and engage in conversation, which made me feel extremely uncomfortable. I would listen to her amusing but very perceptive comments. She believed that her nocturnal presence was essential, as the men on South Street needed her maternal affection to get them through the long, hard hours of work.

"You have to love them. I mean, the boys have to get up in the middle of the night and work, lifting those heavy cases, you have to love them. . . . They feel my humanness. I am like Mother Nature to them, I am the motherly link, the motherly spirit. Some people have no love in their life, especially the old-timers. Sex . . . well, they need it. It's the only love they know if they don't get love at home."

One night I was loading film in one of the booths. Next to me was an owner nicknamed Uncle Rip. He was concentrating on his invoices, adding up some figures on a pocket calculator.

All of a sudden this woman leaned into the booth and pulled one of her enormous breasts out of her shirt for the owner to admire. Clasping her breast with both hands, she turned around, then proudly displayed it to the workers.

I was dumbfounded, but Uncle Rip hardly looked up from his work. Without a doubt, this would have made a great picture. But I knew I couldn't click the shutter. To do so would have devastated this human being. She obviously felt she was giving something special to the "boys."

In those days, deep in the night, the market was still a place where many people did not venture. It could be a bit treacherous, at times, for the homeless who slept beside the Brooklyn Bridge.

"It was in the winter. Me and Tony Bow had a fire going. We were makin' fish deliveries to Pier 20. . . . This guy was sleepin' in a big wooden box. It was a 'smokey,' one of the derelicts. We decided to pick the guy up with the whole box and put him on top of the fire barrel and just watch to see what would happen. He didn't die or nothin'. With all the fire around, it was excitin'. He left that box like a bat out of hell. It was very amusing to watch him leave that box."

"I was in the second market building and was hangin' around in one spot. That makes some people down there uneasy. People notice if you are a stranger . . . they want to know what the hell you're up to . . . if you're observin' whatever."

"Be a survivor."

By 1982, after the piers had been demolished, all the seafood was coming into the market by tractor-trailer. It was removed from the trucks by the crews of unloading companies that were sepa-

rate from the fish businesses. The crews were a motley assortment of high school dropouts, young men without many prospects for the future, along with hit men and convicted felons. Several days a week, when the market was expecting larger deliveries of seafood, extra men were hired. Together, they did the backbreaking task of unloading the crates and boxes weighing up to 125 pounds each. Thousands of pounds of seafood would be unloaded every night.

Because unloaders worked in virtual darkness, the unpacking of the large tractor-trailers was a very tense affair. Anything could happen.

One night there was a blackout. It was in the mid-'70s, and the entire fish market was pitch dark. I was sitting outside in front of Thunder Fillet with this old man named Jerry, and someone came over and asked if I wanted to work, helping out on one of the trailers for a couple of hours. . . . I came to realize later that they needed me by the trucks because some of them were robbin' the coolers and freezers. 'Cause with the blackout, there were no alarms. I was too naïve to know what was going on. That was my first step, my initiation into that side of the market.

Throughout the investigations of the late '70s, agents stationed in unmarked cars or at points on the highway overpass continued "in secret" to photograph the unloaders.

"We would start to see these strange-lookin' cars drivin' around. Sometimes they'd drive into the lot near the trucks or they'd drive by and watch us. They would make their presence more and more obvious. They were there every night at certain hours. We started to hear that it was an organized task force and that it was serious. We could feel that the heat was comin' down."

Any photographs taken by the agents could wind up as potential evidence in front of the grand jury, to back up allegations of "tapping." Tapping was the historical practice on the waterfront of skimming fish from crates before they reached the individual stands for resale.

The guy that was droppin' [cartons] was opening up every carton with his hook. He would pluck two or three fish and there

would be this box right there. They would be fillin' up this box. I was very naïve about what was goin' on. They would say, "It's for the orphans." If a stranger would wander over to the truck as we were working, they would say, "It's for the nuns."

Then we'd fill up these boxes. —— would drop the cartons right at the side door. There'd be a guy there. He'd spread his legs and square himself off in front of a stack of cartons, and his job would be to snatch the cover off real fast. Just slip it right off, an' a guy would be on the other side. *Whoosh. Whoosh. Whoosh.* You'd fall into a rhythm the minute that carton cover would come off. There was this action in your wrist and arms . . . you'd have to decide which fish to peck at, ya know . . . which head was showin' the most. . . . Then the fish would come out beautifully. They'd put me on a load, to "drop a load"—"Just hit the whiting, the butterfish, and the squid. Don't touch the porgies. Don't touch this stand or that stand, 'cause I promised the guy I wouldn't touch his fish." Ya see, the wholesalers knew we were tappin'. It became such a regular thing. It became something they had no control over, unless they wanted to come down at 11 or 12 at night, instead of 4 or 5 in the morning, and watch us. But they knew they couldn't do that, 'cause we wouldn't stand for them being there . . . they took that seriously.

According to the newspaper reports, proceeds from the stolen fish, millions of dollars annually, would go into the coffers of men with mob ties. An unloader described his boss: "He was like a symbol. He never came by the trucks, he always stayed across the street. He was always in the Paris Bar, and he came and went when he wanted to. He was a little bit above, so to speak."

During the investigations in the late '70s and early '80s, the unloaders found themselves in the uncomfortable position of pleading the Fifth, as the names of friends could never be revealed. In addition, the FBI had a strategy of offering individuals within the market immunity if they would testify against each other.

I remember them telling me, "We know what went on, we saw you tapping. We know it was for —— ; we know it was part of your job. *You be a survivor.* Mr. Bookin [the D.A.] wants to talk

to you off the record. He just wants to ask you a few questions." . . . They told me, "*Be a survivor.*" "So-and-so is going to jail, and his brother, and so-and-so from Peck Slip is going to jail. *You be a survivor.*" "We know how it is down there. We see you work hard, you get all that fish water on you, and the smell, and workin' hard, and you get wet, and you have to work hard for a living. We see what it's like down there in that market, it's a rough place, that's a terrible place." They kept tryin' to impress upon me to be a survivor—in other words, a lotta people were gonna go down, and I could make up my mind, make a decision . . . and not go down with the rest.

Before long, they subpoenaed my crew. Naturally we sat down with lawyers and we started to learn about the law, and what it meant to be charged with something. We learned about the Fifth Amendment. All we had to do was plead the Fifth Amendment, and we learned the little dialogue, "On the grounds that it might incriminate me." So we [the crew] went up there, and then I gave my name and pleaded the Fifth Amendment. This D.A. [Bookin] was disgusted . . . he was sick . . . I don't know what he expected. He started to see that, not only with our crew but with each person to come up there, what he was up against. He was going to get Fifth Amendments from everybody.

I protected these people and answered the way I wanted to answer. That's what I was doin' . . . protectin' them, because I felt a *bond* with them. Which is very important. Something which I never felt in my life. Something which I might of felt for my mother's brothers, or my father's brothers. Something *greater* and *better* than I ever felt for my friends as I grew up, at different stages of my life. I felt, "Fuck them"—why should I give in and let them put my friends away. . . . I was a little ob-

sessed, at the time, with the whole image of a "stand-up" guy. I said to myself, "This is really a chance for me to solidify the bond I have with these people, and really enhance my image in the fish market . . . as being good as gold. When people know you're good as gold, they *trust* you. You want to be trusted, you want that *unity*, that closeness with people. . . . In any walk a' life, not to be trusted is the worst thing. So I knew it [the testimony] would solidify, *make me*, so to speak. . . . I was trusted all this time, and loved, and if I copped out and gave in, I woulda felt *terrible*.

Some individuals at the market were too afraid to testify. Some decided to remain in jail rather than name names. In 1981, New York *Newsday* reported that:

M—— claims he is a "victim" of the investigation. "I'm enduring this thing because I'm afraid for my family, my wife, my children, my grandchildren," he said. "I've seen people pummeled, kicked, hooked and shot. I've seen violence and I don't want to be put to the test." His voice cracked as he told of recent threats against his life. "There's nothing direct," he said. "It's always subtle . . . innuendo, but I got the message clearly." After one of three appearances before the grand jury M—— said, "I was approached on the street (South) and I was asked by unnamed persons what happened. I said I took the Fifth. They said, 'Good.' They knew each time I was going to the jury, and each time they approached me." One said, "You're not gonna say anything that's gonna hurt me are you?" M—— said another unnamed man from the market said, "How much time in jail can it be for not talking? A couple a months? For us it can be many years." M—— admitted that Bookin, the assistant United States Attorney on the case, had offered him protection. He said Bookin had given him a telephone number that he could call 24 hours a day in case there was any trouble. He said that he asked Bookin, "How can I use the telephone number if I'm bleeding in the gutter?"

By the early '80s, on the heels of law enforcement investigating the unloading and allegations of extortion and other criminal

activity, the IRS increased tax audits of many of the small business owners. Although many of the fish dealers had nothing to hide, the legal problems were time-consuming and expensive. The scrutiny fueled everyone's paranoia and anger and continued to erode the reputations of the individual businesses. By now, virtually the whole market was angered and frustrated by what seemed an unrelenting crusade to indict everyone on the street. I began hearing comments like:

"They were trying to get him [my father] on criminal tax evasion and my father was facing the potentiality of jail. He sat in the tub for hours 'cause he had so many boils over his body from nerves. Anyway, it turned out that my father won the case, they found him not guilty. Then my father turned around and wanted to sue the government because they had tried to maneuver him and push him, and they caused him so much misery."

"Ya know what they're doin'? They're tryin' to demolish this market."

"They look to throw these kids in front of a grand jury."

"Fuckin' Rouse [Corporation], fuckin' project."

"Rouse is putting pressure on the feds to get rid of us."

"Now they're pushin' us out like dogs."

Much media attention was directed toward the Fulton Fish Market during this period. There appeared to be a connection between the relentless assaults of the government, local law enforcement, the press, and the Rouse Corporation and the slow, steady erosion of the market's reputation. Animosity toward the "corporation" seemed to be intensifying:

Who runs all these corporations? They don't know, but they'll answer to whoever is the next person in command. There's a string of command that goes on forever. . . . There is a whole analogy between corporate philosophy and religious reincarnation. Corporate people think, "If I enter into the next strata, I'm closer to seeing God." You can find God on the board of directors of IBM, Rouse, the city government, etc. . . . Their gods get changed every year. Rouse is a prime example. Did you know that he [Rouse] is not the president of the company anymore? We keep on talking about this company as if there's a man there. All they have is a computer for a head. I am not

convinced that they believe in their causes. What they believe in, "Is this going to get me a promotion? Will I look good if I do this? And, if I do this, I can enter into the next strata?" They are ass kissers of whoever they think is on top.

As the journeymen kept pushing their hand trucks and the businesses tried to keep operating, the mall was being built around them and on top of them. Construction crews worked in the same spaces as the fishmongers. Loading zones for retailers' vans were moved to parts of the neighborhood that were farther and farther away.

The smallest businesses were the first to disappear. Due to the lack of operational space in and around South Street, companies run by one or two people did not survive. For a fee to a larger company, a small business could share some space, making one company a landlord over the other. The market was shrinking.

As the situation continued to heat up, there was an increase in petty robberies. Cash was stolen from individual companies, seafood was stolen out of the freezers, and vans were broken into during the night.

A few weeks ago, on Good Friday when I was walking from where I parked my truck, I went to get coffee and the newspaper like I do every morning. I was carrying a lot of money. All of a sudden two guys jumped out from behind the trucks, carrying guns, and wearing masks over their faces, and demanded my money. "Don't kill me," I said, and I quickly showed them my money. I could see through their masks how their faces lit up when they saw how much money I had. Well, what I'm saying is, *don't walk in any dark places down here.* Now, I only walk where it's all lit up.

An organized strike by the journeymen and the filleters ensued. It seemed like the internal structure of the market was falling apart. I would hear people saying things like, "If Carmine was around, this strike would be over."

Who were the union leaders, and what role did they play historically? Joe "Socks" Lanza was one of a small group of mythical figures who "kept the peace." His name was revered in the market, and several accounts of his life have been written. Lanza saw the need

to separate the tasks of the men who worked for the fish market from the duties of the other longshoremen. With the blessings of those individuals who lorded over the waterfront, he called his association, founded in 1919, the United Seafood Workers Union Local 359. Lanza, according to one account, got his nickname from wearing "funny looking" socks. As the "appointed" head of the union, he would hold court in the back room of Meyer's Hotel on South Street. According to the old-timers,

"Yeah, Al Capone was working' Chicago, ya had Lucky Luciano in New York, then ya had that Lanza guy down here. He was like Robin Hood. Down here he was a 'well-liked man.' If people got dispossessed, he paid the rent."

"I knew the guy who ran it, Joe Socks. Nice fella. Why, if you was broke and needed a job, if you were sick, he would help you. He would make a collection to see your wife and kids were taken care of."

"The President," as he was called, would offer people handouts, particularly if they were sick or in need, and would make sure that every one of the men in his union was working and never lost a day's wage. Lanza sought to outmaneuver just about everybody for the good of his men and, of course, to fill his own pockets and those of his associates. For these reasons, he earned the workers' respect. Joe was also known, according to some personal accounts, as a man who ordered "hits." His association with Charles "Lucky" Luciano and the men who dominated the waterfront rackets at the time has been well documented. He was sent to prison on a number of extortion charges in the late 1930s, but later returned to South Street as a hero.

Up until recently, the union leader's position seems to have been "inherited" and kept among blood family members. "You see, down here, things are inherited and passed on."

The reputation of old man Carmine Russo in the 1960s, like that of his predecessor, Joe "Socks," grew to mythic proportions.

My all-time favorite character was old man Carmine, bar none. I feel for you that you never met him. The man *was* the fish market. He was my friend. Whenever I would be down in the dumps I would go into Carmine's Bar and see him. He had a full head of white hair and a gravelly, gravelly voice, and he feared no one, absolutely no one. He would say, "Come on,

let's have some coffee." Then he would start telling me stories. He used to tell stories about the time he had a speakeasy in the market. There was a tough crowd at one time comin' down here. The people on the boats. There were some hard drinkers, and they'd go into the place a lotta times. One time one of the guys from the boats came in the bar and held everybody at bay with a shotgun. Then in comes old man Carmine from the back of the bar. He walked right in and took away the gun and hit him over the head with it. He broke the shotgun and then gave it back. Everybody knew him. In the summertime, he would either sit on his favorite chair outside the bar or walk around the market and see that there was no problems. As tough as he was, there was nobody better, provided you was on his side. If he didn't like you, he'd let you know it. I remember an incident one day when a big Hollywood movie star [Charles Bronson] went into the bar with his whole crew. They were makin' a film down here. They had their trucks and lights and equipment outside Carmine's. Anyway, they went in, the movie crew, and they didn't pay for their food and drinks. Maybe the movie company was gonna pick up the tab. I don't know, but Carmine got annoyed and threw them out, including the big Hollywood movie star.

One day, a loader at the market drew a diagram to explain to me how the streets were broken up into parking areas. The names of some of the loading zones had historical references to places or people, like Coal Chute (named after the coal barges under the Brooklyn Bridge) and Ferry House (named after the pier where Robert Fulton's steam-propelled ferry landed). There would always be a man standing near his zone and pointing journeymen to parked vans, each displaying a customer number. The journeymen, pushing hand trucks filled with sold seafood and pointed in the right direction, would then load the boxes into the correct vans.

The loader watched the vans and made sure that nothing was stolen. The loaders would openly collect money for this, even giving receipts to their customers. This practice had been in place for decades, as theft was a constant problem at the market.

But in the eyes of the law, it was illegal. The district attorney claimed that loaders illegally collected parking fees ($20 per week)

from retailers on city-owned streets. Technically it was against the law, I thought, but nevertheless the loader truly provided the customers with a service in return for his weekly payments. During the investigations of the late '70s and early '80s, several men "went away" for doing this. One day I asked a loader who had recently been released from jail what he thought about the situation. In the papers, he'd been described as a "strong-armed enforcer." Well, maybe he was. But the guy was barely five feet tall and pencil thin.

"No, I wasn't bitter at serving time. The income taxes I admitted, but I was bitter at the lies that were printed. It's not a nice thing to open up the paper and read that people consider you a shake-down artist, an enforcer, an extortionist. It's so far from the truth it's laughable."

It was clear that an infrastructure—a power structure and a complex social structure—existed and had kept the market going for over a century. The critical component were those who inherited the businesses from their fathers.

My story is no different than anybody else's. I was born on Cherry Street in 1941, between Market and Madison. I think my father lived there for the convenience of working at the market. My mother gave birth to me physically in the apartment, with the help of a midwife, my aunts, and whatever help they had then. My father was a partner at Joseph Carter. I used to help him after school, and then I went in Saturdays, and then after high school I went in full time. The work consisted of a lotta common sense and the will to survive in the elements. . . . South Street was a vast, vast area. It was like going into a dark tunnel. Unloaders, hand trucks, ya had to learn the names of fish. It is a traditional way. If the father is in the business, the son will tend to come down here and start. I've been told many years ago, "If you start down here, it'll get into your blood and you'll never get it out of your blood. And you're gonna stay here."

[My father] had a heart attack and died in the back room. It was very upsetting to me that he should die here [and] alone. But I see now, I see that's the way it should've been. I remember that I heard the seagulls that morning, making noises, clutching

and clawing on the skylight over his office. He goes into posterity as long as the business doesn't die, and if everything that he stood for doesn't die. Now you see his own grandchildren working here. It [the business] was for their own benefit. His spirit lives on through the family business.

There were a few individuals remembered for their persistence, intelligence, and ferocious appetite for success. These were men who came to the market without traditional blood ties, fought for a place of their own on the street, and built enormous businesses from scratch.

"My father started here as a bookkeeper, and when he retired he was the owner of one of the largest businesses in the market. My father would leave in the dark and come home in the dark. The old-timers, literally, this was their entire life. They worked fifteen, sixteen hours a day, came home and slept for a few hours, and then went back to work. That's what was required for our fathers to succeed. The man was always working."

That kind of effort was required to build a successful business. The American Dream had been slowly realized. Over time, the "mom and pop" businesses became lucrative and grew into multi-million-dollar entities.

One night, during the extreme heat of August, I stood with the owner of an unloading company who had just been released from jail. We started talking about his childhood.

"I was born on Monroe Street. It was a badass neighborhood, everybody was poor."

I said, "Describe it a little more." The old man responded,

We were so poor, I don't wanna remember, we had eleven kids in four rooms, an' a bathroom in the hallway. We used to take newspaper, bang a nail on the wall in the bathroom, and use it. Toilet paper cost three cents in those days. You could buy a loaf of bread with that. So we used newspaper. It was really a slum neighborhood, but nowadays, they give it a fancy name: ghetto.

Italians, they didn't know nothin'. . . . The priest used to say, "God bless," and they would have anotha kid. . . . Where we lived, we had what you would call in Italian an *abronda*, a day

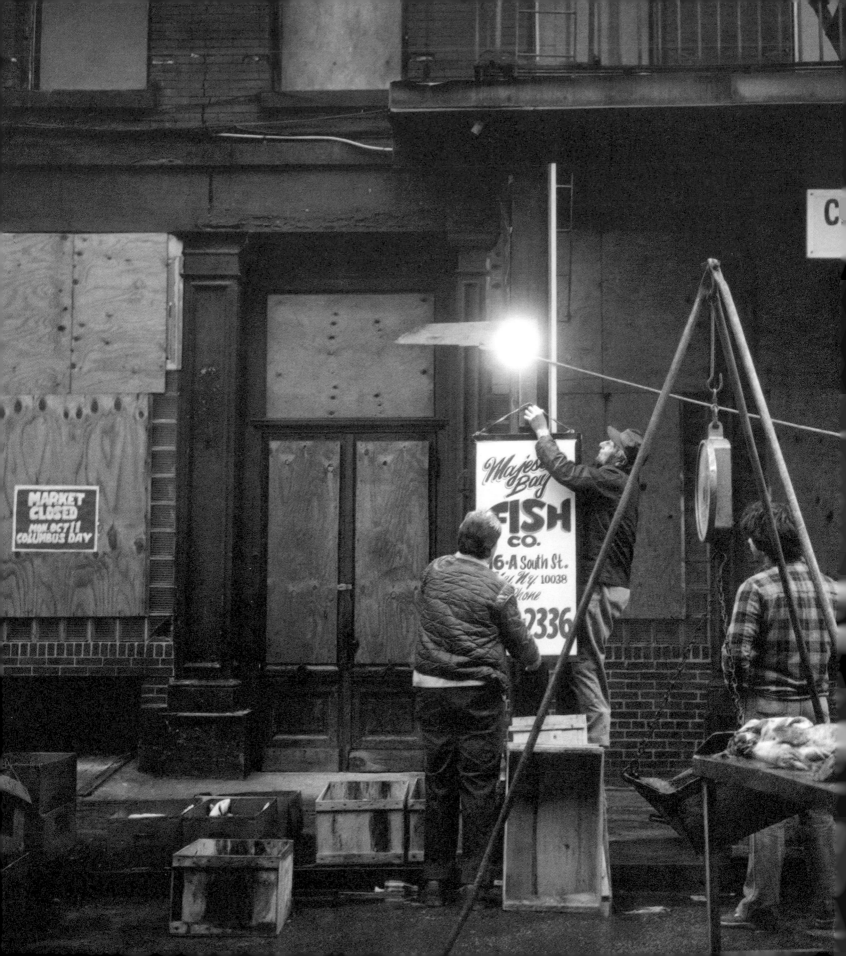

bed, on accounna you could fold it up durin' the day an' sleep on it at night. You would have to double up at night, 'cause there would be two, sometimes three kids to a bed.

When I was fourteen years old . . . I started workin' down at the market. I was a basket boy. I used to pick up baskets an' get paid a dollar a day. My father was makin' about twenty dollars a month. He would say to me, "Son, are you going to school today?" Then I would say, "No, I don't feel good." Then he would say, "Okay, you're workin' with me." So I started picking up boxes and baskets at the market. . . . Then I just got used to the place. I just grew into it.

Another old-timer commented,

I was born at 38 James Street. Years ago, it was part of the Fourth Ward. The old politician Boss Tweed gave it that name after the 1850s. People were poor. They all worked. In them days we had no electricity, we had gas lamps, and we had no bathrooms in the apartment. They were on the roof or in the backyards. We had coal stoves in the kitchen. . . . It was the roughest neighborhood in the city. Your life wasn't worth a penny. They would hit you, and throw you down the stairs. . . . I had lots of friends, but they're all gone now. I grew up with Meyer Lansky, Louie Lepke (in Yiddish, "Little Louie"), and Smokey Weiss [all gangsters who grew up together in the Fourth Ward]. Friends of mine worked over there on South Street, pushing hand trucks. I was different; I became a pro boxer instead.

It mattered little what job had to be done or where a man was in the powerful pecking order on South Street. All the men tried to feel pride in their work. The waterfront had always been a place where men with minimal education could become part of the labor force. To have employment on South Street was key to self-esteem and self-worth.

There was an honor code about work. . . . My father was grateful for work. They were children of the depression. The only way out of their situation was to work. When they got a job,

it meant a lot. In their time, nobody needed a psychiatrist because their job was their worth and to do your job well meant something. They didn't stand there and say, "I gotta see a psychiatrist, I have no worth in life, I sell fish." After my father died, we went to talk to the doctor about what had happened. The doctor said, "Your father should have been dead about five years ago." His arteries were shot, his heart was pumping just enough blood to sustain life, and the fact that he lived was amazing enough. The man never complained.

"Johnny [an old-timer fillet man for forty years] told me a story about the time he cut his hand open. My father said, 'What happened? What's the matter?' Johnny was standing there with his hand cut wide open. 'What are we gonna do, Cap?' They used to call my father Cap. My father said, 'Wrap it up.' They wrapped up his hand in some bandages, and then went to Carmine's. My father bought a bottle, gave Johnny four shots, then Johnny went back to cut [fish] for four more hours."

"My father would get up in the morning when my mother was still carrying me. (I was born in 1930.) He would steal a couple of loaves of bread and milk off the delivery trucks, and return home. Then he used to walk to the market to get work. Even in winter, when he had nothing but a suit jacket on and shoes that were stuffed with newspapers to block up the holes, he would look for work [at the market]. Every so often, he'd get a day here, and a day there, and after a while, he'd get on steady."

"The market is the bastion of the old way."

The denizens of South Street observed the world from protected place where everyone knew and was used to one another. They considered themselves to be "family," and they would "stick together." If you were threatened, there would be many around to support or defend your position, or make sure you were out of harm's way.

"The market gives strength to people where they didn't feel they had it. . . . There's group strength, there's mob strength, or whatever you want to call it. The market gives them a real sense of importance. You substitute, the market becomes like your family. . . . It is

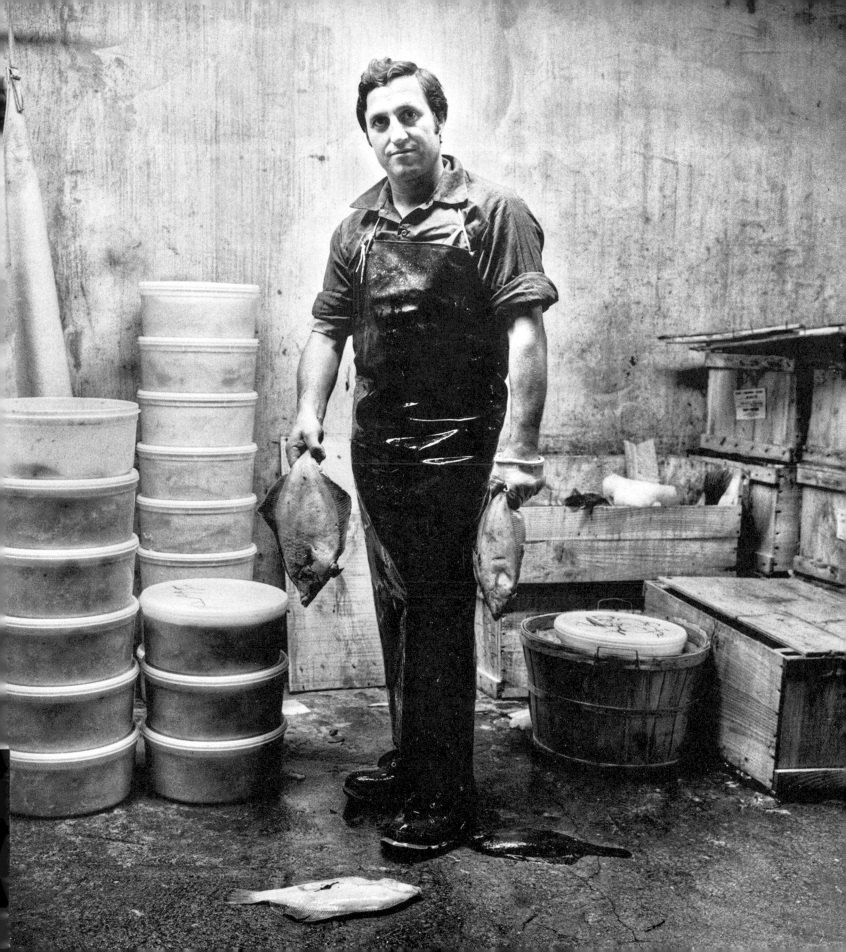

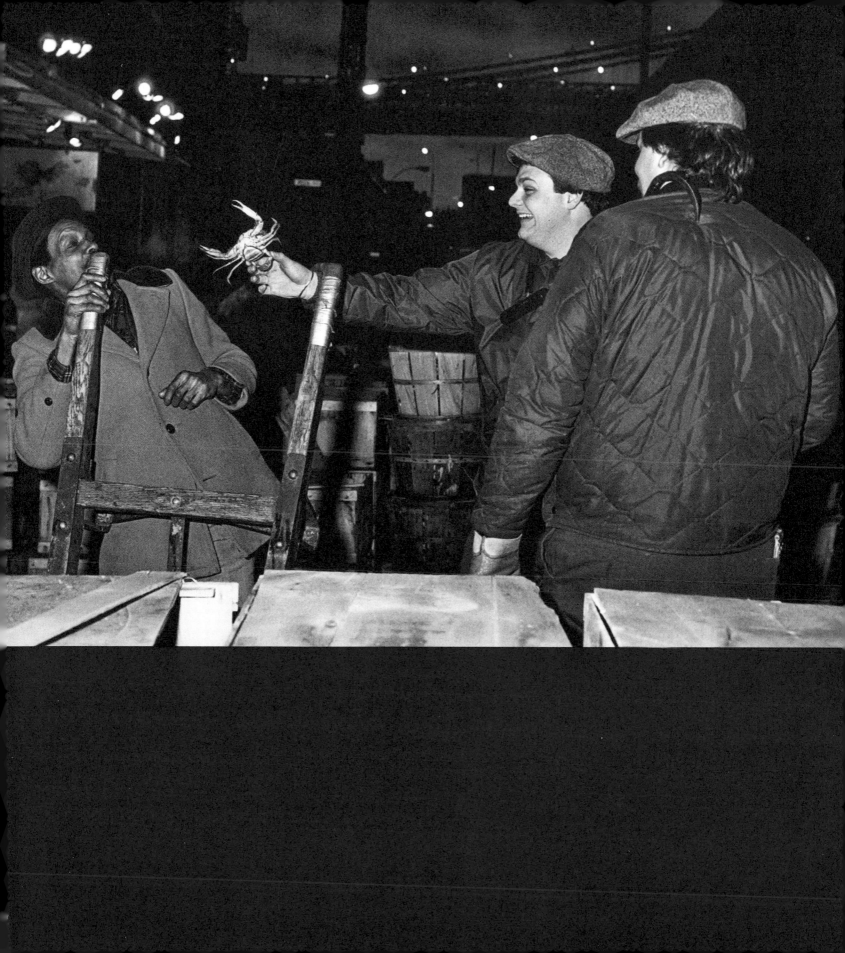

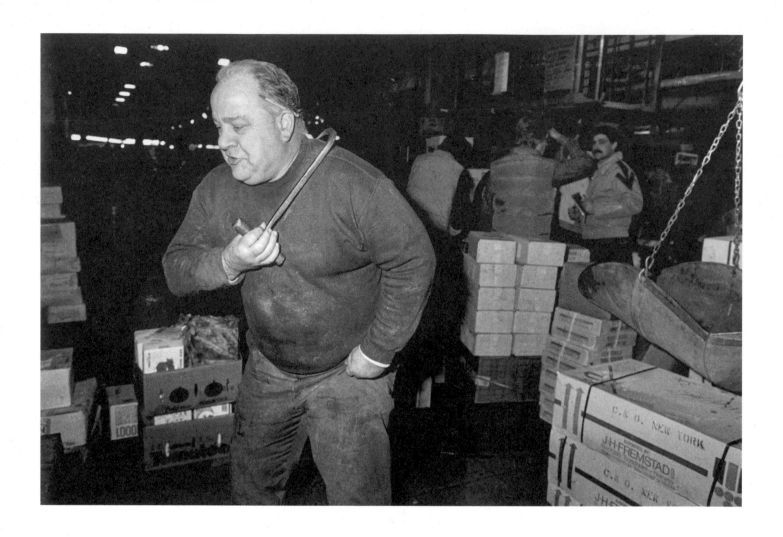

not a place where you demean workers. If you do, the man is going to react."

Occasionally, my telephone would ring after midnight. Usually it would be a "wake-up call," or sometimes, news of a special delivery of "pups." I would "have to come down at once" to experience the unforgettable sight of enormous headless fish lying on South Street.

One Sunday night, I awoke to a phone call. The familiar voice sounded nervous and upset and warned me not to come down to the market. Then the caller hung up.

On Monday morning the local newspapers reported that a murder had occurred in the area. The "hit" had taken place overnight in

a parking garage near South Street. It was not clear to me what connection it had to my work at the market. Nevertheless, that grisly event kept me away for weeks.

When I returned to South Street, I began to see the world more and more from the perspective of the men whom I had been photographing for so long. Their makeshift booths and the many wooden crates stacked high on the street were similar to a great fortress protecting them and their way of work. From their vantage point, I could look out toward the street.

"What are some of your biggest problems?" I asked an old-timer who puffed on his cigar.

He looked down and then spat on the ground. "Our only problem down here is with the outsiders."

But who were the outsiders? Individual workers mentioned the word frequently, in references to the IRS, the federal government, the district attorney, the assistant district attorney, the press and the news media, the police, the federal agents, the Rouse Corporation, Wall Street white-collar workers, and the Mayor of New York City, the landlord of most of their working environment. In short, anyone who "had no business in the market" was considered an outsider.

"The world has changed, the world was simpler when my father worked here. Now it's harder and we're still trying to put up this wall, to protect the market against the outside pressures of the world. . . . The point is, the market is the bastion of the old way."

In the early morning hours, the area between South Street and the river transformed into one giant commercial parking lot. Corporate men and women, wearing pressed suits and polished shoes, would emerge from their parked cars and briskly walk to their jobs, crossing South Street toward Wall Street just a few blocks away.

At the same time, workers pushing hand trucks amid filth and fish stench, their clothes drenched in sweat, would gaze at the suits. The stark contrast between their white-collar counterparts and themselves provoked hostility and resentment. Every member of the market community was sensitive to all the changes. The "outside world" was creeping in.

I began talking about outsiders one day with a journeyman pushing his hand truck toward "Pier 20" (which actually had not existed

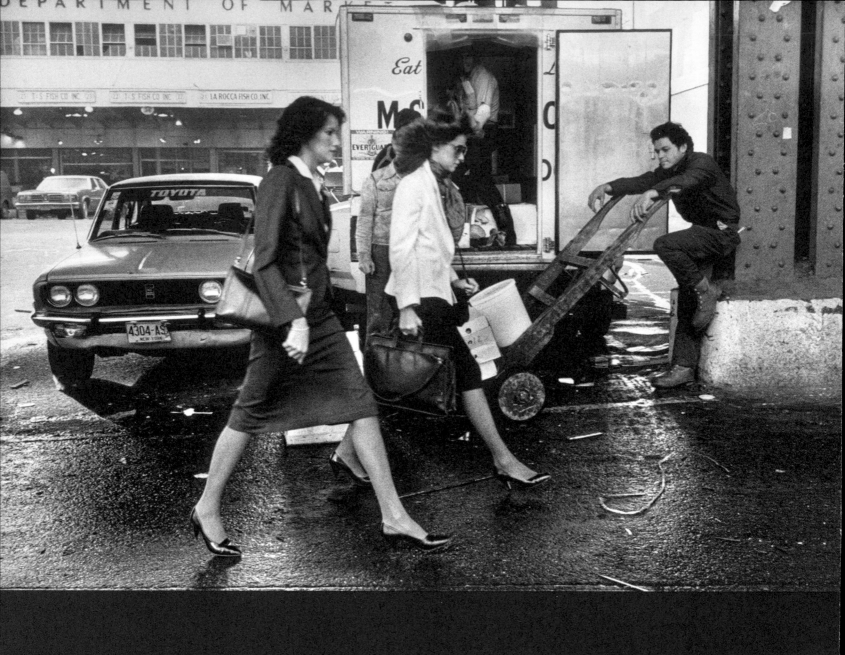

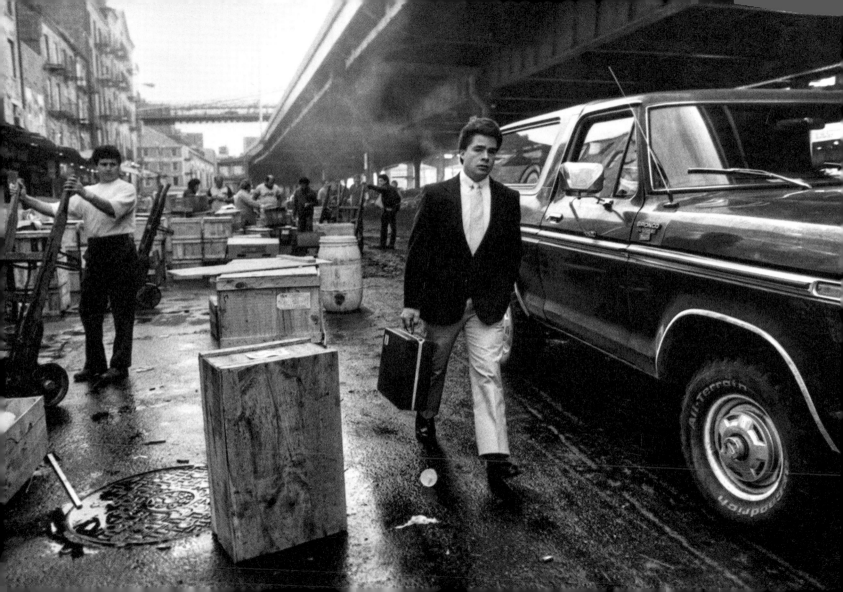

for a long time) under the Brooklyn Bridge. The journeyman was extremely bright, an avid reader, and was always eager to share his revelations. After he unloaded a heavy crate of flounder into the back of a waiting customer's van, he paused and took off his thick work gloves. He lit a cigarette and began to share some interesting thoughts about being a Sicilian.

He spoke of his ancestors in Sicily, whose lives were filled with abject poverty and misery. They lived in a world of suspicion and paranoia, in constant fear of government officials whose physical brutality and unfair treatment in matters of tax collection and usurping their personal property made their lives unbearable. Family men who defied draft orders from the local military would see their women and children subjected to gruesome torture, and in some cases, their homes burned to the ground.

A man had to be alert and cunning to survive, and had to outsmart "the outsiders." The young man explained that men developed ways of protecting themselves and their families from harm by creating systems of secret communication. For example, it would be difficult to isolate a family member or distinguish someone from a group if they were known only by a nickname. Nicknames could refer to a distinctive personal or physical character trait, or to a birth location. Other methods included communicating with direct eye contact, stares, winks, nods, whispers, or hand gestures, or dressing in a similar fashion to one another. In addition, and most important, a man had to remain silent when confronted by strangers.

The men of South Street shared work ethics and habits, and codes of moral behavior, originating deep in the past. Almost unconsciously, the owners, their work crews, and their associates functioned as an insular group, every member with his particular role and all working to guarantee the survival of the market.

By 1983, after the Rouse Corporation had its official opening of Schermerhorn Row, once the site of many fish businesses, I planned my last photographs on South Street. I asked all those I'd come to know during those incredible years if they would "cooperate" one last time. The request was simple. At 7:00 on an early summer morning, every boss and trusted worker, every customer on the street would stop what they were doing for a couple of minutes, while I stood on top of a customer's van to shoot a large group pic-

ture. It would be a quintessentially New York photograph, one to rival Weegee's famous group portrait of Coney Island bathers.

I tirelessly walked around talking up the idea with my friends. I planned the shoot for days and weeks, and even considered having an official assistant. I studied every part of South Street: where the sun would hit, where the shadows would fall, how many men would appear in the front.

The day arrived. At approximately 7 a.m., I climbed on top of a retailer's van. My tripod was in place, the film was loaded. The light was perfect. The weather was warm.

But the market did not stop, not for me or anyone else. A few of the men, however, put down their hooks and axes and sadly looked in my direction. I didn't get the shot. I left the market that day filled with disappointment and rejection. This project was over. Even though I lived in the area, I had to move on with my work and life.

Incredibly, more than twenty years have passed. In that period of time, the final stage of South Street's decline was marked by Rudolph Giuliani's inauguration as mayor and a mysterious fire that consumed parts of the old Tin Building (the press claimed that it was arson perpetrated by the mob in retaliation for ongoing investigations, but the case was never solved). The "new wave" of investigations resulted in more incarcerations.

Ambitious plans to convert the historic warehouses of the area into high-end residential housing were put in motion. Finally, a new mayor, wanting to build on the policies of the Giuliani administration, "sealed the deal" to move the market to Hunts Point in the Bronx.

I was sent down to photograph the last days of the fish market for a newspaper assignment. It served as a catalyst to return.

As I turned the corner by the Paris Bar once again, I could tell, even in the pitch dark, that everything had changed. The street could not and did not have the same ambiance.

Many of the faces were new. There were different ethnic groups, including a whole new set of people in the fish business, the Asians. Men of Puerto Rican heritage were now delivering the seafood to the customers' vans by forklift, and fewer hand trucks were in use. There were security guards everywhere. All the stands in the market were labeled with numbers. In fact, the fishmongers themselves

had to wear identity badges so they could do business on the street (conforming to the new rules that had been imposed by the city). Much of the fish had to be packaged in Styrofoam, raising the question as to whether or not the packaging could be reused. The market had shrunk even more. So many of the companies I remembered, even the older, more established ones, had gone out of business. FOR LEASE and FOR SALE signs were displayed on storefronts.

But then I saw my friends. Most of them were working in different locations or for different companies in the market. They no longer appeared so big and tough. They were older, most of them middle-aged, some with glasses and with their hair and beards graying. But they still carried themselves with self-assurance and pride, grappling hooks still swung over their shoulders.

That same captivating warmth was apparent in their voices.

"Where ya been?"

"Ya back."

"Ya made it."

They began to converse as if all the time that had passed was inconsequential. I learned that all the old-timers, Jake, Mortimer, Nunzi, Old Johnny, Mikey the bartender, and so many others were dead and buried. I heard about the incarcerations, who had "went away" and for how long. I mourned the death of a fishmonger's wife; who knows what decisions they would have made together about their future, now that the market was moving? Then, a week before the market left South Street for good, I heard that the owner of one of the oldest fish businesses had committed suicide.

One of the fishmongers, an old friend, had a sad request. He asked if I would take pictures of his "place" so that he could always remember it as it was. His company went back three generations. For decades and decades, his family had sold fish from the same two-hundred-year-old counting house.

The clock was ticking. The market's move was looming. Maybe it would take place next week, or maybe the week after. Of course I would do the pictures.

I was back, if only for a short while. One of the workers called me a couple of times to get me out of bed at three in the morning. They pointed out little "things" to photograph: a corner of the upstairs office where one of the brothers sat and changed into his work

clothes every night, and where he would reach for his favorite work boots.

The company's most trusted worker led me to an upstairs changing room. In the bathroom, there were intricate collages of pornographic pictures of women pasted onto the walls. Some of the images were so small and cryptic, they seemed meant to be read like Egyptian hieroglyphics. Within a collage over the sink, the worker pointed out a face recognizable to both of us. It was an image of the boisterous woman who'd serviced the men on South Street for so many years. She was running on a beach with her hair flowing and her breasts bursting from her tight blouse. She was young and vivacious.

Downstairs, in the office interior, I photographed some of the details. Below rows of Christmas and holiday greeting cards on the wall sat a tattered green couch, its shredded insides exposed. On another wall near the owners' desks, among the myriad of family photographs and the plaques, trophies, and other items alluding to a time when sailing and the sea were a part of these men's lives, was a faded brown poster. It listed the members of the Fishery Council, the organization itself harking back to another era, before the rise of the fish market's own labor union.

As I was taking pictures, some of the employees came to hand in their paperwork and to review the day's sales and inventory. It was about 7:30 a.m. There was an uncomfortable silence, and the workers coming and going had long, sullen expressions on their faces. Finally, after what seemed a long time, one of the owners looked up from his bookkeeping in my direction. In a tone of voice that suggested resignation, he said they'd been robbed of thousands of dollars' worth of inventory during the night, and there was no chance of getting it back.

The city was making final preparations. Fishmongers argued among themselves. Some couldn't wait to leave the smells and the rudimentary working conditions, while others were reluctant to move; letting go of the sun rising over the Brooklyn Bridge would break their hearts. I thought about the market's history, and how for almost two centuries the city officials had wanted to remove it. That this was actually happening—that outside, corporate interests had managed to wrest control of the area from the fish businesses and the wise guys who'd been rooted there so long—was amazing.

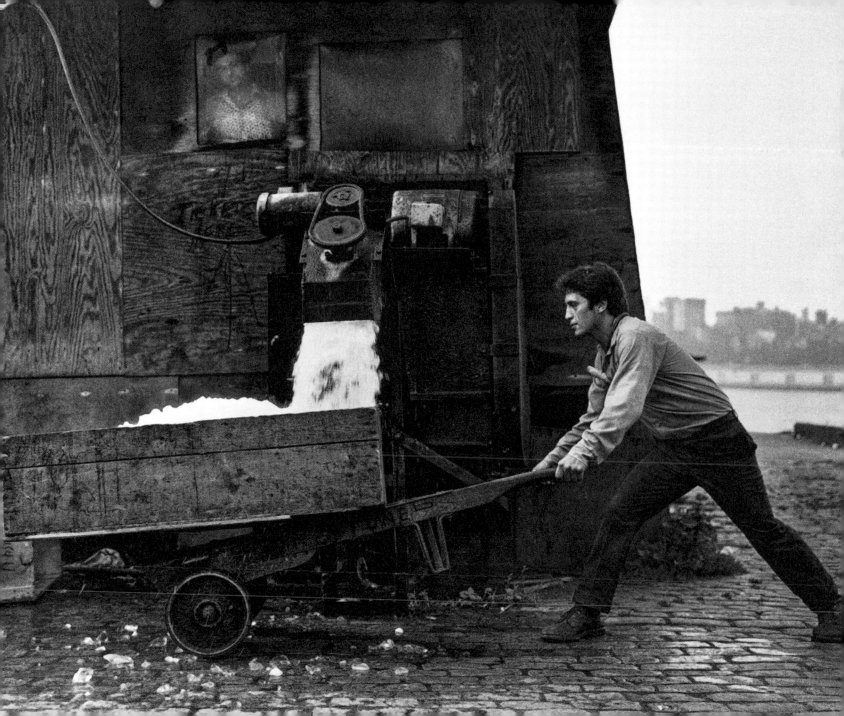

The day arrived. It would be the last day on South Street for-ever. I returned to watch the dismantling of the time-honored fish market.

Outside the New Market Building, just below the Brooklyn Bridge, signs of the old businesses were torn from the walls and fish bins were thrown out onto the curb. The old wooden pallets, office furniture, every hint of the fish market's existence was dragged out to South Street and broken apart. Large industrial-size Dumpsters were hauled in and placed outside the old sheds. Sanitation workers were busy gathering up enormous piles of debris.

On that very last day, I saw more cameras in one place than I'd ever seen before. The press photographers were stepping over one another to get the "last picture." It was a feeding frenzy, similar to that of seagulls shredding pieces of discarded fish. City officials, either walking around or leaning on their parked cars with very little to do, were waiting uncomfortably, planning to take control of the premises the following evening.

I photographed the "event" that day, particularly horrified at the decay that was once the New Market Building. The scene even provoked thoughts of my own mortality. A recollection of an old-timer came to mind, about the day the building was opened: "Every-body was there, bosses, workers, the customers, everybody. Mayor Fiorello La Guardia was there. They called him 'Little Flower.' Why, even the President of the market was there. Joe Socks, he was a nice fella! Then the mayor said, 'Now youse all make a good living, and remember to keep the market clean.' Then they cut the ribbons and everybody clapped."

I came out of my momentary trance. Workers and owners were walking around the debris shouting, "See ya in the Bronx." Amid all the mayhem, the very same woman who for so many years had loved "her boys" appeared like a ghost. Her long hair had turned white, and her large breasts drooped. Stoop-shouldered and wear-ing a pair of very large bifocals, she was gesticulating, hugging and kissing the men. I noticed that she still had her shopping cart.

For so many decades, this "Street of the Tall Sailing Ships" had been synonymous with America's growth and expansion. South Street led the way and was instrumental in New York becoming an important international port, based on the volume of its trade and its critical location. In the 1970s, America witnessed the birth of the

megacorporation, which began to exert enormous influence over economic and political policy, particularly in New York City. Unimpeded corporate interests, backed by the most powerful system of law enforcement ever assembled, sought to claim victory over Cosa Nostra in New York and a century of mob rule on South Street. In those crucial years, I witnessed a confluence of unique historical forces. The destruction of the docks and the building of the Seaport mall was the symbolic end of the maritime era below the Brooklyn Bridge.

Toward the end of my four-year exploration, and in putting this book together, I searched for more recollections and more old-timers to communicate with. Although so much time had passed and many of the individuals and stories that I had pursued were long gone, still, people were "reluctant to say certain things." I called former Assistant District Attorney Daniel Bookin, now in private practice in San Francisco, asking him to reflect on his experiences on South Street, but he refused. So in the end, all I had left by way of epitaph were the words of my first friend, who said to me long ago, "My prognosis for the market is that it will not remain. The market is like a very delicate ecosystem. If you alter the water temperature by a few degrees, eventually all the fish will die off or move to another ocean, and that's what was intended. You can't come out right in the beginning and say, 'Okay, you guys, you got another five, ten years here and then we will finally screw you.'"

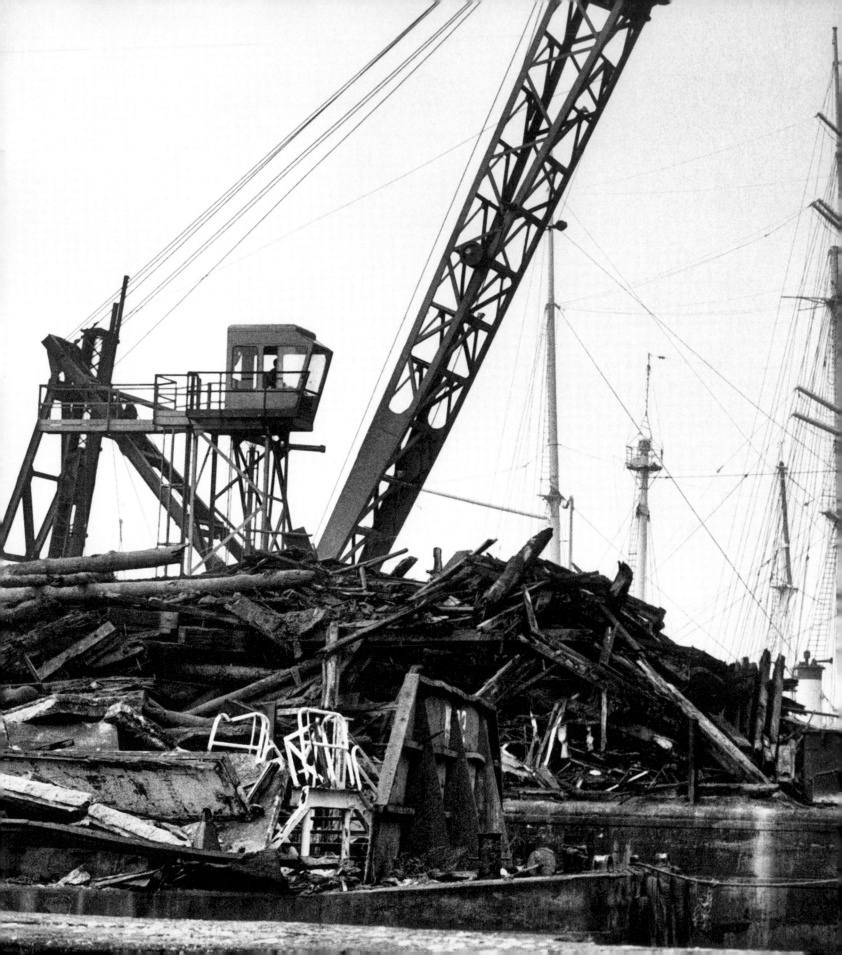

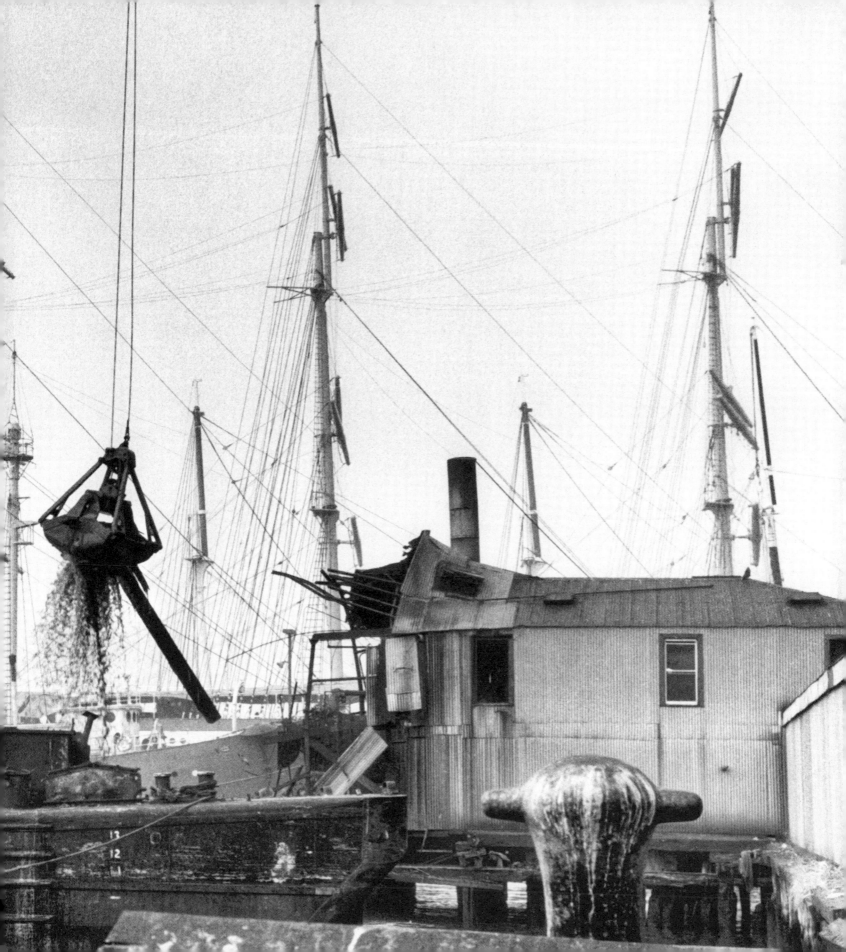

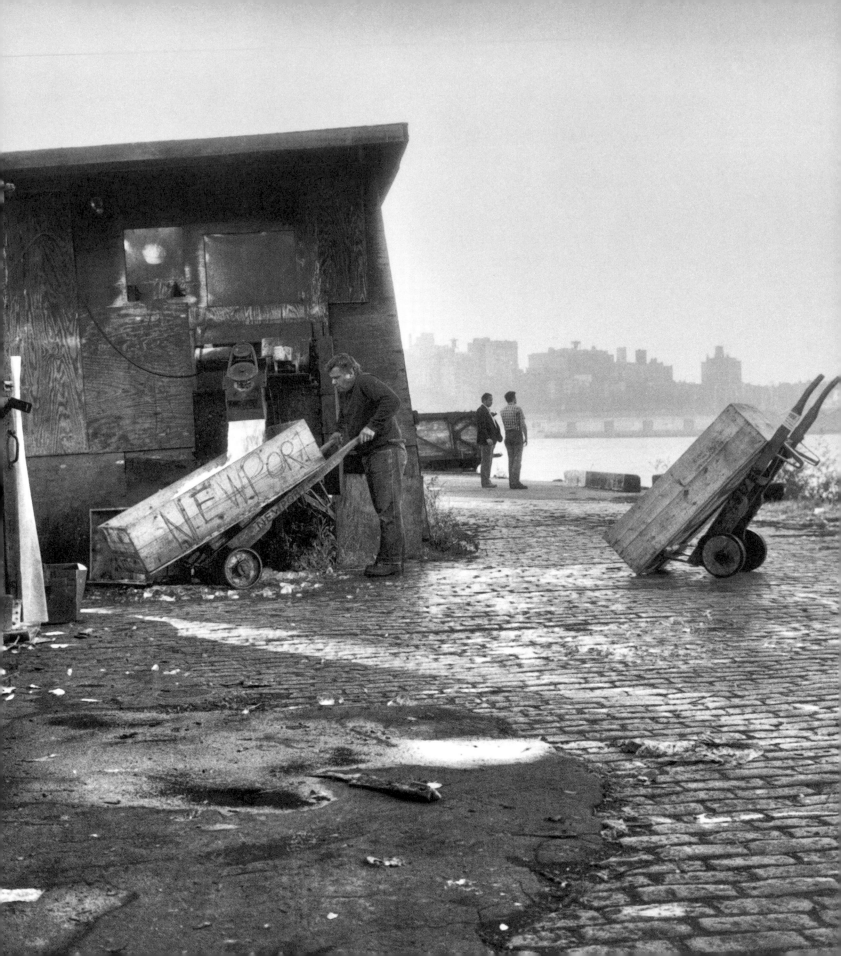

GLOSSARY

BUYERS: Owners of restaurants, agents for restaurants, and retail fish businesses in and around the New York City area who visited the market to buy seafood.

CREWS: Groups of men who worked for the individual fish companies.

FILLET MAN: The man employed by the owner of the fish company to hand-cut fish. He possessed high technical skills at cutting and separating the meat.

FISHMONGER: Years ago, the man who handled, packaged, and sold fish. In modern terms, the owner of the company, also referred to as "wholesaler" or "owner."

JOURNEYMAN: The man who "journeyed"—transported the crates, baskets, and cartons of (sold) fish by hand truck from the fish company's stand to the customer's waiting van.

LOADER: A man who worked outside, in the environs of South Street. He was responsible for pointing the journeymen to the correct customer vans. Often the loader became a director of traffic, making sure that cars, trucks, and taxis moved through the area without accident. Most importantly, he watched the customers' trucks and vans and safeguarded them from theft.

LUMPER: The worker who unloaded fish from the hull of a fishing trawler.

SHAPING UP: The regular search for work by men who did not have steady employment on South Street. They would walk around to all the company stands looking for jobs.

SMOKIES: Homeless men living under the Brooklyn Bridge. During the Giuliani administration, they were removed from their makeshift homes and moved into shelters involuntarily.

STAND MAN: The man who stood outside on South Street and dispatched (to the journeyman) the seafood by indicating on the crates (writing with marker or crayon, or on a label) a number that corresponded to the number on the customer's vehicle, parked in a loading zone.

UNLOADER: Worker in the earlier hours of the market's operation, from approximately 11 p.m. to 3 a.m. The unloader removed thousands of pounds of seafood packed in crates and cartons. After the crates were unloaded on South Street, they would be further "broken down" and distributed by hand truck to the individual companies. The seafood would then be "broken down" again and separated into displays in the fish bins for sale to the customers.

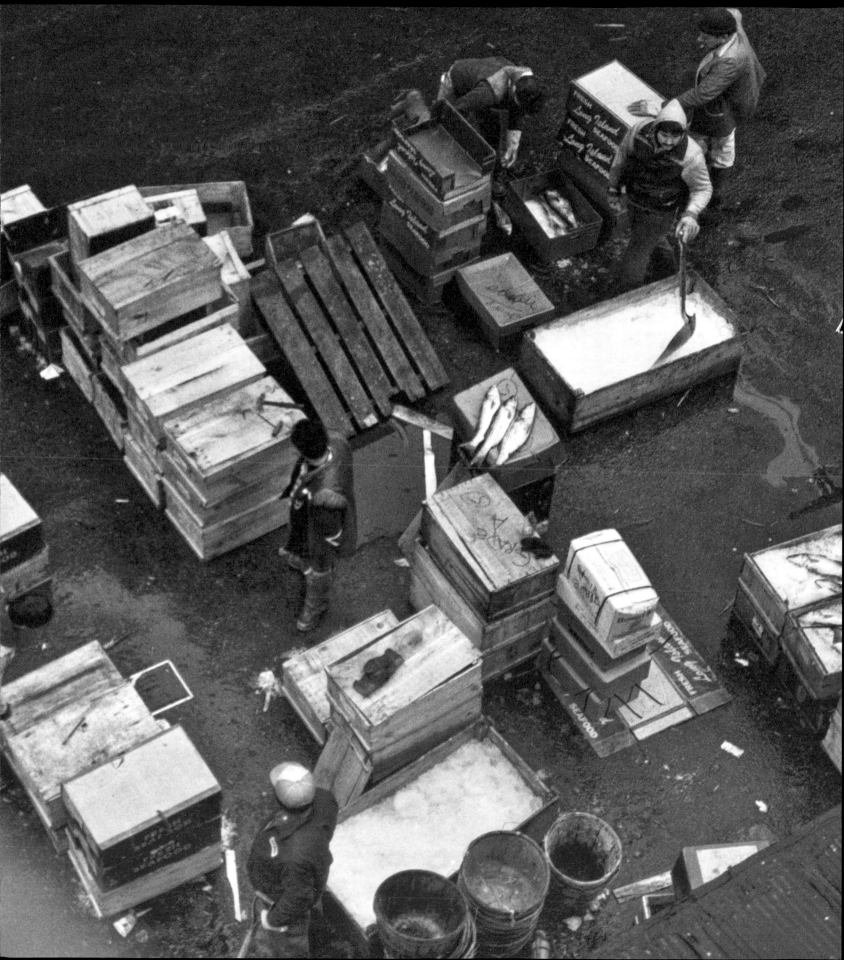

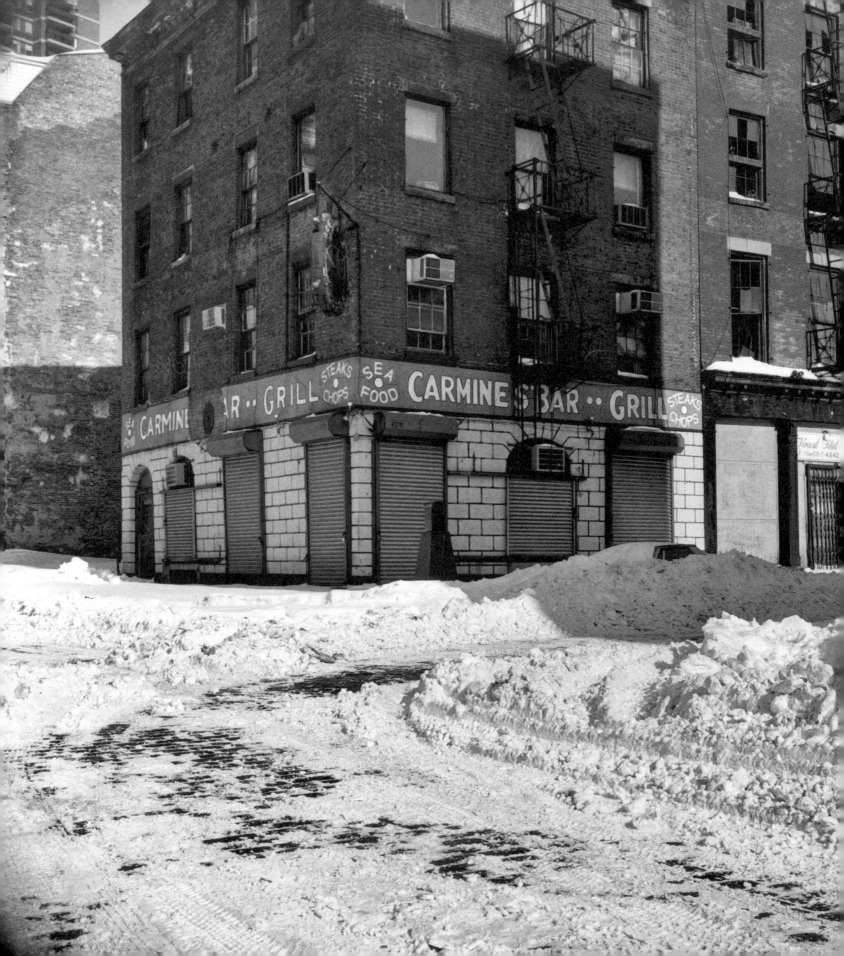

REFERENCES

Asbury, Herbert. *The Gangs of New York*. New York: Knopf, 1928.

Barzini, Luigi. *The Italians: A Full-Length Portrait Featuring Their Manners and Morals*. New York: Atheneum, 1983.

"City Considering a Modern Fulton Fish Market at a New Site." *The New York Times*, May 14, 1999.

Gambino, Richard. *Blood of My Blood*. New York: Doubleday, 1974.

Kaplan, Marjorie and Tony Brenner. "Fish Market Probe Finds Organized Crime Control." *Newsday*, May 10, 1981.

Lombardi, Frank. "The Catch of the Year." *New York Daily News Magazine*, December 12, 1982.

Lubasch, Arthur H. "Mafia Runs Fulton Fish Market, U.S. Says in Suit to Take Control." *The New York Times*, October 16, 1987.

McCullough, David. *The Great Bridge: The Epic Story of the Building of the Brooklyn Bridge*. New York: Simon & Schuster, 1972.

Mensch, Barbara. *The Last Waterfront: The People of South Street*. New York: Freundlich Books, 1985.

Museum of the City of New York, Collection of Prints & Photographs.

New-York Historical Society, Department of Prints and Photographs.

Quindlen, Anna. "$270 Million Project for South Street Planned." *The New York Times*, September 28, 1979.

Riis, Jacob. *How the Other Half Lives*. New York: Dover, 1971.

Ryan, Dick. "Countdown on Fulton Street." *New York Daily News Magazine*, 1975.

"Seaport Plan Stirs New Uncertainty at Fish Market." *The New York Times*, November 8, 1980.

Sexton, Joe. "Fire Sweeps Through Major Building at Fulton Fish Market." *The New York Times*, March 30, 1995.

U.S. v. Local 359, United Seafood Workers, et al. http://caselaw .lp.findlaw.com/scripts/getcase.pl?navby=search&case=/data2/ circs/2nd/946103.html&friend=nytimes (accessed July 18, 2006).

ACKNOWLEDGMENTS

I wish to thank all those individuals who supported my work during those incredible years on South Street. Although many of the faces are stored in my mind forever, nevertheless as time passes it becomes more difficult to remember each and every one. To all the people of the market who believed in me—you know who you are.

Here are just some of the names of the companies, owners, members of their crews, and other members of that nocturnal world to whom I wish to dedicate this book:

Mikey the Bartender; Mikey the Watchman; Larry; Buddy and the crew from R. J. Cornelius; Clay; Curly; Larry and Tony Lombardi; Jimmy Falzone; Ed Moran; Old Johnny, who sat with me at the bar in Carmine's after hours and spun stories of the depression years; Sonny "the Cooper" Ferris; Jimmy "Fishcakes"; Wobbo; Butchie Kaline and his brother Peter; Little Al; Jerry and Frankie "Twin"; the crew of Messing Fish Company, including Charlie Pavia, who nicknamed me "Little Lamb Chop"; Joe and Sonny in Pier 20; Dominick Ferraro; Tony C.; Frankie and Vinny "Fair" and the crew of Fair Fish, especially Ziggy; Charlie the Greek; Chief; Moose; Rocky at "the Club"; Bootsy; Bobby L. the loader; Paulie A.; Danny and Bob Behrens (on the corner of Hollywood and Vine); the one and only Roy at the coffee truck; Charlie and Pete at the Smokehouse;

Frank and his crew at Smitty's (and also Frank's sister Elaine, and Dotty); John from Smitty's; Mikey Cara; The Grippa Brothers; Crown Fish Company; Mortimer Woods; "Captain Tony"; Philly; Dave the crab merchant; Maxie from Cinrox; Frank Wilkisson; the crew of Lochwood and Winant; Blue Ribbon; Beyer Lightning; faithful customers Heschy from Essex Street Market and Mr. Rosedale from uptown; Frankie "T"; Mike and Tony from T & S; Herman and Al; Nicky and Dino from M. P. Levy; the crew of Royal; Vinny from Carter; Archie and Al from Wadman; Louie Selika and his son Mark; "Football"; Joey; Sabo; VJNL Unloading Crew; South Street Unloaders; Mr. Miller; Victor the loader; the crew of Wallace Keany & Lynch and North American Lobster; Nicky (who first threw me out of the Paris Bar and then years later became a friend); Joe Cantalupo (the cleanup guy); Johnny Lollygag; Jimmy Red; the inimitable Herbie Slavin and his crew, especially Sal and Kenny; Bobby Mullans; Jake the Snake and his brother Bo (although he was already deceased, all the stories I heard about him made me feel that I knew him anyway).

Lastly, I want to mention the most "photogenic" stands in the market—Dynasty Fish Company and Reliable Fillet—who as a group and as individuals taught me some crucial lifelong lessons in survival. I want to thank each and every one of them for their unique wisdom. I particularly want to thank Bobby and Ronny for their unflinching and unwavering support of my work.

The downtown community has traditionally been the home of the world's great artistic talent. In my earlier years I had the opportunity and privilege of being involved with some of these artists, both as friends and as professional colleagues. I want to thank Phill Niblock, whose masterful film work was an early inspiration. I also want to thank James Staley, director of Roulette. My periodic opportunities to photograph one-of-a-kind music performances in his loft heightened my visual acuity, instincts, and awareness. It was through these early experiences that I met my lifelong friends, filmmakers Nicolas Humbert and Simone Fuhrbringer.

I want to thank the brilliant Phillip Lopate (my kindred spirit) for his amazing contribution to my book; my colleague, photo historian Bonnie Yochelson; her daughter Emily for interning in my loft, which has been an interminable construction site; and Rob Chatterson, my assistant in initially organizing the waterfront material.

Special thanks to Bruce Davidson for his wisdom. Finally, thanks to my photography dealer, Bonni Benrubi, for supporting my current work.

Without Bob Klass, a masterful printer and my close friend, I could never have resurrected this body of work. Heartfelt thanks for his collaboration. I must mention the "crew" of Columbia University Press, particularly Leslie, Linda, and the ebullient Jennifer Crewe, for taking on this project.

Grateful acknowledgment to my friends Pete, Lynn, Janet, Laura, Annie, and Kari. Heartfelt thanks to my wonderful "family," Margrit, Bill, Russ, "Oma," Ivan, and "Lucy"; "Dot" and the late "Coco"; Robin; Victor and Sara; my son, Jesse; Agnieszka; Johnny; Al; Gary; and my soulmate Greg. . . . I pay special tribute to my parents and my immigrant grandparents long deceased—I have them in my heart always. Lastly, I couldn't have evolved to where I am today without Edith. Thank you all.

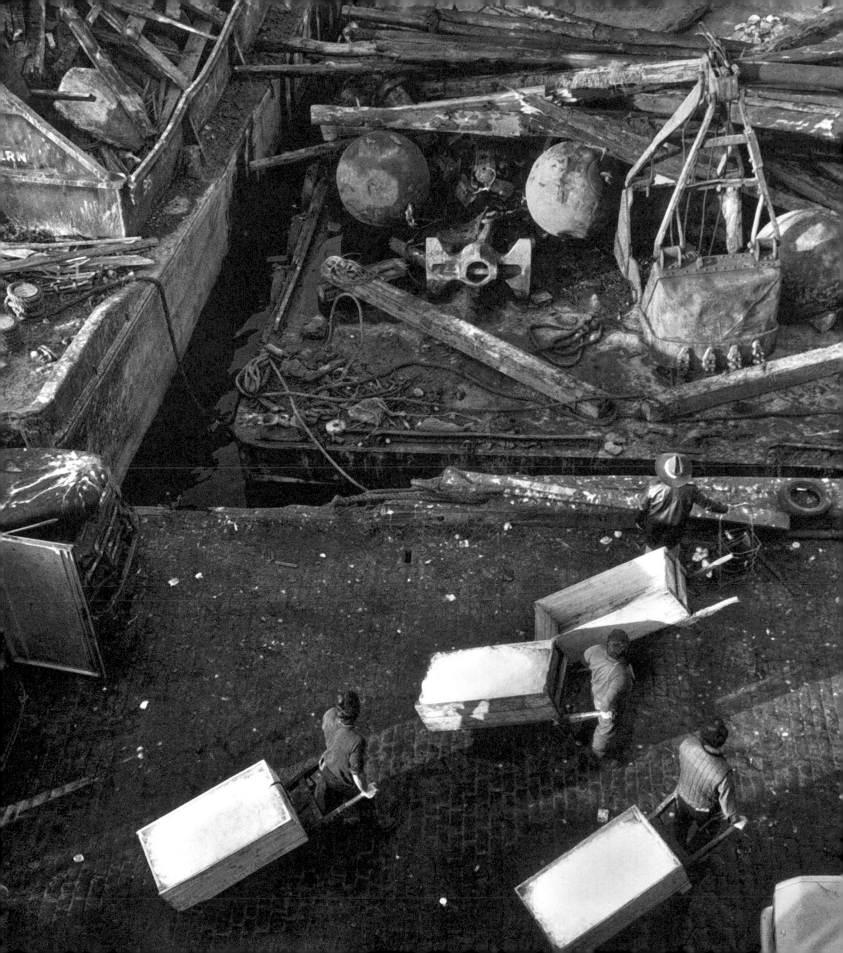

Columbia University Press would like to express its appreciation for assistance given by Furthermore: a program of the J. M. Kaplan Fund and by Gary Joel Rubinstein in the publication of this book.

This project is made possible in part with public funds from the Fund for Creative Communities, supported by the New York State Council on the Arts, and by the Manhattan Community Arts Fund, supported by the New York City Department of Cultural Affairs, both of which are administered by the Lower Manhattan Cultural Council.

Columbia University Press
Publishers Since 1893
New York — Chichester, West Sussex
Copyright © 2007 Columbia University Press
Library of Congress Cataloging-in-Publication Data
Mensch, Barbara.
South Street / by Barbara G. Mensch ; introduction by Phillip Lopate.
ISBN 0–231–13932–2 (cloth : alk. paper) —
ISBN 0–231–51134–5 (electronic)
1. South Street (New York, N.Y.) — History — 20th century — Pictorial works. 2. South Street (New York, N.Y.) — Social life and customs — 20th century — Pictorial works. 3. New York (N.Y.) — History — 20th century — Pictorial works. 4. New York (N.Y.) — Social life and customs — 20th century — Pictorial works. 5. New York (N.Y.) — Social conditions — 20th century — Pictorial works. 6. Fulton Fish Market (New York, N.Y.) — Pictorial works. 7. Fishery processing industries — New York (State) — New York — Employees — History — 20th century — Pictorial works. 8. Fishery processing industries — New York (State) — New York — Employees — Biography. 9. Organized crime — New York (State) — New York — Employees — History — 20th century. 10. Oral history. I. Title.
F128.67.S65M47 2007
974.7′10430222 — dc22
2006018750

∞

Columbia University Press books are printed on permanent and durable acid-free paper.
This book was printed on paper with recycled content.
Printed in the United States of America
c 10 9 8 7 6 5 4 3 2 1

203-929 8661 John?

Seafood Emporium

turbot 150 turbot
hale 80 hake
Catfish plus 60 —
10 brook trout

Norwegian 550 2-3
 565 3-4
 585 5